MW01152897

SEARCHING

FOR THE PERFECT BEAT

FLYER DESIGNS OF THE AMERICAN RAVE SCENE

A PROJECT OF THE EARTH PROGRAM LTD. NYC

JOEL T. JORDAN • SUMMER FOREST HOECKEL • JASON A. JORDAN

INTRODUCTION BY NEIL STRAUSS

DESIGNED BY JOEL T. JORDAN

WATSON-GUPTILL PUBLICATIONS/NEW YORK

First published in 2000 in New York by Watson-Guptill Publications,
a division of BPI Communications, Inc., 1515 Broadway, New York, NY 10036

Library of Congress Cataloging-in-Publication Data
Jordan, Joel T.
 Searching for the perfect beat : flyer designs of the American rave scene / a project of the Earth Program Ltd. NYC ; Joel T. Jordan, Summer Forest Hoeckel, Jason A. Jordan ; introduction by Neil Strauss ; designed by Joel T. Jordan.
 p. cm
 ISBN 0-8230-4751-2
 1. Advertising fliers—United States—History—20th century. 2. Commercial art—United States—History—20th century. 3. Graphic arts—United States—History—20th century. 4. Rave culture—United States. I. Hoeckel, Summer Forest. II. Jordan, Jason A. III. Earth Program Ltd. IV. Title

NC1002.F55 J67 2000
741.6'7'097309049—dc21
 99-055667

Printed in Singapore
1 2 3 4 5 / 04 03 02 01 00

cover artwork ©1999 the earth program ltd. nyc: searching typeface by joel t. jordan / cg glowstick modeling by patrick james lavin / headphone character by kon trubkovich

here we go…

Searching for the Perfect Beat was a necessary project. It had to be done.

After ten years of growth, evolution, and expanding graphic influence, the rave flyer had come into its own.

We were there—collectively, participating along the way, feeling part of something larger, something we knew would inevitably have a profound effect on a spectrum of mediums. We were there—producing our own events, putting out music, DJing, creating rave graphics, photographing, filming, and, most importantly, raving. So now, at approximately the ten-year anniversary of the rave scene's birth in the United States, we seize the opportunity to proudly bring forth a retrospective look at this wholly unique genre of graphic design, one that is so close to our own hearts. Bred entirely in the underground, the work presented here is gratifying evidence that our early intuitions were accurate: the rave scene has had a tremendous impact on contemporary mainstream culture in its musical, social, and, in so many ways, creative growth. The flyer is the primary testament of this transmission, standing not only as an important commercial art form, but also as a concise and substantive record of an entire movement. Work by old-school pioneers appears here alongside pieces by some of today's most innovative young designers, who continue to push the limits of this ever-changing medium. By no means is this collection complete; we would need volumes to contain the great quantity of flyer designs generated during this period. It is, however, a cohesive and inspiring representation of the genre. The works included were chosen based on design ingenuity, technical innovation, and style, as well as event location and historical importance.

You hold in your hands a document of some of the best American rave flyers of the decade, a colorful and incredible visual record of a movement that will live forever in our memories and beyond through these works.

—The authors

intro

by Neil Strauss

In 1998, the blue-jeans company Levi Strauss brought its $90-million-dollar account to a new ad firm in hopes of making its brand name cool again. The company's top executives met and came up with a new strategy for this big client. The idea was to employ a "viral" attack, modeled specifically on the way raves are promoted through the spread of flyers. "Levi's," wrote *The New York Times,* "needed to insinuate itself into the consumer's own clubs, covert venues, street scenes, favorite stores, Web sites and fanzines in order to leave the company's tag, spoor, logo, presence or aura for kids to discover for themselves. Viral communications."

And so, in roughly nine years, the underground art of making and distributing rave flyers became a multimillion-dollar corporate strategy known as viral communications. On their journey from street to boardroom, rave flyers became one of the most potent symbols of youth culture in the 1990s—their bright colors signifying a return to optimistic psychedelia, their computer-generated design a clue to a technology fetish, their dense text an invitation to a subculture with its own deities and language.

Everything you need to know about a rave is encoded in its flyer, each one a key promising to unlock a night—and morning—of liberation and transcendence in a self-contained world with its own rules. (Of course, the occasional flyer may also be a beautiful lie leading to a bad trip.) With images of space and fractal patterns, flyers reveal a movement with one foot in the abstract world of the repetitive and infinite; with images appropriated from Japanese cartoons and grocery products, they reveal another foot grounded in the very real world of consumerism. Their evolution from tiny black-and-white Xeroxed squares of paper to glossy color foldout posters mirrors the growth of raves themselves.

Consequently, besides the street and the boardroom, American rave flyers began to appear in one other unexpected place in the early 90s: the art gallery. At first, flyers were saved as souvenirs of memorable parties, proof of early membership in a growing community. Then, beginning with the first gallery shows of rave flyers, they became pop art in their own right. (Legend has it that at the first flyer art show, half the exhibit was stolen by a raver intent on beefing up his personal collection.)

Two of the dominant avant-garde art movements of the twentieth century, Dada and Fluxus, incorporated typography, with lettering design one of their main concerns. As an art form, rave flyers cover similar ground, offering some of the most cutting-edge examples of computer design in the 90s. By coincidence, the emergence of rave flyers in America in 1991 paralleled the introduction of the computer program Adobe Photoshop, beginning a long relationship between innovative, economical flyer creation and new design software. Original, eye-catching fonts were a Holy Grail to early flyer designers, who, when they didn't create new typefaces on their own, would trade a new pair of sneakers or an armful of records for a computer disk containing the desired fonts. The layout of flyers, the way the arrangement of text and lines moves the eye through large quantities of information, by necessity became innovative as parties boasted more and more DJs, promoters, and accouterments, and the resultant rave linework (flow of text) was quickly imitated in advertisements by everyone from MTV to Microsoft. The earliest American rave flyers, however, were as amateurish as the parties themselves. Hand-drawn and Xeroxed on office paper, they expressed a hesitancy, a doubt, that the dance culture that swept through England in 1988 would take hold here.

One can trace raves back to the transgressive Four Arts Balls in Paris in the 1920s, the Acid Tests of Ken Kesey and the Merry Pranksters in San Francisco in the 60s, or, for the more mystically inclined, Native American religious ceremonies and the shamanistic rites of other tribal societies. But their direct roots are in England's so-called summer of love in 1988.

The English rave scene was born of a collision between DJs trying to make their own sample-heavy version of Chicago

1990

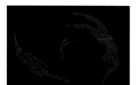

1991

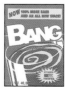 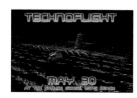

1992

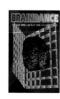 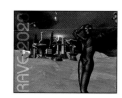

1993

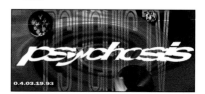

house music (called acid house) and club promoters trying to recreate the decadent, Ecstasy-fueled nightlife of the Spanish island of Ibiza. Though the first rave is sometimes traced to late 1987, when the English DJ Danny Rampling started his Shoom party at a gym in London, acid-house culture truly took hold the following summer, when football hooligans could be found in clubs grinning on Ecstasy, wearing smiley-face shirts, dancing madly amid smoke and light and bubbles, and hugging everything in sight.

The word rave itself (as in "out-of-control, raving mad") had popped up in the past in everything from a 1966 Pink Floyd concert that was described as an "all-night rave" to a 1972 David Bowie song, "Drive-In Saturday," with a lyric about "ravers." But it really took hold in 1989, when clubs and gyms became too small to hold these electronic-music free-for-alls and it became necessary to rent out venues like airplane hangars and farm fields to accommodate crowds as big as 17,000. By then, however, the scene had reached critical mass, had become too big and too renowned for Ecstasy use. So the press and the police closed in. Raves were vilified as drug parties; undercover policemen were sent to them to bust dealers, laws were passed banning large gatherings, and promoters were fined and even imprisoned. Promoters who tried to throw parties outside of clubs soon had to resort to keeping the locations a secret until the last minute, so that finding some raves became a scavenger hunt involving multiple phone calls and visits to places with clues.

But as rave culture was being squashed in England, it was beginning to take hold in America. After all, the roots of the British scene were in American music: Chicago house, Detroit techno, and New York garage—and when American musicians, producers, and partygoers noticed that the British had taken their music and fashioned a whole youth movement out of it, they took it back. Thus came the first raves on this side of the Atlantic and, soon after, the first American rave flyers.

In New York, half-baked acid-house nights started popping up in 1988 at clubs like the Pyramid, but the first bona fide raves were held the following year, after the Brooklyn producer Frankie Bones came back from DJing in England and began throwing small parties for a couple dozen people at apartments on Coney Island Avenue and elsewhere. These eventually evolved into the Storm parties, held at warehouses and parking lots and

underneath bridges. Meanwhile, raves in Los Angeles grew out of a trendier, artsier Hollywood scene, namely, after-hours-club parties with a $20 cover. In San Francisco, the first raves grew out of a combination of wild gay clubs, the city's post-hippie techno-pagan movement, and British expatriates looking to update the local club scene. But in the regimented atmosphere of such established clubs, everybody was carded, drinks were expensive, trendy dress was required, neighboring residents complained about noise, and DJs and promoters had no control over the visual appearance of the spaces where these events took place. So promoters started finding alternative locations where they could decorate for their parties—raves like Moonshine in Los Angeles, Catastrophic in Washington, D.C., and Toon Town in San Francisco.

Parties began to grow concurrently—although in complete ignorance of one another—in New York, L.A., and San Francisco, and in clubs like Tracks in D.C., underage juice bars in Chicago, and elsewhere. The fact that many of these were held in or soon moved to abandoned warehouses or deserted waterfront locations made them feel new and illegal, especially when combined with a style of electronic instrumental music the mainstream wasn't yet aware of. Thus, attending a rave became an exciting and subversive act. To be there was to belong to a community, a feeling heightened by the one-love trip of Ecstasy and the hypnotic, unceasing beat of techno.

The names of many parties (Storm, Catastrophic) were inadvertently similar, conveying the idea that raves were powerful, unpredictable, and dangerous, on the margins of society. The precedent for these warehouse parties was not just in England, but also in Detroit, where in the late 80s DJs like Derrick May hosted raves like the Music Institute, forced into an empty loft or warehouse on the outskirts of the city because the clubs catered to a predominantly white crowd that listened to commercial house music.

The first rave flyers for these were simply photocopied sheets of paper with directions, perhaps a map, and a phone or beeper number. There was no art element yet: just information. But the stakes were quickly raised.

"At the first party I went to," remembered Dennis the Menace, a pioneering New York rave promoter, "everyone had to go to a map point in Brooklyn, where they got information on how to get

1994

1995

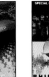
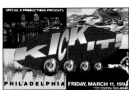
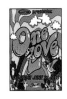
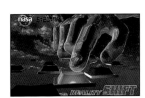
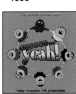
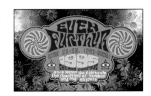

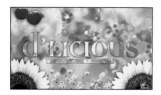 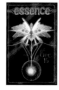 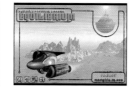 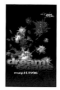 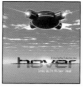

1996 1997

to the party in Queens. I asked them, 'What are you doing to make it [the rave scene] bigger?' And when we started to put the marketing behind it, it just blew up. The only thing I can compare it to is the Electric Kool-Aid Acid Tests in the 60s. But they [Ken Kesey et al.] were [like] Nobel Prize winners; we had less on deck. The original flyers for the Storm parties had my beeper number on them and the artwork was very basic. It didn't have to be flashy. Now, unless you're putting out a newspaper or a magazine, you're not going to get a crowd at your party."

In the early 90s parties might be held at places like an abandoned brickyard, with DJ booths fashioned out of stacked bricks and a hundred or so ravers dancing in the filth. But soon the parties got too big to hide. The record stores where DJs and music fans met to pick up the latest singles became small community centers, with technoheads and potential ravers meeting to find out by word of mouth or through Xeroxed flyers and postcards where the week's parties were. Soon, promoters began hooking up with friends doing design work on the computer—using Adobe Illustrator or Photoshop—and coming up with more elaborate flyers to make their events stand out.

As the popularity of raves grew, it became increasingly important to create an eye-catching flyer to outdo all other flyers before it as a way of letting ravers know to expect the same from the party. It was assumed by partygoers that the more care that was taken in the design of a flyer—the more colors used, the better the linework, the higher the quality of the paper stock, the more professional the printing job—the more care would be taken with the design and execution of the rave itself.

Soon, flyers grew from index-card size to poster size. Some promoters began creating a whole series of flyers for a rave, releasing first a small teaser, then a large leaflet with all the information, and finally a last-minute reminder and update. In New York, the NASA parties that popped up in 1992 were heralded by flyers parodying a commercial product like Bazooka bubble gum or *U.S.A. Today,* and each new design was as eagerly awaited as the rave itself. These parties were in some measure responsible for changing the rave demographic from Brooklyn post-teen casual to Manhattan high-school fashion plate. In Los Angeles, the designs and logos Rick Klotz used on rave flyers he created for free soon became the basis for his own clothing company, Fresh Jive, and were emblazoned on T-shirts and labels. By now designers were becoming an important

element in coordinating events and helping to ensure their success. A flyer by certain designers, like Klotz, Stimuli, Under, Joel T., or Mars, gave a party the stamp of legitimacy.

Because it was linked to a technology-based music, rave culture grew and spread along with the use of personal computers. While the first promoters had to search hard to find someone proficient in digital design, within a few years they had thousands of people to choose from, some of them using state-of-the-art tools, like Alias/wavefront's 3-D modeling program Maya (used for 1999's *Star Wars Episode I: The Phantom Menace),* to add original elements to a simple, disposable color flyer.

Unlike the rock concert business, rave culture was never centralized or nationalized. It remains a local phenomenon, with each region distinguished by its own kinds of parties and flyers. In Los Angeles, for example, where raves are held on a much grander scale and attract a larger audience than anywhere else in the country, the flyers can be expensive, sophisticated die-cuts with an overall look that suggests good California vibes. In New York, flyers are often sleek and modern, with space-age and technology-oriented graphics. In the South, there's a tendency toward flyers with exaggerated cartoon drawings, big fat lettering, and bright colors. In New Orleans, high-quality raves are suggested by such creatively produced flyers as thin roll-up posters or school folders with pockets filled with individual sheets of paper. In Wisconsin, flyers for the multiday Furthur raves parody the psychedelic art of the 60s. And San Francisco made itself the capital of message flyers, with holistic, positive slogans like "We cannot change unless we survive, but we cannot survive unless we change."

Beyond the language of each city, there is a national visual language: scary images (knives, blood, bats, horror-movie scenes) suggest the fast, relentless, jackhammer beats of hard-core parties that might attract an angel dust–smoking crowd; images of butterflies and children's toys suggest a soft techno party appealing to Ecstasy-popping, candy-sucking ravers; a creamy design with an abundance of text but few visuals might be for a house party drawing a mixed crowd; and psychedelic fractal-pattern designs might be used on a flyer to attract an acid-dropping, Goa-trance crowd.

Above all, American rave flyers—particularly because they are almost the sole means of promoting a party—provide a

 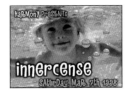 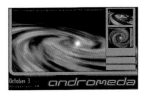 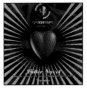 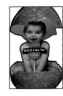 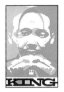

1998 1999

microcosm for the development of advertising culture and competitive independent entrepreneurialism. This can be seen in each successive attempt by young designers and promoters to outdo the competition. First this meant spending a little more money on four-color silk screens or silver-foil stamps, then it became attaching 3-D glasses to red-and-green flyers, or printing information on fans in the summer, or publishing thick, full-color booklets.

Perhaps as important as a flyer's design is its distribution. Early on, promoters began sending groups of attractive, funky club kids to hand them out by the exits at parties. It was also a necessity to find the hip stores and cafes ravers frequented in different neighborhoods and maintain piles of flyers there. The wider the area of flyer distribution, the larger the audience that would attend a rave. In some cases, flyers were distributed for parties that never happened—that were either shut down by the police or canceled when promoters took the money and ran.

Phil Blaine, a Los Angeles rave promoter, remembers how quickly the ante was upped for flyers. "At first we'd do 2,000 flyers, then it was 30,000 flyers," he said. "In Los Angeles, there was a talent pool of designers who'd work for free if they could put their logo and phone number for work in the corner. And each time we went back to the printer, we would find new ways to design things and add colors without spending much more money. But now, for a really big party, I'll do a quarter of a million flyers. I just did 350,000 for a party Labor Day weekend in a waterslide park. It cost twenty-five grand for the flyers. And it's worth it, because the flyer is the only vehicle to promote these events."

Although by the mid-90s most flyer designers had set up small companies and were turning a profit, the money was pocket change compared to the time and resources they put into their work. Most designers weren't as lucky as Rick Klotz. As flyers developed their own visual language, the look and sound of rave culture was appropriated by advertisers attempting to be cutting-edge.

With the original rise of rave culture in 1991 and the success of pop techno bands like the Prodigy in 1997, pundits predicted that raves and techno would be the next big thing. But although new converts continued to be attracted to rave culture, the mainstream never embraced the music in America quite the way it did in Germany or England. Instead, it was American advertising that

gave the culture its biggest exposure, using the look and music in ads for computers, shoes, jeans, cigarettes, and most everything else; in promotional spots for youth-oriented TV stations and movies; even in cartoon series like *The Powerpuff Girls,* starring three Japanimation-like characters who seem to have sprung to life out of a particular flyer style. A contest by 7-Up even involved giving the winners cell phones that would ring on a certain night, the caller divulging the secret address of a corporate rave.

All of this may seem appropriate, since many flyers originally repurposed corporate logos and brand names, but it wasn't always so amusing to the designers who worked for free, only to see their ideas used and uncredited in multimillion-dollar advertising campaigns. Fortunately, thousands of ravers saved party flyers as souvenirs and designers preserved samples of their work, making possible art exhibits and books like this one, which attempt not only to give credit where it's due but also to convert the ephemeral into the eternal.

Editor's Note:

Credits are listed on each page as follows:

event title I location
year I promoter(s)
dimensions (inches), specifications (format, colors, paper stock, etc.)
d: designer(s)

The letters cmyk stand for cyan, magenta, yellow, and black, the colors used in standard four-color printing. The letters uv in this context stand for ultra-varnished, a plastic-like finish.

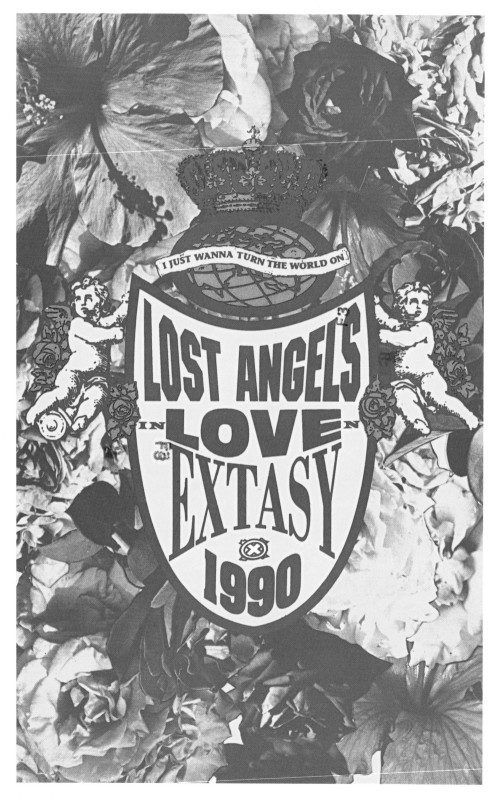

PRESENTING LA'S FIRST
AIRCRAFT HANGAR PARTY
**ALICE'S HOUSE/THROUGH THE LOOKING GLASS
IN ASSOCIATION WITH THE CREATORS OF
LSD, SEX, LOVE, LSD 2, MR. BUBBLE,
AND THE HAPPY HIPPOS ELECTRIC CIRCUS
PRESENT**
THROUGH THE LOOKING GLASS WITH
DOUBLE HIT MICKEY
IN A MASSIVE AIRCRAFT HANGAR WITH AERONAUTICAL PROPS
THE ULTIMATE NEW YEARS EVE CELEBRATION
**DJ'S RANDY MR. KOOL-AID BEEJ
INTELLABEAM & LASER LIGHTING BY C.C.C.P.
AND THE RETURN OF THE**
MENACING MOONBOUNCE
**COMPLIMENTARY BAR INCLUDING SOFT DRINKS & WATER
PLUS MORE TO BE ADDED, STAY TUNED FOR DETAILS.**
LAST NEW YEARS, ALICES HOUSE THREW THE BIGGEST PARTY
LA HAD UNTIL THEN. THE ENERGY HAS NOT BEEN MATCHED
SINCE. THIS YEAR IN COLLABORTION WITH THE PEOPLE
MENTIONED ABOVE, WE PROMISE AN EVEN BIGGER, MORE
ELABORATE EVENT. WE ALL HOPE YOU ATTEND AND DONT
MISS THIS ONE. WE GUARANTEE IT WILL BE THE
BIGGEST AND BEST PARTY SO FAR!!
FOR DIRECTIONS AND FURTHER INFO:
(213) 960-5199

* TINA TRIPP's *
MAGICAL MYSTERY TOUR
CONTINUES
FRIDAY SEPT 13, 1991
11 P.M. UNTIL DAWN
- RAIN OR SHINE -
IN AN ABANDONED WAREHOUSE
SOMEPLACE IN BROOKLYN
* D.J.'s *
FRANKIE BONES
GONZO
LEE-BOTIX
JIMMY CRASH
JEFF KAOS
ADAM 'X'
PROMOTIONS BY HEATHER HEART + LIL LISA
INFO → BEEP TINA (718) 481-2905
MEET AT CEASER'S BAY PARKING LOT
BY TOY'S R US AT 10:30 SHARP!!
Transportation by TRIPP 4 MILES Transportation inc.
$5.00 DAMAGE + $2.00 FOR RIDE
HARDCORE · ONLY 4 THE HEADSTRONG

lost angels in love n extasy los angeles
1990 | haven v12 productions
6 x 9 yellow/green/orange on glossy card
d: jive

through the looking glass los angeles
1990/91 | alice's house | double hit mickey
4.25 x 5.375 photocopy on card
d: unknown

magical mystery tour brooklyn, ny
1991 | tina tripp
4.375 x 5.5 photocopy on pink card
d: unknown

flyers in the earlier years of american rave culture were often simple but creatively designed photocopies, with directions and other information handwritten or typeset with rub-on letters or linotype machines. at the other end of the spectrum, artists with access to desktop publishing software bypassed these cruder production methods, introducing computer graphics to the genre.

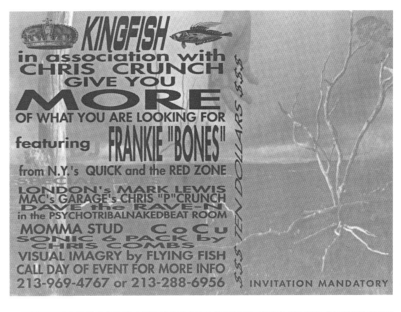

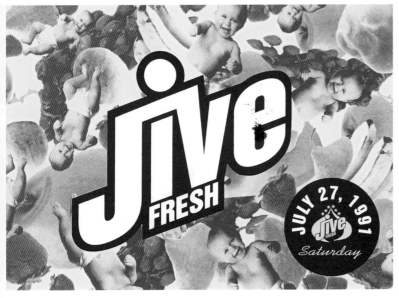

stranger than fiction los angeles
1990 | alice's house
5.5 x 8.5 red/black on glossy card
d: jive

more los angeles
1990 | kingfish | chris crunch
4.25 x 6 blue on glossy card
d: philip blaine

jive fresh los angeles
1991 | jive | mdm | mr. kool-aid
4.25 x 6 yellow/blue/orange on glossy card
d: jive

under the paw paw ranch los angeles
1991 | daven the mad hatter
4.25 x 5.5 red/black on card
d: unknown

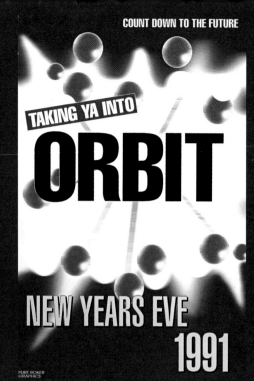

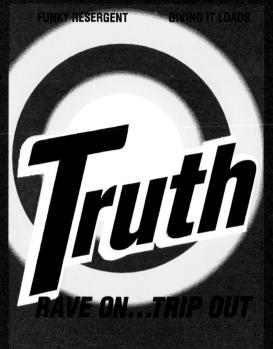

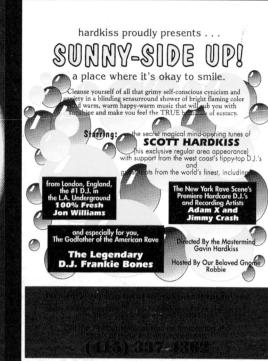

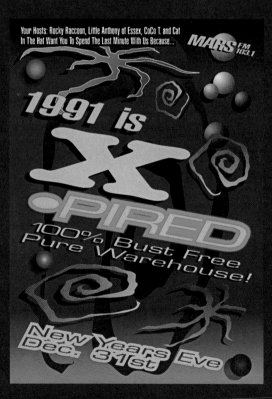

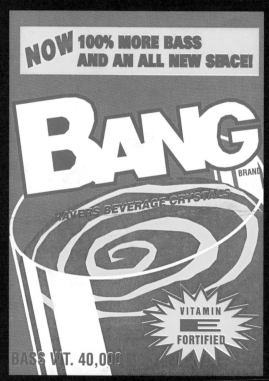

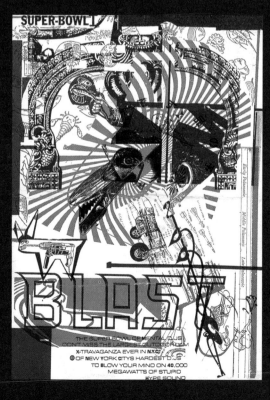

orbit los angeles
1991 | moonshine | artist groove network
5.5 x 8.5 cmyk on glossy card
d: pure roker graphics

truth los angeles
1991 | moonshine | lost angels
4.25 x 6 yellow/blue/orange on glossy card
d: jive

sunny-side up san francisco
1991 | hardkiss
4.25 x 5.5 yellow/purple/pink on paper
d: hardkiss

xpired los angeles
1991/92 | rocky raccoon and friends
5.25 x 7.125 cmyk on glossy card
d: pure roker graphics

bang los angeles
1991 | mr. kool-aid | double hit mickey
4.25 x 5.5 yellow/green/orange on card
d: unknown

blast new york
1991 | matt e. silver
4.5 x 6.5 red/blue/orange on card
d: thunder-jockeys

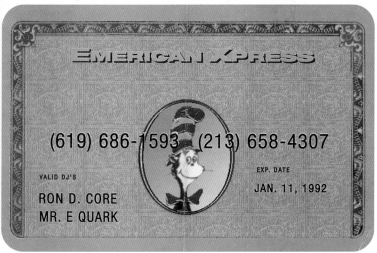

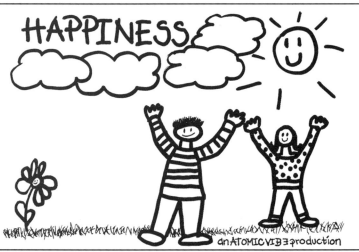

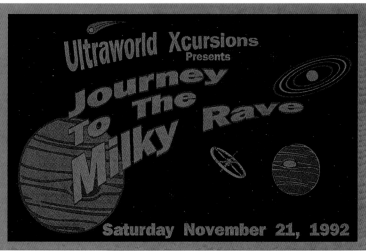

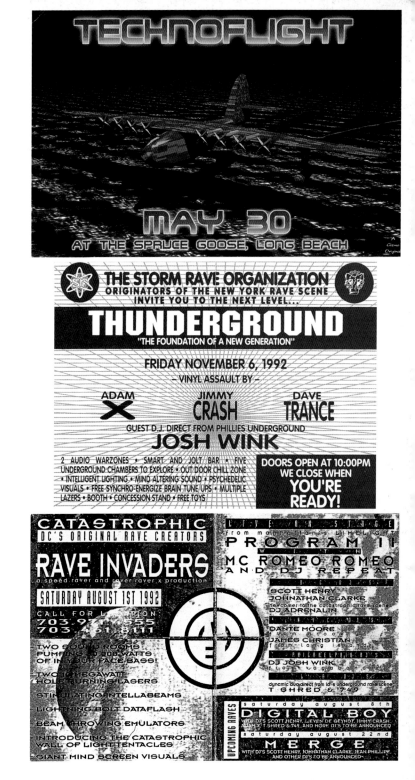

emerican xpress san diego
1992 | diesel
5 x 8.125 gold/black/red on glossy card
d: justin holebody design

technoflight long beach, ca
1992 | dy-na mix
5.5 x 8.5 cmyk on glossy card
d: d.b. designs/gary gizmo graphics

happiness maryland
1992 | atomic vibe
5 x 7.5 purple on glossy card
d: unknown

thunderground brooklyn, ny
1992 | storm
6 x 8 foldout blue on glossy text
d: frankie bones/revar design

journey to the milky rave md
1992 | ultraworld
5.5 x 8.5 photocopy on orange paper
d: lonnie fisher

rave invaders washington, dc
1992 | catastrophic
5.5 x 8.5 photocopy on card
d: unknown

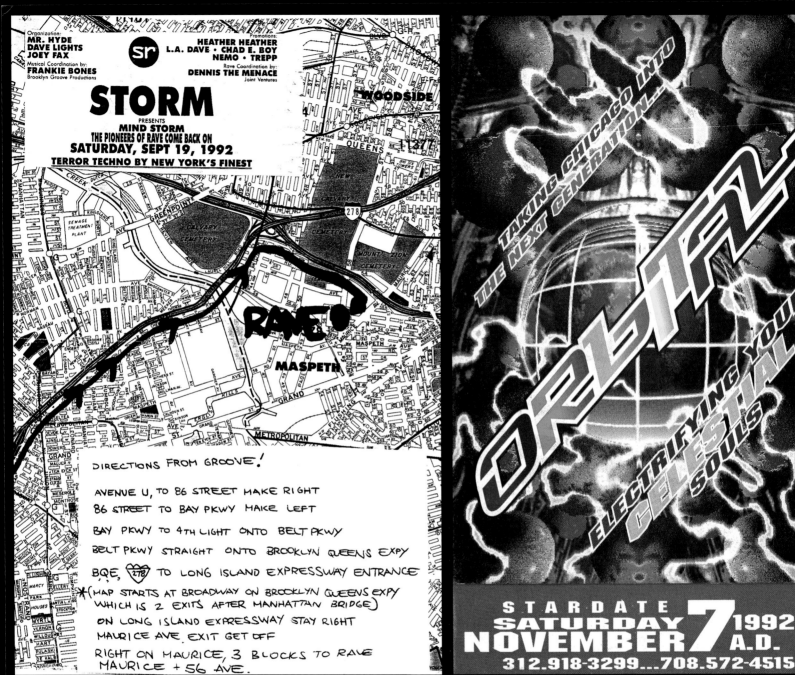

STORM
PRESENTS
MIND STORM
THE PIONEERS OF RAVE COME BACK ON
SATURDAY, SEPT 19, 1992
TERROR TECHNO BY NEW YORK'S FINEST

Organization:
MR. HYDE
DAVE LIGHTS
JOEY FAX

Promotions:
HEATHER HEATHER
L.A. DAVE • CHAD E. BOY
NEMO • TREPP

Musical Coordination by:
FRANKIE BONES
Brooklyn Groove Productions

Rave Coordination by:
DENNIS THE MENACE
Joint Ventures

WOODSIDE

RAVE

MASPETH

DIRECTIONS FROM GROOVE!

AVENUE U, TO 86 STREET MAKE RIGHT

86 STREET TO BAY PKWY MAKE LEFT

BAY PKWY TO 4TH LIGHT ONTO BELT PKWY

BELT PKWY STRAIGHT ONTO BROOKLYN QUEENS EXPY

BQE, 278 TO LONG ISLAND EXPRESSWAY ENTRANCE

*(MAP STARTS AT BROADWAY ON BROOKLYN QUEENS EXPY WHICH IS 2 EXITS AFTER MANHATTAN BRIDGE)
ON LONG ISLAND EXPRESSWAY STAY RIGHT
MAURICE AVE. EXIT GET OFF

RIGHT ON MAURICE, 3 BLOCKS TO RAVE
MAURICE + 56 AVE.

TAKING CHICAGO INTO THE NEXT GENERATION...

ORBITZ
ELECTRIFYING YOUR CELESTIAL SOULS

STARDATE
SATURDAY NOVEMBER 7 1992 A.D.
312.918-3299...708.572-4515

rave called **Quest** OutaControl
NET WT. (HEAVY) negativity fighting brainrave with neurolube

AmoebaHead Productions with MelloMello/BigFuNHOUSE, Joint Ventures/Trepp invite you to brighten your smile & freshen your mind

eight DJ LIVE TECHNO

DJ's NYC: ADAM X, JIMMY CRASH, DAVE TRANCE, JAMES CHRISTIAN RAVE GEAR CONCESSIONS: JOINT VENTURES
DJ's BOSTON: MAYHEM, TIM RYAN, DIABOLICAL VISUALS: AMOEBAVISION ALPHA 7/ MOJO II
DJ PROVIDENCE: OTTER POP INTELLIGENT LIGHTING BY: Z TRAN & SONIC VIBE
(NYC) DISINTEGRATOR ◄ LIVE! PERFORMANCES ► COLLOSAL AMOEBA (PROVIDENCE)

LOOP BigFuNHOUSE IS DESIGN

FRIDAY JULY 24
9:30 pm/6:30 am

ADVANCED TICKETS $9 AVAILABLE AT BOUNCE,
CHURCH HOUSE INN TUESDAY NIGHTS, PROVIDENCE
AVAILABLE ON THE 24th $11 AT THE RAVE VEHICLE
FROM 8-12 PM ON THAYER STREET, PROVIDENCE
LEGAL LOCATION IN PROVIDENCE/GET MAP WITH TICKETS

BOSTON BUS & INFO: 617-267-6905
NYC BUS & INFO: 718-766-5369
GENERAL INFO: 401-766-5334

mind storm brooklyn, ny
1992 | storm
8.5 x 11 photocopy on paper
d: frankie bones

orbital chicago
1992 | mr. happy | global underground network
4.125 x 7 foldout cmyk on glossy card
d: mpyregrafx

rave called quest providence
1992 | amoebahead productions
2 x 8.5 blue/red/silver on glossy card
d: big fun house

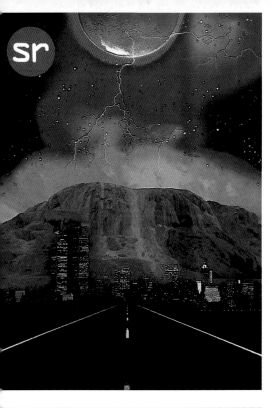

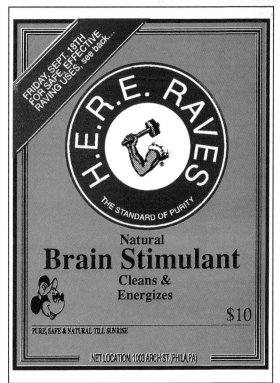

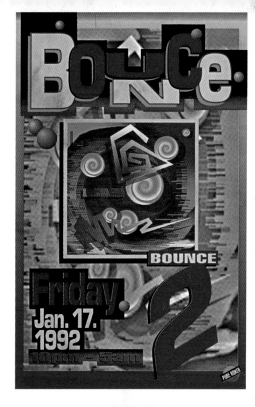

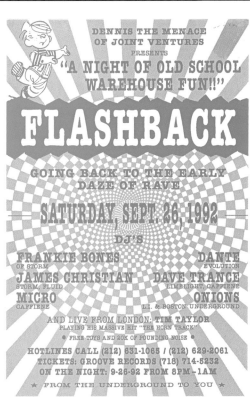

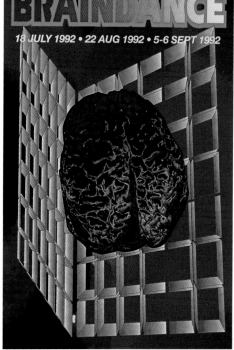

storm rave closing party brooklyn, ny
1992 | storm
5 x 7 cmyk on glossy card
d: frankie bones/revar design

brain stimulant philadelphia
1992 | h.e.r.e. raves | dj wink
4.25 x 5.625 red/blue/orange on card
d: unknown

bounce 2 los angeles
1992 | pure roker
5.5 x 8.5 cmyk on glossy card
d: pure roker graphics

flashback brooklyn, ny
1992 | dennis the menace of joint ventures
4.25 x 5.375 blue on glossy card
d: dennis the menace/frankie bones

braindance chicago
1992 | mr. happy | mr. rave | e-tea of crisp
5 x 8 cmyk on glossy card
d: print ps graphics

brain sr Storm

June 20, 1992
12 MIDNIGHT TILL 9 AM . . . 100% HARDCORE

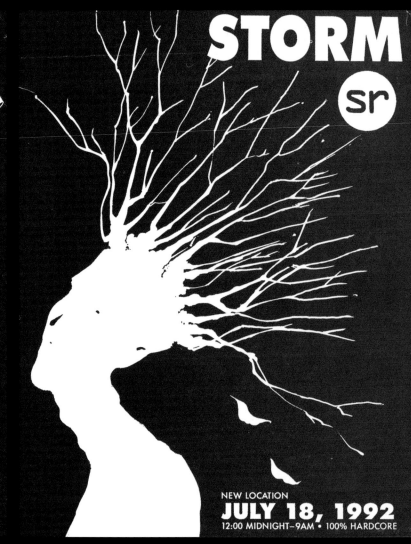

STORM sr

NEW LOCATION
JULY 18, 1992
12:00 MIDNIGHT–9AM • 100% HARDCORE

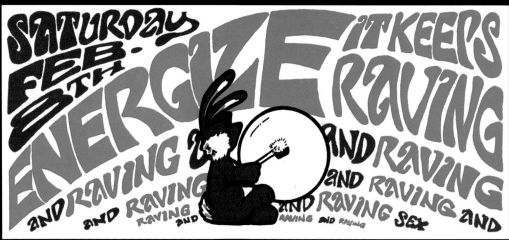

SATURDAY FEB-8TH ENERGIZE IT KEEPS RAVING AND RAVING AND RAVING AND RAVING AND RAVING SEX RAVING AND RAVING AND RAVING AND

brain storm brooklyn, ny
1992 | storm
8.5 x 11 purple on glossy text
d: frankie bones

your destiny brooklyn, ny
1992 | storm
8.5 x 11 red on glossy text
d: frankie bones

energize portland, or
1992 | three fallen stars productions
4 x 8.5 cyan/magenta on glossy card
d: mike friolo/groovin design

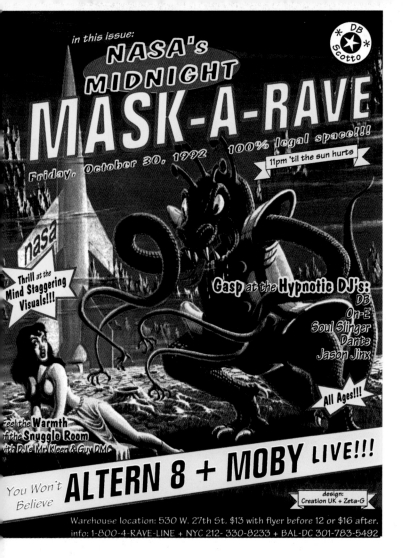

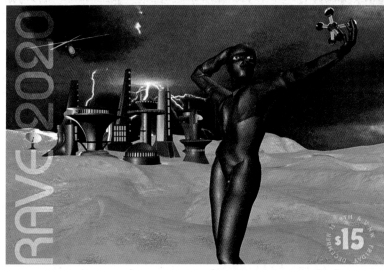

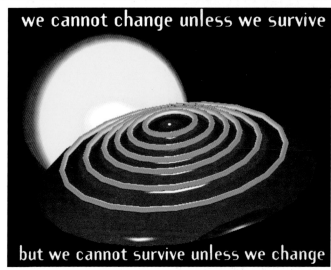

maskarave new york
1992 | nasa
8.5 x 11 cmyk on glossy card
d: creation uk (db)/zeta-g

rave 2020 washington, dc
1992 | 7 productions
5 x 7.5 cmyk on card
d: studio x

osmosis san francisco
1992
4 x 5.5 cmyk on card
d: unknown

wacky citrus san francisco
1992 | wacky citrus
7 x 7 die-cut cmyk on glossy card
d: jive

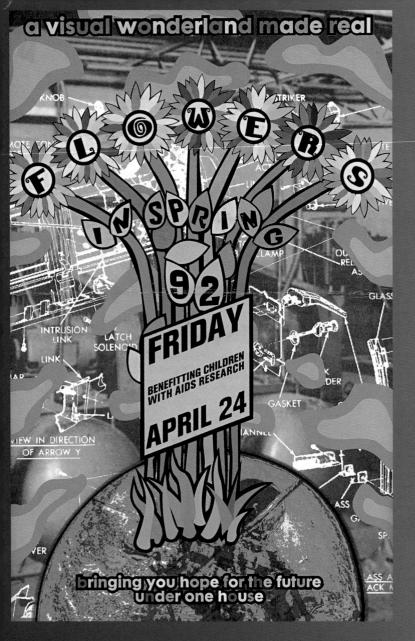

a visual wonderland made real

FLOWERS IN SPRING 92

FRIDAY
BENEFITTING CHILDREN WITH AIDS RESEARCH
APRIL 24

bringing you hope for the future under one house

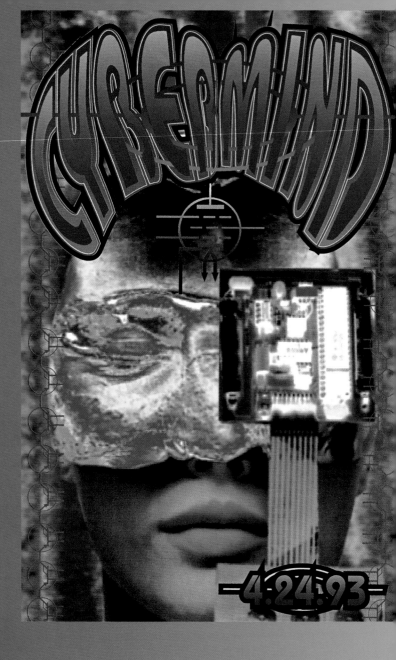

CYBERMIND

4.24.93

flowers in spring los angeles
1992 I feels good productions
5.5 x 8.5 cmyk on glossy card
d: jive

cybermind chicago
1993 I good guyz productions
4.75 x 7.25 cmyk on glossy card
d: sir real grafix

nasa new york
1993 I nasa
4.75 x 7.25 cmyk on glossy card
d: creation uk (db)/reb

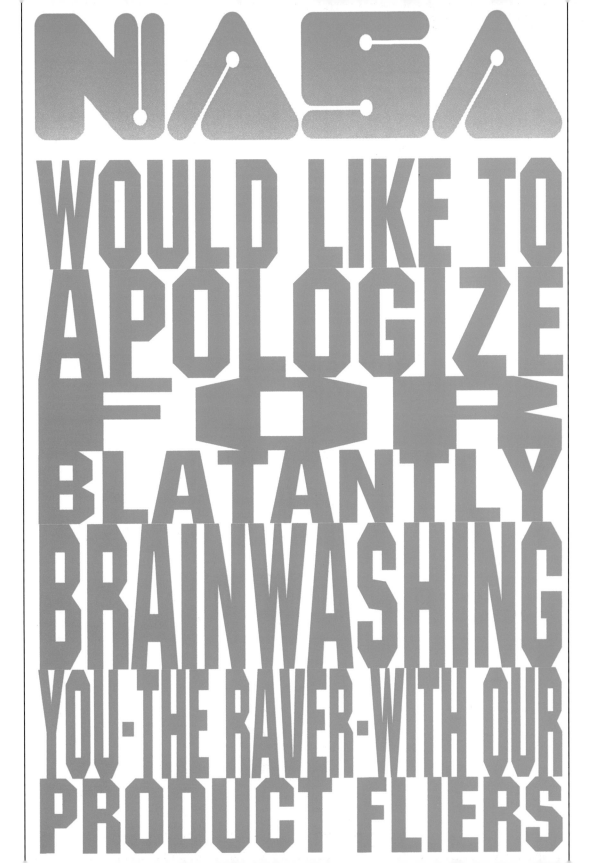

NASA
WOULD LIKE TO
APOLOGIZE
FOR
BLATANTLY
BRAINWASHING
YOU-THE RAVER-WITH OUR
PRODUCT FLIERS

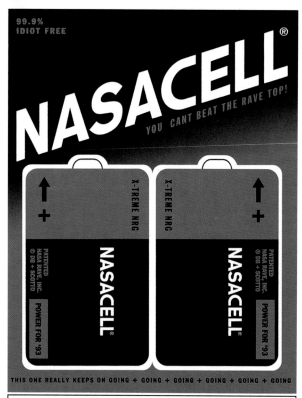

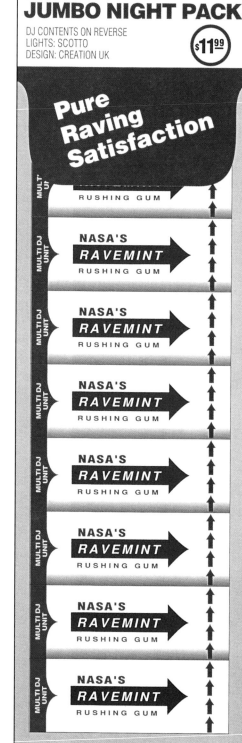

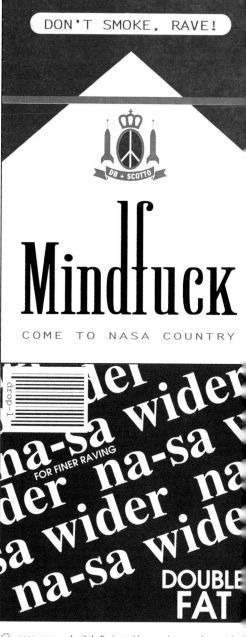

↪ nasa, new york city's first weekly rave, became famous for introducing product spoofs to flyer design.

nasacell new york
1993 | nasa
4 x 5 black/gold on glossy card
d: creation uk (db)/reb

masterrave new york
1993 | nasa
4 x 5 blue/brown on glossy card
d: creation uk (db)/reb

ravemint new york
1992 | nasa
3.25 x 10.25 red/green on glossy card
d: creation uk (db)/reb

mindfuck new york
1992 | nasa
2.25 x 3.25 red/black/gold on glossy card
d: creation uk (db)/reb

na-sa wider new york
1993 | nasa
3 x 3 brown on glossy card
d: zeta-g

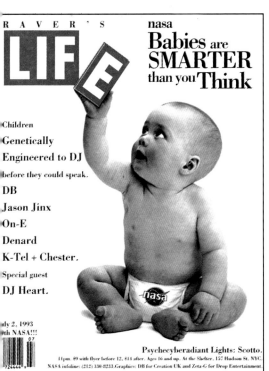

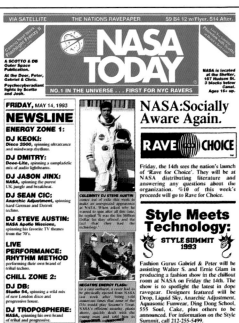

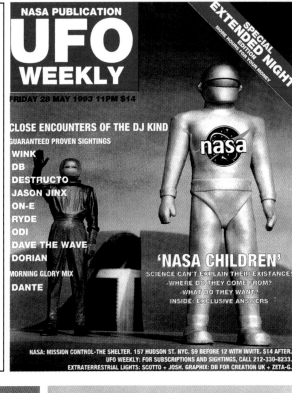

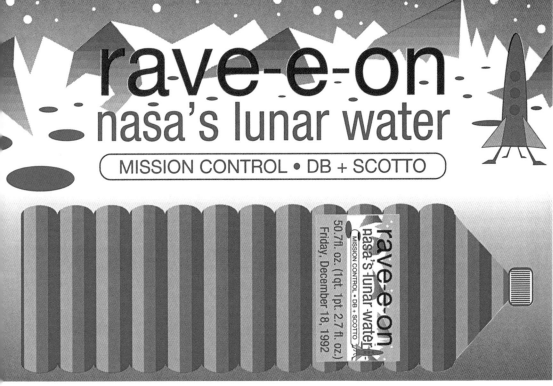

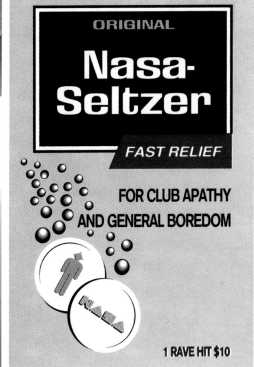

raver's life new york
993 | nasa
x 7.5 black/red on glossy text
: creation uk (db)/zeta-g

nasa today new york
1993 | nasa
6 x 8.5 black/blue on glossy text
d: creation uk (db)/zeta-g

ufo weekly new york
1993 | nasa
6 x 7.25 black/red on card
d: creation uk (db)/zeta-g

rave-e-on new york
1992 | nasa
4 x 6 blue/red on card
d: creation uk (db)/zeta-g

nasa seltzer new york
1992 | nasa
3.625 x 5.5 blue/red on card
d: creation uk (db)

psychosis

0.4.03.19.93

12 10 93

communion

psychosis chicago
1993 | thee exploding galaxy
4 x 9 cmyk on glossy card
d: r design

communion minneapolis
1993 | disco family plan | sub zero | brass
4.125 x 9.25 cmyk on glossy card
d: cody hudson/43d

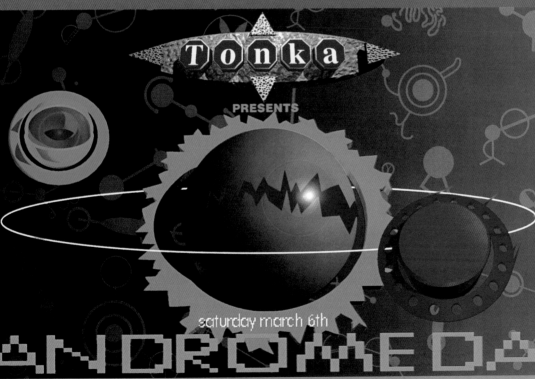

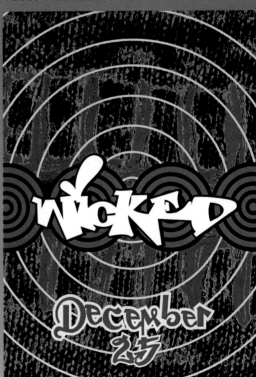

essence the new generation new york
1993 | essence
6 x 8.5 gatefold cmyk on glossy text
d: a&a graphics

andromeda washington, dc
1993 | tonka
5 x 8 cmyk on glossy card
d: unknown

tip toe through the tulips san francisco
1993
4.25 x 5.5 cmyk on glossy card
d: mark subotnik/brian

wicked san francisco
1993 | wicked
3.25 x 4.75 cmyk on glossy card
d: unknown

CiRCA · NINETY THREE

TIME ONCE AGAIN TO LIVE HARD AND DREAM FAST

NOVEMBER THIRTEEN 9PM-5AM LOS ANGELES, YOUR PLANET
RAIN OR SHINE, YOU ARE COVERED. SEE YOU ON THE DANCEFLOOR

...LIVE AND DIRECT:

MOBY
STORMING THE HEAVENS WITH MIDI RAIN

MASTERS OF OPERATIC TRANCE AND NAKED TRIBAL DUB

ORBITAL

APHEX TWIN
THE FIRST L.A APPEARANCE
THE DIGITAL CHEMIST AND CEREBRAL CRAFTSMAN

CREATING AN AMBIENT HYPNOTIC TEXTURE

VAPOUR SPACE

SOUND
BOOMBOY
SHREDDER
BASSLINE

GUIDING YOUR SOUL DEEP INTO THE ABYSS
DIMITRY FROM DEEE-LITE DJ TIM FROM UTAH SAINTS
CHICAGO'S MARK FARINA & DEREK CARTER ON THE 2X4
SAN FRANDISCO'S ERNIE MUNSON & JON WILLIAMS
CALIFORNIA'S STEVE LORIA ALONG WITH SPECIAL GUESTS
INTRODUCING: LENNY V AND SUNNY STONE YOUR MC: ARMED AUDIO ASSAULT

TECHNOLOGICAL (LIGHT AND VISUALS) ASSAULT
AREA 17 (DDO CD)) • CARL SIMS (THINKING MACHINE) • WILLIAM LATHHAM (IBM UK SCIENTIFIC CENTER) • ART FUTURA (BARCELONA SPAIN) • MEMORY
PALACE • OM LABORATORIES • GEORGE MONTGOMERY • PATRICK RICE (FRACTAL ART) • STEVE MONAG (REAL ART) • JOSEPH RIE (OTHER STUFF)
VERONIKA SANDER (TEXT AND STATEMENTS) • AREA 17 ARE: MICHAEL C DIEH <NDIEHRBR)CSD.EDU> MARK D. RUDHOLM <RUD@CIU@AMIA.COM>
LIGHTS AND ALL STRUCTURES OF VISUAL DESIGN BY OM LABORATORIES • LASER IMAGERY AND OPTICAL
DISTORTION EFFECTS BY MIRAGE • MULTI GIANT 9X12 COMPUTER SCREENS • VIDEO WALL

WHY ARE THE TRUE TRIBES DY

circa 93 los angeles
1993 | om laboratories | urb
6.625 x 19 cmyk on glossy text
d: pure roker design

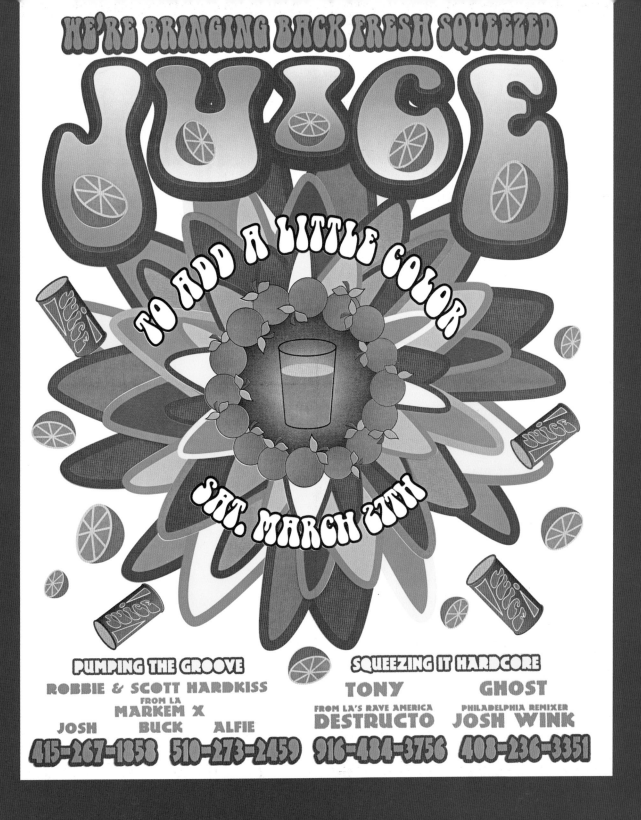

juice san francisco
1993 | juice
11 x 14 cmyk on text
d: michael rosenberg/brian

CIRCUIT BOARD PRB -5077

FULL SPECTRUM ANALYSIS

NEXUS 8

THE COMING OF A NEW GENERATION TOWARD A BRAVE NEW WORLD

matt e. silver, blunt academy, and inter-modo present

the journey

SATURDAY, OCTOBER 23, 1993

nexus 8 los angeles
1993 | philip blaine | our world our future
5 x 8 cmyk on glossy card
d: philip blaine

swirl indianapolis
1993 | sin productions
4 x 7 black/yellow on printer paper
d: maxart

the journey new york
1993 | matt e. silver
5 x 8 die-cut foldout cmyk on card
d: under design

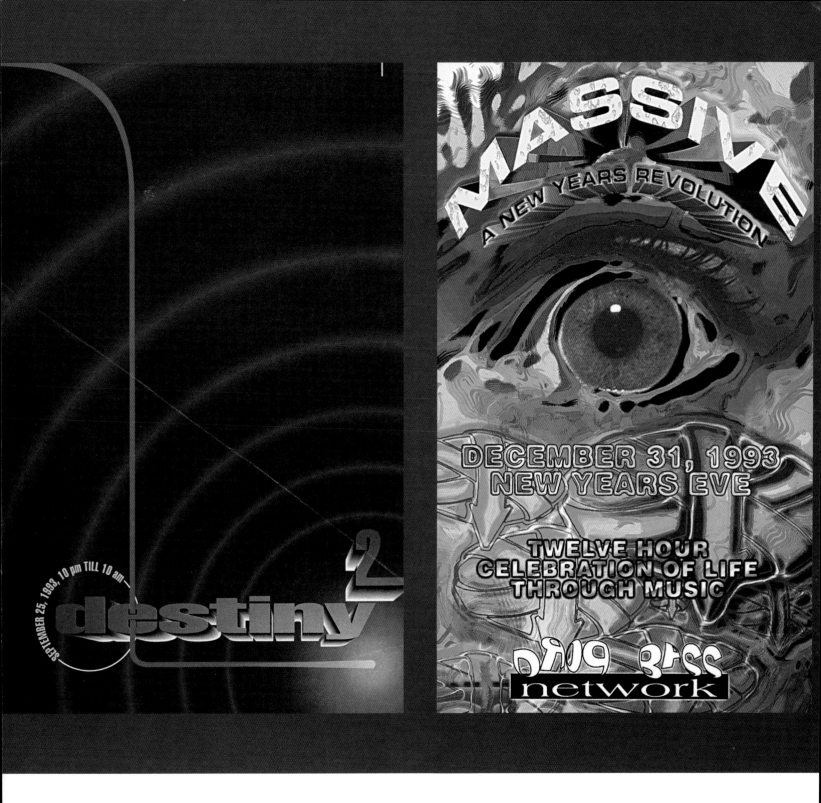

destiny 2 toronto
1993 | destiny
8.5 x 11 foldout cmyk on text
d: unknown

massive milwaukee
1993 | drop bass network
5.5 x 9.125 cmyk on glossy card
d: cody hudson/43d

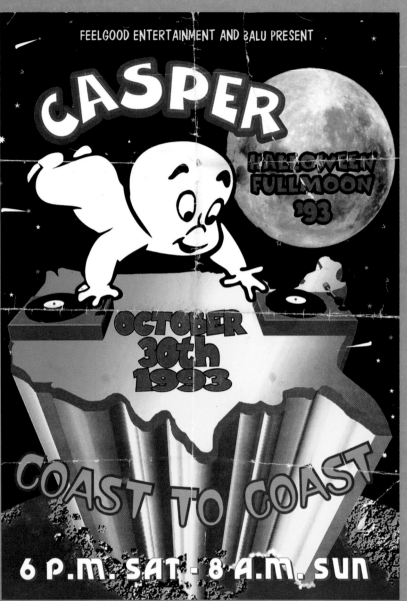

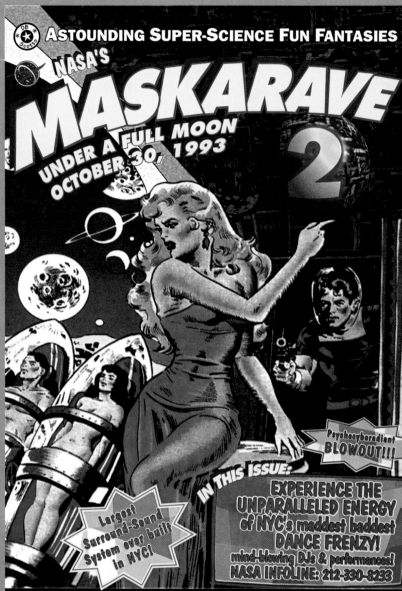

casper warwick, ri
1993 | feelgood entertainment | balu
11 x 17 foldout cmyk on glossy text
d: e con

maskarave 2 new york
1993 | nasa
7.75 x 10.25 black/yellow on printer paper
d: creation uk (db)/zeta-g

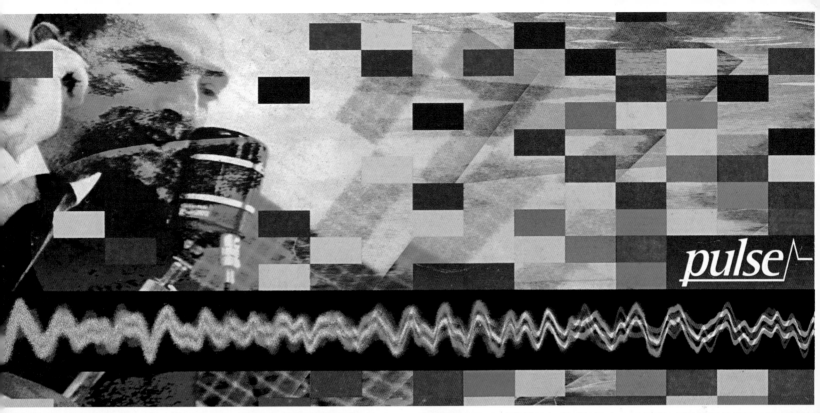

WE ARE NO LONGER ALONE

UFOs are real

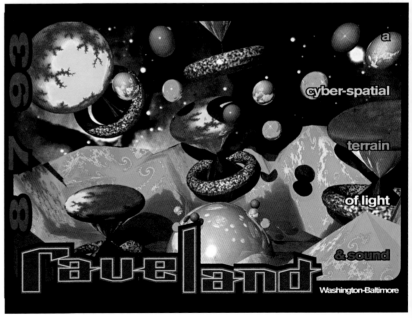

a
cyber-spatial
terrain
of light
& sound

raveland

Washington-Baltimore

→ the pieces on the following two pages mark a distinct evolution in flyer design: use of the customized die-cut. this trend became extremely influential; as designers became more ambitious, so did the die-cuts, taking on every imaginable shape and size.

pulse new york
1993 | pulse
4 x 8 cmyk on glossy card
d: zeta-g

ufos are real san francisco
1993 | toon town
4 x 10.875 gatefold cmyk on printer paper
d: multimedia

raveland washington, dc/baltimore
1993 | thermonuclear worldwide
4 x 6 cmyk on card
d: rivas grafix

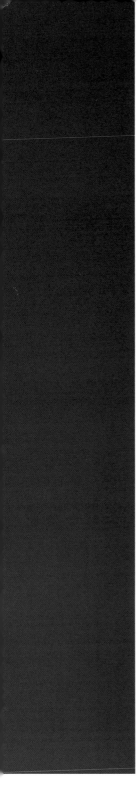
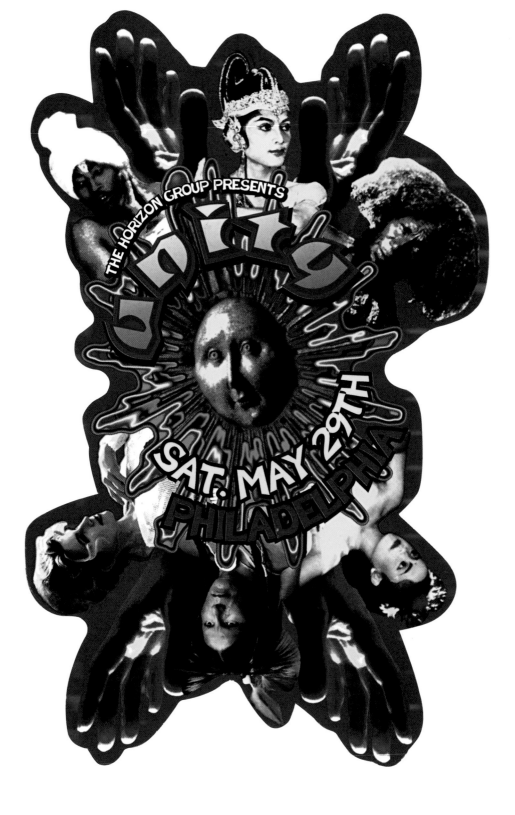

unity philadelphia
1993 | horizon group
4.5 x 8 die-cut cmyk on glossy card
d: a&a graphics

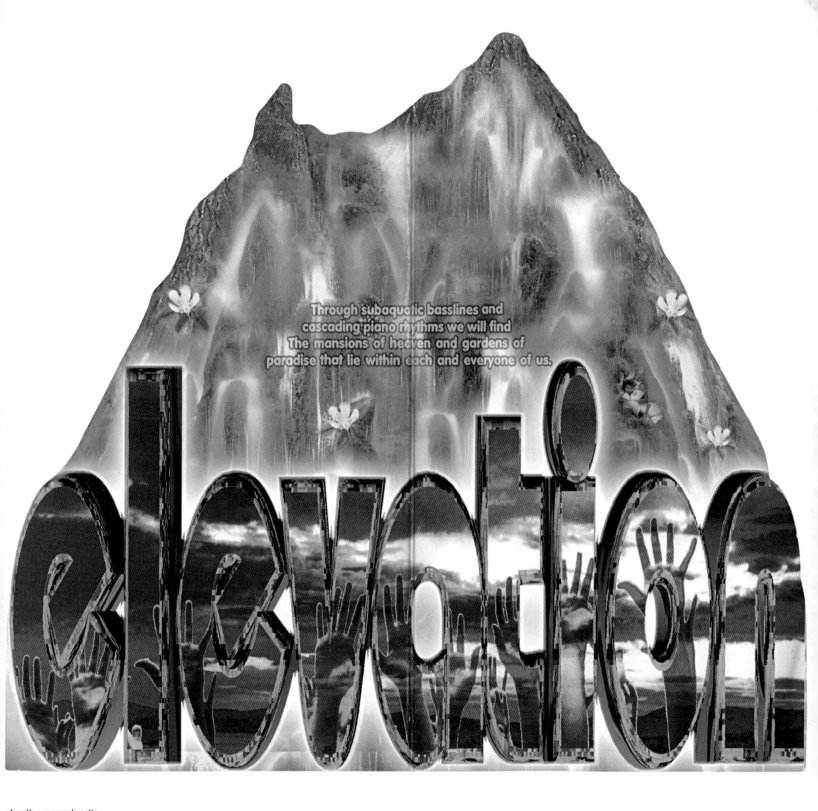

Through subaquatic basslines and
cascading piano rhythms we will find
The mansions of heaven and gardens of
paradise that lie within each and everyone of us.

elevation massachusetts
1993 | tempest productions
7.75 x 8.5 die-cut cmyk on glossy card
d: rise graphics

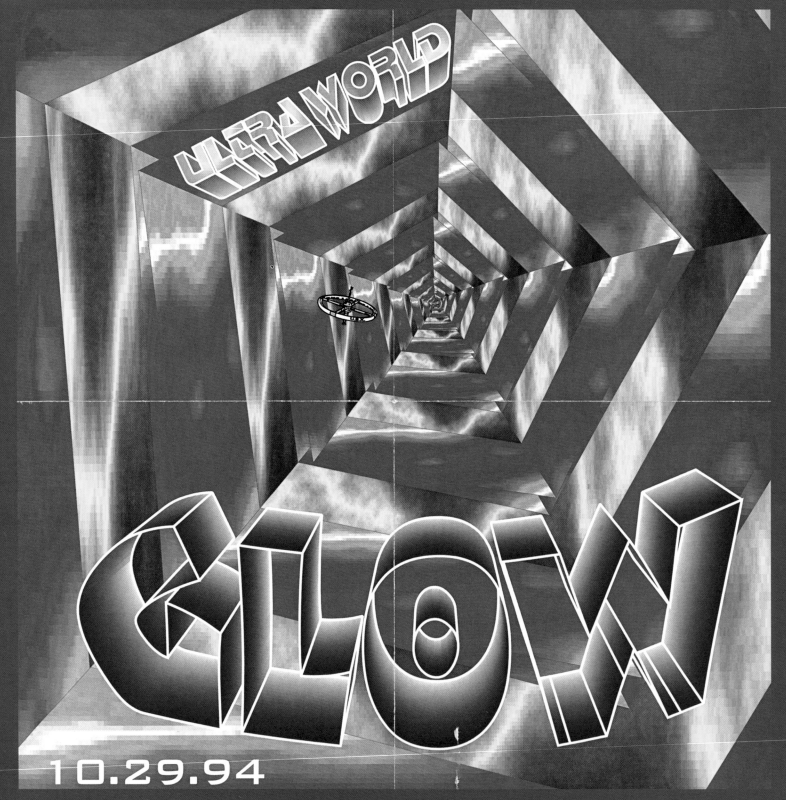

ULTRAWORLD

GLOW

10.29.94

glow baltimore
1994 | ultraworld
11 x 11 cmyk on glossy text
d: lonnie fisher

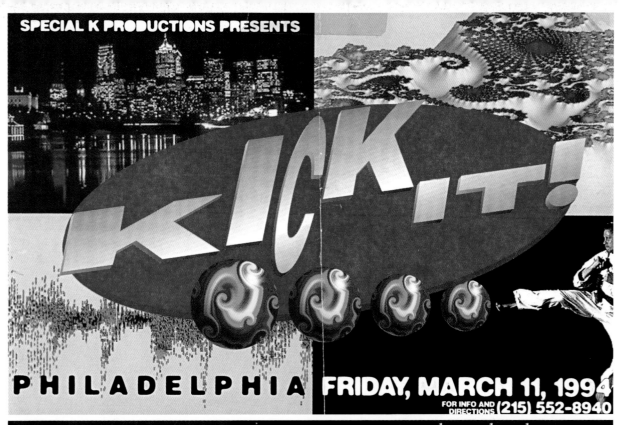

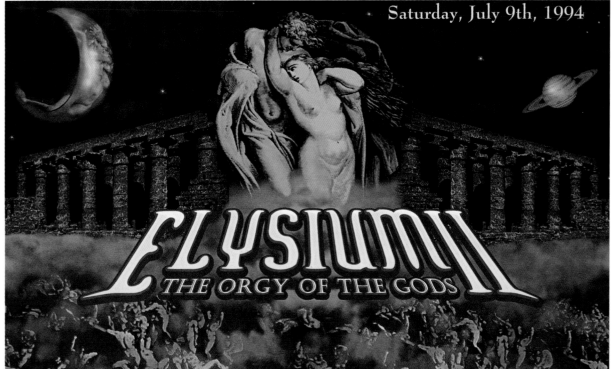

kick it! philadelphia
1994 | special k
5.5 x 8.5 cmyk on glossy text
d: under design

elysium 2 seattle
1994 | apollo | s.u.n. | innermind
5.5 x 8.5 cmyk on glossy card
d: e con

one love portland, or
1994 | core
5 x 7.75 cmyk on glossy card
d: mike friolo/groovin design

rave krisp-e's chicago
1994 | peterbilt | mite.e.23 | mr. vick's | e-1.0
5.5 x 8.5 cmyk on glossy card
d: e con

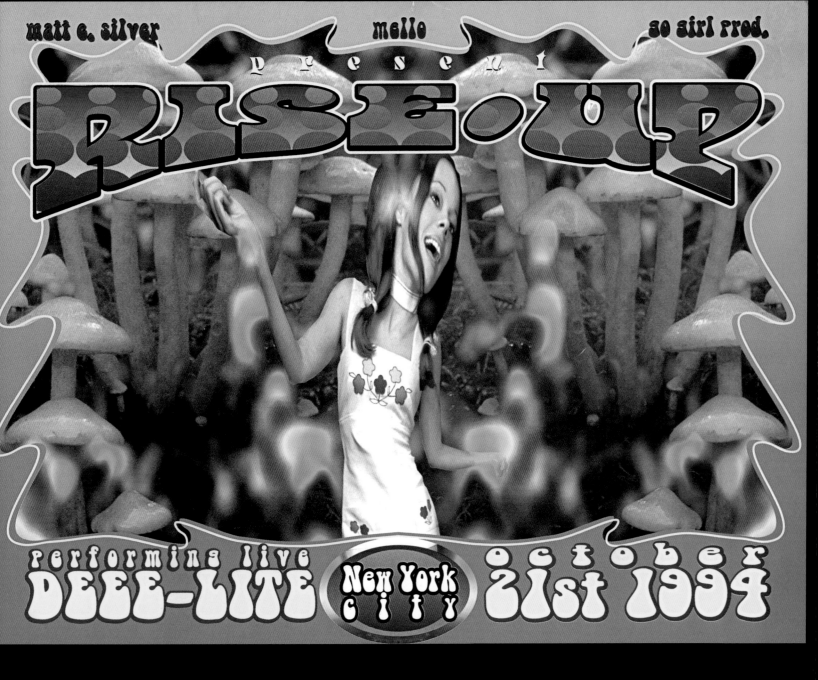

rise-up new york
1994 | matt e. silver | mello | go girl prod.
8.5 x 11 cmyk on glossy text
d: stan endo

Alan Sanctuary presents

Heaven
new year's eve

Sat. 12.31.94
New York City
9pm — noon
Location TBA

heaven new york
1994 | alan sanctuary
10 x 10 foldout cmyk on glossy text
d: spork

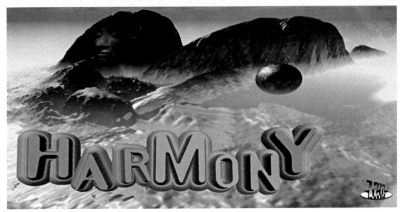

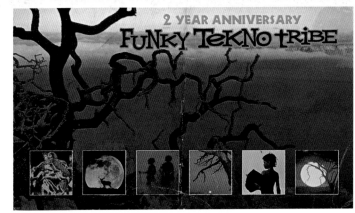

↪ 1994 saw two major trends: use of the environmental rendering program KPT bryce, and of unaltered photographic images.

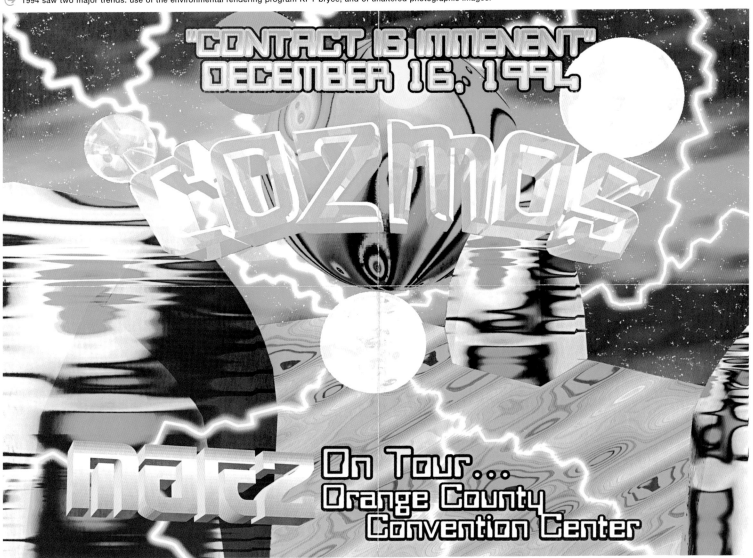

harmony akron
1994 | eternal peace tribe
3.875 x 7.75 cmyk on glossy card
d: 1212

funky tekno tribe san francisco
1994 | funky tekno tribe
3.875 x 7.75 cmyk on glossy card
d: unknown

cozmos orlando, fl
1994 | marz
9.625 x 13.5 cmyk on glossy text
d: a&a graphics

nature

SATURDAY OCTOBER 1st 1994
AT OUR VIRGIN WAREHOUSE IN CHICAGO

ON-E
Dee-Lite ~ NYC
DERRICK MAY
Detroit
O'KEEF
PHILI'S SPECIAL K
ROBERT ARMANI
DJAX RECORDS - Chicago
TERRY MULLAN
Chicago
HYPERACTIVE
Chicago
TRAXX
Chicago

INSTALLATIONS & DÉCOR BY ARTISTS PICTURE FRAME
PROJECTIONS BY BOBBY FRESH (X-FX) IN COOPERATION WITH VIDEO DRUGS
LIGHTING BY TECHNOCOLOR 4 BLOCKS OF SOUND PROVIDED BY DIVERSIFIED AUDIO

E Conspiracy Flyer
510.601.5611

312.851.5434 312.202.5597 414.256.1775 800.794.4555 Ext.4090

NOVEMBER 12, 1994

HoMe

A CELEBRATION OF ART, MUSIC AND TECHNOLOGY
GENERATED FROM THE MIDWEST AREA

nature chicago
1994
10.5 x 21 cmyk on glossy text
d: e con

home chicago
1994 | vibe alive | ripe
8 x 16 cmyk on glossy text
d: cody hudson/43d

joy minneapolis
1994 | m.o.r.e.
5.4 x 6.25 cmyk on glossy text
d: e con

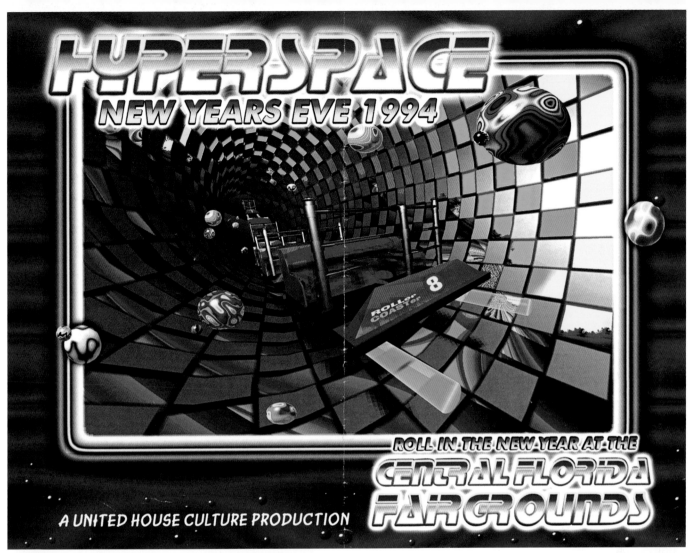

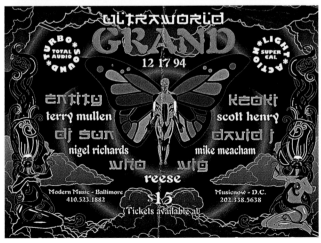

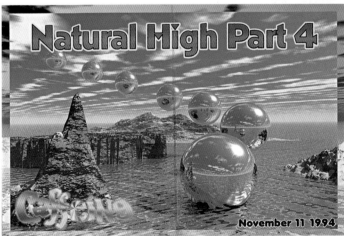

hyperspace orlando, fl
1994 | united house culture
8.5 x 11 cmyk on glossy text
d: jaysen

grand baltimore
1994 | ultraworld
5.125 x 7 black/silver on glossy card
d: lonnie fisher

natural high part 4 long island, ny
1994 | caffeine
5.375 x 8.375 cmyk on glossy card
d: unknown

IT IS THE YEAR 2008

THE CAMPAIGN FOR INFINITE LOVE
UNLIMITED LAUNCHED BY THE
SUPERSTARS OF LOVE HAS INSPIRED
AND OVERWHELMED OUR NATIONS'
HIGHER CONSCIOUSNESS. OUR SOCIETY
HAS FINALLY BEEN EMANCIPATED
FROM THE REIGN OF GREED AND
NEGATIVITY UNDERMINING OUR
GALA-GLOBULAR VIBRATIONS. YOU, THE
CHILDREN OF THE COSMOS, ARE
INVITED TO FEEL THE INNER LIGHT OF
LOVE ILLUMINATING OUR MINDS AND
SOULS AS WE ASCEND INTO THE
SUPERNATURAL BLISS OF OUR
STELLAR EXODUS.

2008: A LOVE ODYSSEY...

a multi-dimensioned omniversal
soul stimulitoriumyum

OUTER SPACE

keoki scott hardkiss
new york city san francisco

mystic bill davey dave
chicago sundowners madison

SAINT LOUIS VIBE TRIBE DJS
terry mullan · jojo · merlin

astroboy marc buxton
n. carolina st. louis

HYPER SPACE

jethrox R.P. Smack
milwaukee chicago

matt brendle, morbe and droid from saint louis

THE SAINT LOUIS VIBE TRIBE
TIME WARPS TO TECHNO DIMENTIA

INNER SPACE

a high altitude ambient playground

ray velasquez riverman
kansas city chicago

live drum circle by
sundowners & the tribe

STARDATE
APRIL 23, 1994

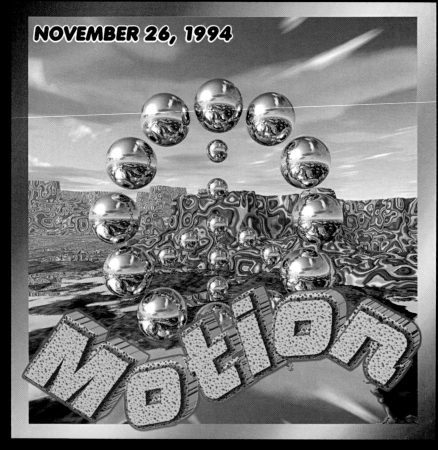

NOVEMBER 26, 1994

motion

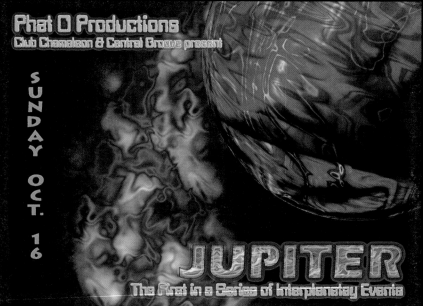

Phat O Productions
Club Chamaleon & Central Groove present

S U N D A Y O C T. 1 6

JUPITER
The First in a Series of Interplanetay Events

2008: a love odyssey st. louis
1994 | superstars of love
3.75 x 10.5 silver on black card
d: superstars of love

motion long island, ny
1994 | motion
7.35 x 7.35 cmyk on glossy card
d: unknown

jupiter syracuse, ny
1994 | phato productions
5 x 7 cmyk on card
d: zeta-g

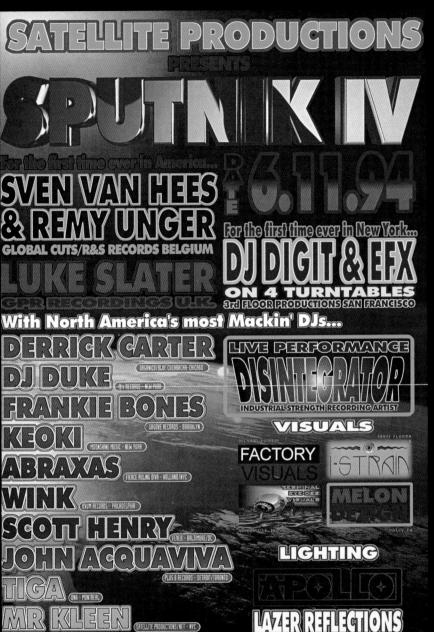

SATELLITE PRODUCTIONS
PRESENTS
SPUTNIK IV

DATE 6.11.94

For the first time ever in America...
SVEN VAN HEES & REMY UNGER
GLOBAL CUTS/R&S RECORDS BELGIUM

LUKE SLATER
GPR RECORDINGS U.K.

For the first time ever in New York...
DJ DIGIT & EFX
ON 4 TURNTABLES
3rd FLOOR PRODUCTIONS SAN FRANCISCO

With North America's most Mackin' DJs...

DERRICK CARTER
ORGANICO/BLUE CUCARACHA - CHICAGO

DJ DUKE
Hft RECORDS - NEW YORK

FRANKIE BONES
GROOVE RECORDS - BROOKLYN

KEOKI
MOONSHINE MUSIC - NEW YORK

ABRAXAS
FIERCE RULING DIVA - HOLLAND/NYC

WINK
OVUM RECORDS - PHILADELPHIA

SCOTT HENRY
FEVER - BALTIMORE/DC

JOHN ACQUAVIVA
PLUS 8 RECORDS - DETROIT/TORONTO

TIGA
DNA - MONTREAL

MR KLEEN
SATELLITE PRODUCTIONS/NET - NYC

SCOTT RICHMOND
SATELLITE PRODUCTIONS/NET - NYC

MGee
PRIMARY PRODUCTIONS - BOSTON

ENTITY
ULTRAWORLD - BALTIMORE

SMARTBAR BY MONA

LIVE PERFORMANCE
DISINTEGRATOR
INDUSTRIAL STRENGTH RECORDING ARTIST

VISUALS
FACTORY VISUALS
BREAKAWAY FLORIDA

I-STRAIN
MIAMI FLORIDA

TERMINAL EYE-DEE VISUALS
INDIANAPOLIS, IN

MELON DESIGN
PHILLY, PA

LIGHTING
APOLLO
LAZER REFLECTIONS
FULL COLOR AND ARGON LAZERS

MIND NUMBING SUPERSONIC SOUND

AFTERHOURS

DJ REESE	DJ SPROUT
DAVE TRANCE	NIGEL RICHARDS
TROPOSPHERE	RYDE

AT THE ORIGINAL SPUTNIK LAUNCH POINT - NEWBURGH SKATE PARK
ADMISSION WITH AFTERHOURS FLYER / BREAKFAST WILL BE SERVED

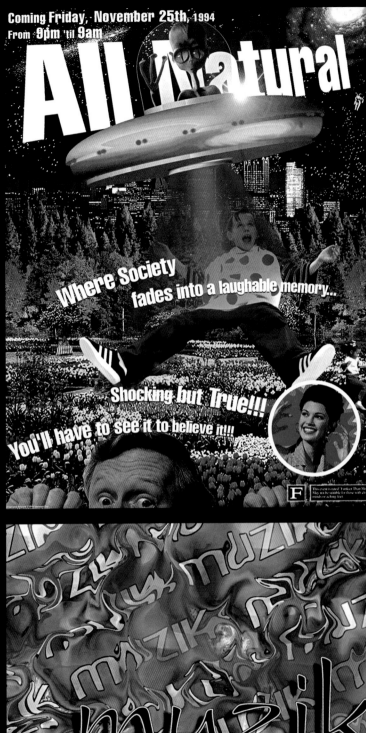

Coming Friday, November 25th, 1994
From 9pm 'til 9am
All Natural

Where Society fades into a laughable memory...

Shocking but True!!!

You'll have to see it to believe it!!!

muzik

sputnik IV poughkeepsie, ny
1994 | satellite
8.5 x 14 cmyk on glossy text
d: mr. kleen

all natural pittsburgh
1994
8.5 x 11 cmyk on glossy card
d: under design

muzik new york
1994 | mello | john trepp | vicious muzik
4.25 x 7 cmyk on glossy card
d: studio x

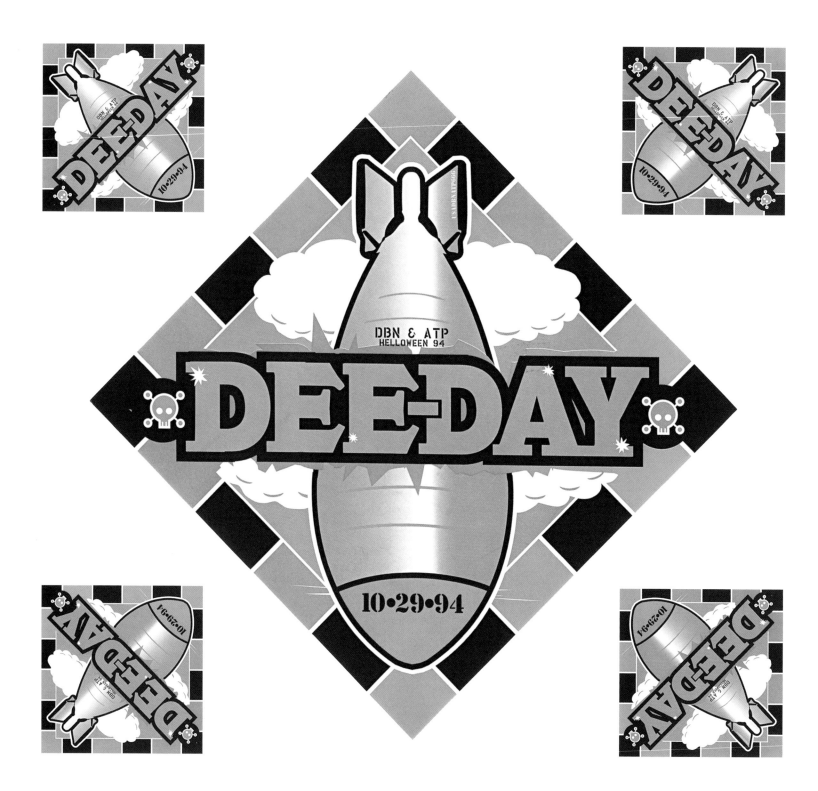

dee-day chicago
1994 | drop bass network | a.t.p.
5.5 x 5.5 purple/neon orange/silver on card
d: cody hudson/43d

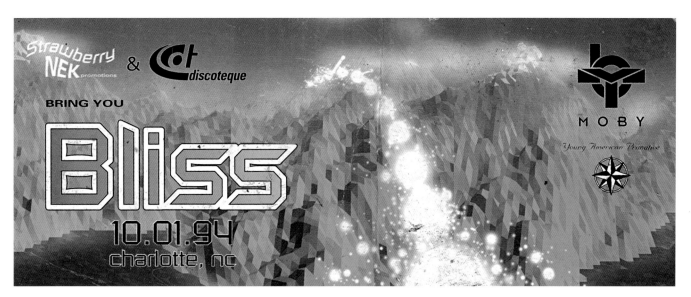

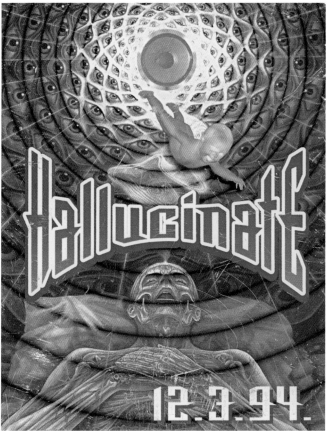

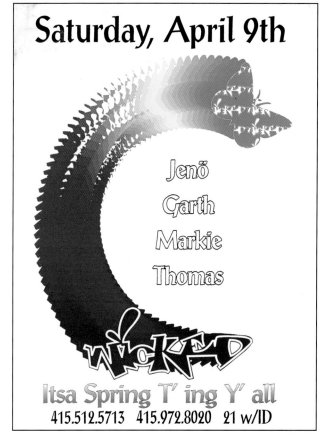

bliss charlotte, nc
1994 | strawberry nek | discoteque
4 x 10 cmyk on card
d: davin kluttz/unquiet design

hallucinate roanoke, va
1994 | sonic life productions
4.25 x 5.5 cmyk on glossy card
d: unknown

wicked: itsa spring t'ing san francisco
1994 | wicked
4 x 5.5 cmyk on card
d: alan mcqueen

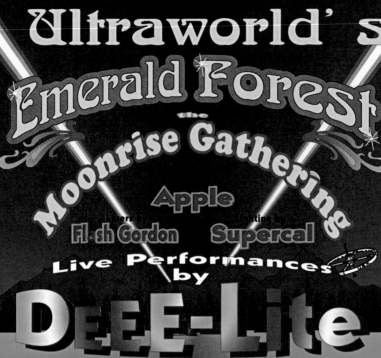

Ultraworld's
Emerald Forest
the Moonrise Gathering

Apple

Lasers by **Fl-sh Gordon** Lighting by **Supercal**

Live Performances by
DeEE-Lite

"You know that's right!"

and Baltimore's
Almighty Senators

Gates open
9:00 p.m.

Saturday
September 10

DJs in the Energy Field

Tiga
D.N.A., Montreal

On-E
Deee-Lite, N.Y.C.

Scott Henry
Fever, Baltimore

Dave Trance

Greg Sargent
Musicnow, D.C.

Dj Sun
Ultraworld

333
Primary, Boston

DJs in the Magnetic Field

Super Dj Dmitry
Deee-Lite, N.Y.C.

Osheen
Renegade Records, Rhode Island

Nigel Richards

Feelgood
Fever, Baltimore

Joeski
Chocolate Factory, N.Y.C.

Who
Defective Records, Baltimore

emerald forest thurmont, md
1994 | ultraworld
8 x 10 die-cut cmyk on glossy text
d: lonnie fisher

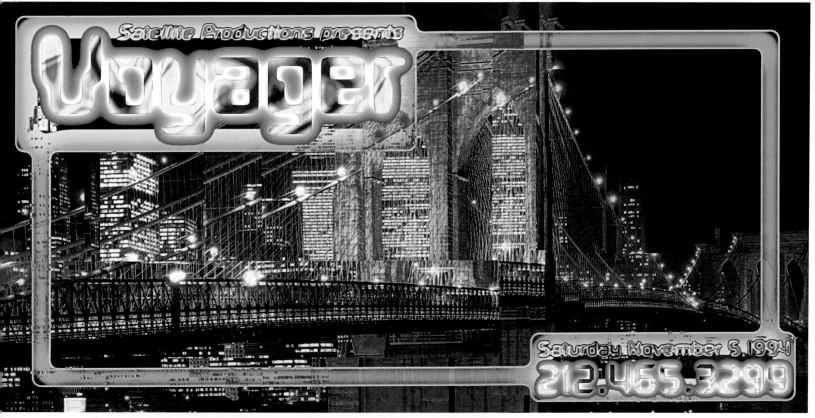

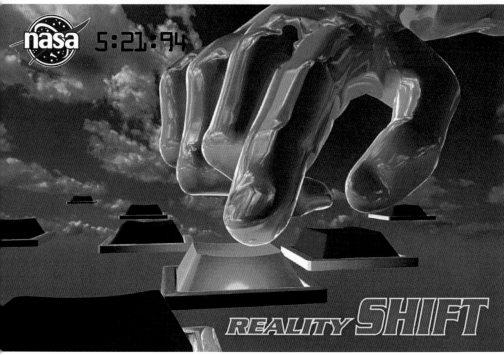

voyager new york
1994 | satellite
6 x 12 cmyk on glossy card
d: zeta-g

reality shift new york
1994 | nasa
6 x 9 cmyk on glossy card
d: db and rebecca

sun (teaser) new york
1994 | joint ventures
3.5 x 4.25 photocopy on yellow card
d: st. stephen

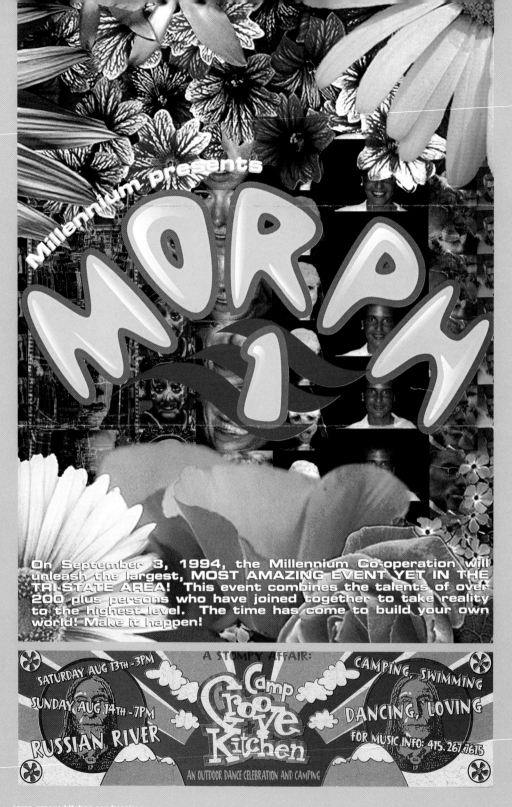

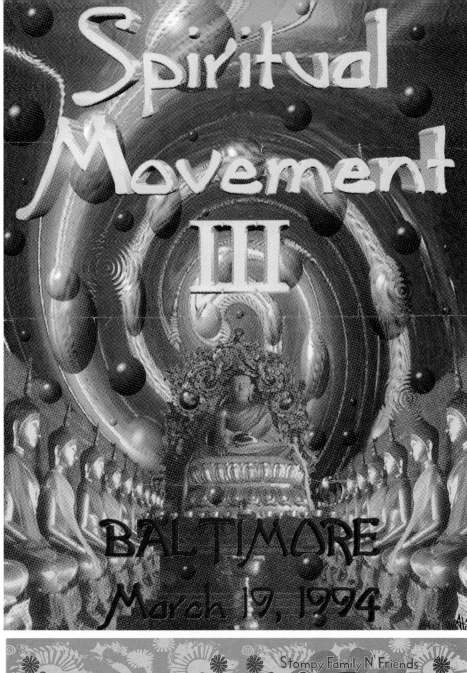

piritual movement III baltimore
994 | spiritual movement
.5 x 11 cmyk on glossy text
: unknown

stompy stomp san francisco
1994 | stompy | preston
2.5 x 8.5 green/orange/blue on card
d: mike friolo/groovin design

611 Records, Buzz, Alan Sanctuary's Primal Posse, and Scotto present

a rave called

Saturday, May 7, 1994 11PM - 8 AM

In our very own 75,000 square foot Fun Warehouse:

Two Sound Systems · Bumper Cars · Indoor Laser Tag · Video
Games · Mini Golf · Hoops · Carnival Games · Face Painting · and
more shit that you can shake a stick at....

INTERSTELLAR
OUTBACK
NEAR LEXINGTON, KY. 26-28 AUGUST 1994

third eye grafix 606.225.3617

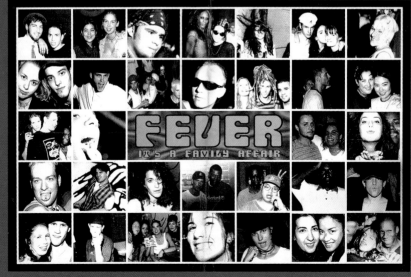

FEVER
IT'S A FAMILY AFFAIR

a rave called scott philadelphia
1994 | 611 | buzz | alan sanctuary | scotto
8.5 x 11 cmyk on glossy text
d: under design

interstellar outback lexington, ky
1994 | those meddling kids | aided&abtd | j3
8.5 x 11 cmyk on glossy text
d: third eye grafix

fever baltimore
1994 | fever
6 x 9 orange/black on glossy card
d: scott henry

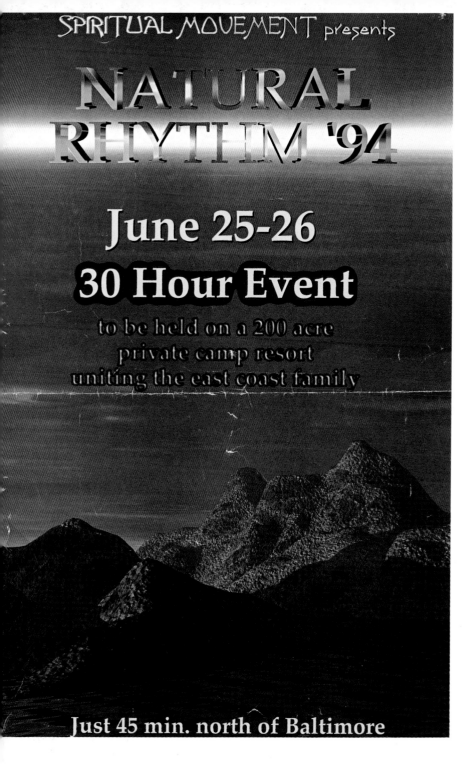

natural rhythm '94 baltimore
994 | spiritual movement
1 x 17 cmyk on glossy text
: atomic design and media

together new york
1995 | mello
4 x 8.5 cmyk on glossy card
d: 1212

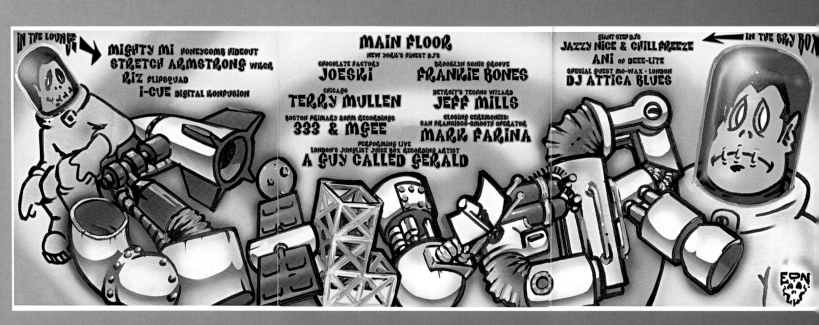

IN THE LOUNGE
MIGHTY MI HONEYCOMB HIDEOUT
STRETCH ARMSTRONG WKCR
RIZ FLIPSQUAD
I-CUE DIGITAL KONFUSION

MAIN FLOOR
NEW YORK'S FINEST DJ'S
CHOCOLATE FACTORY
JOESKI
CHICAGO
TERRY MULLEN
BOSTON PRIMARY KORM RECORDINGS
333 & MGEE

BROOKLYN SONIC GROOVE
FRANKIE BONES
DETROIT'S TECHNO WIZARD
JEFF MILLS
SAN FRANCISCO-SMOOTH OPERATOR
MARK FARINA

PERFORMING LIVE
LONDON'S JUNGLIST JUICE BOX RECORDING ARTIST
A GUY CALLED GERALD

GIANT STEP DJS
JAZZY NICE & CHILL FREEZE
ANI OF DEEE-LITE
SPECIAL GUEST MO-WAX • LONDON
DJ ATTICA BLUES

IN THE SKY BOX

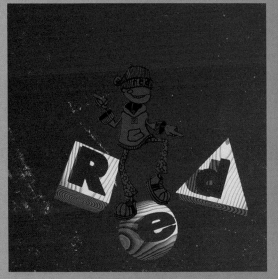

red, purple, and green were just a few in a series of east coast raves built around a common theme, color. this is a great example of a concept established early to reflect the promoters' long-term vision. the flyers that were created to promote the "color" parties cast a distinctive and consistent feeling, as did the events. in this way, the promoters ensured a loyal following throughout the life span of the concept

silver new york
1995 | mello
8 x 24 foldout cmyk on glossy text
d: eon-one/1212

red fitchburg, ma
1994 | primary productions
6 x 6 booklet cmyk on glossy text
d: reload/mark and paul slater

purple new york
1995 | mello | primary productions
6 x 6 booklet cmyk on glossy text
d: sara rundlett/ohm graphics

green great barrington, ma
1995 | primary productions
6 x 6 booklet cmyk on glossy text
d: sara rundlett/ohm graphics

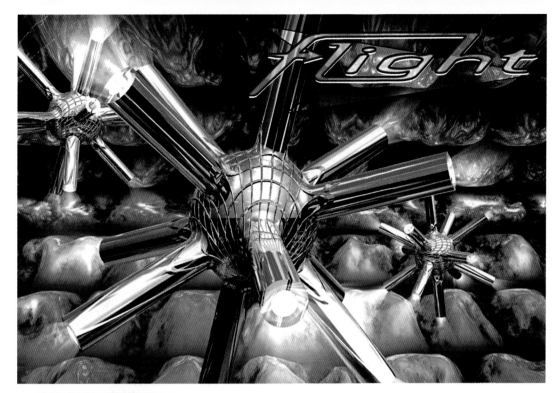

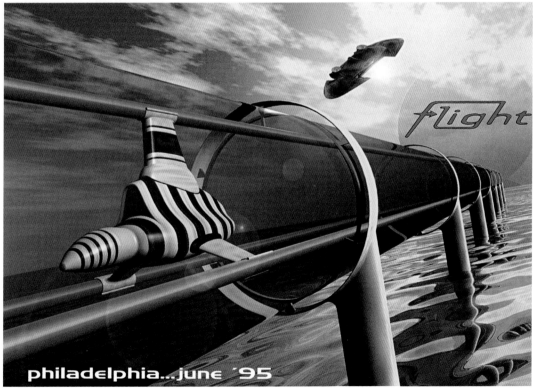

flight philadelphia
995 | headstrong people
x 6 cmyk on glossy card
: studio x/zack detox

flight philadelphia
1995 | headstrong people
5 x 7 cmyk on glossy card
d: studio x

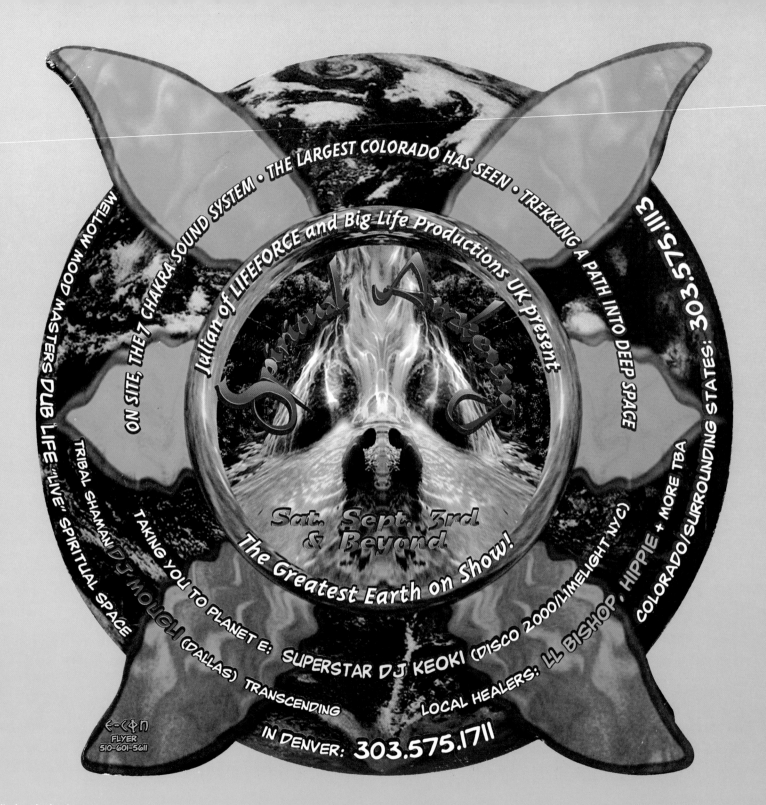

spiritual awakening denver
1995 | julian bradley
8 x 8 die-cut cmyk on glossy card
d: e con

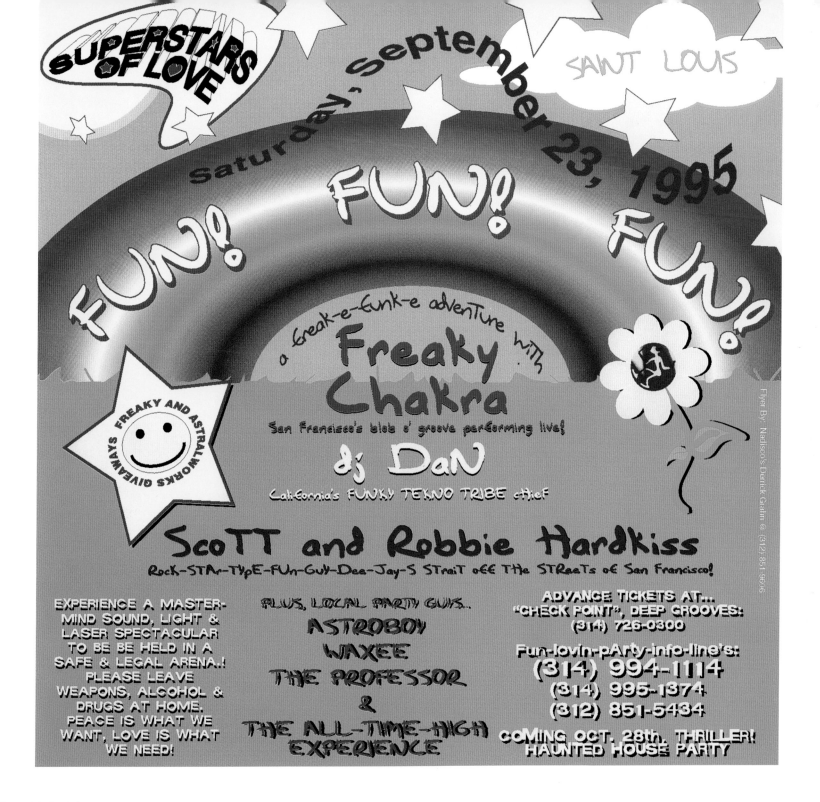

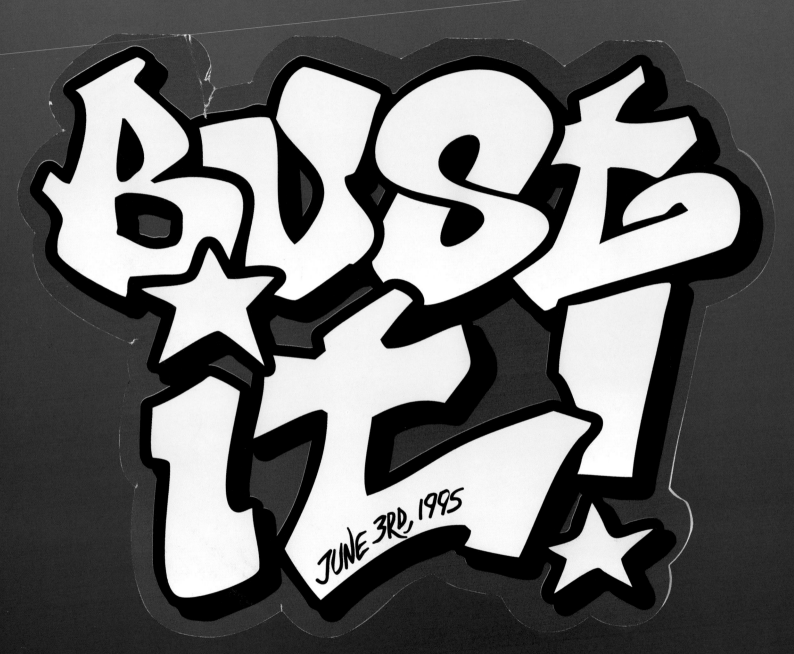

JUNE 3RD, 1995

In the evolutionary process, it was only natural for cross-pollination to occur between underground scenes—in this case, between rave design and graffiti art. rave flyer designers were never hesitant to collaborate with artists of any medium; graffitists, illustrators, photographers, 3-D animators, and painters were all potential contributors when the goal was to continually push the graphic envelope.

bust it! philadelphia
1995 | special k (circle)
8.5 x 11 die-cut foldout cmyk on glossy text
d: under design/adam swank

do it philadelphia
1995 | circle productions
9 x 22 foldout cmyk on glossy text
d: under design

oooooo...yeah! philadelphia
1995 | pure children
5.375 x 5.375 cmyk on glossy card
d: joel t/the earth program ltd.

ultraviolet columbus, oh
1995 | zap
6 x 6 blue foil stamp/red on glossy card
d: solar graphics

twister chicago
1995 | a.t.p.
8 x 8 cmyk on glossy card
d: cody hudson/43d

Warped & Polar Productions
presents

Paradise

SATURDAY JANUARY 28

Robbie Hardkiss : Hardkiss Music

Dante : Back from San Francisco

Dale Charles : Space Records

Dj Dan : Dynamix (First East Coast Appearance Ever!)

Sir Charlz and Es-One : Warped Crew

Tiga : DNA Records

Lighting Effects by Jerkyspacebodyoptics
Visual Treats by Xelibrium
Live Video by Caprice
Sound by Sona Audio

11:30pm - Till?
$20. all ages
Main Info Lines
203.454.6643
401.621.1578

hardkiss music

paradise connecticut
1995 | warped | polar productions
5.5 x 17 gatefold cmyk on glossy card
d: spirit/a&a graphics

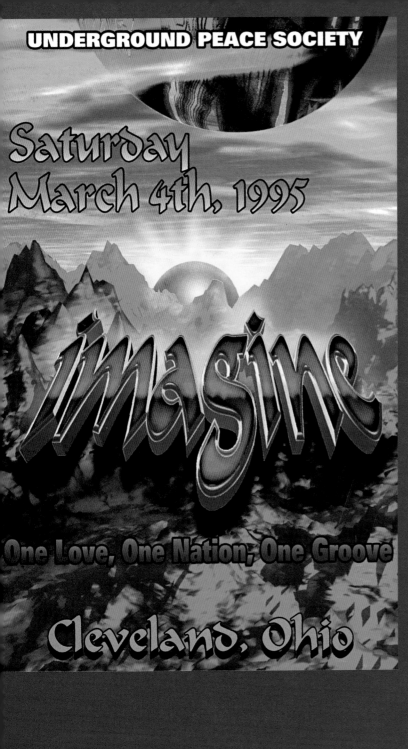

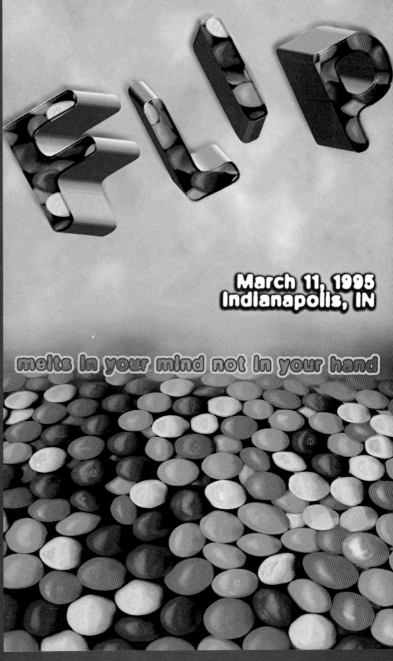

imagine cleveland
1995 | underground peace society
5.5 x 8.5 cmyk on glossy card
d: bleep/a&a graphics

flip indianapolis
1995 | sin productions, inc.
5 x 8 cmyk on glossy card
d: superfreak

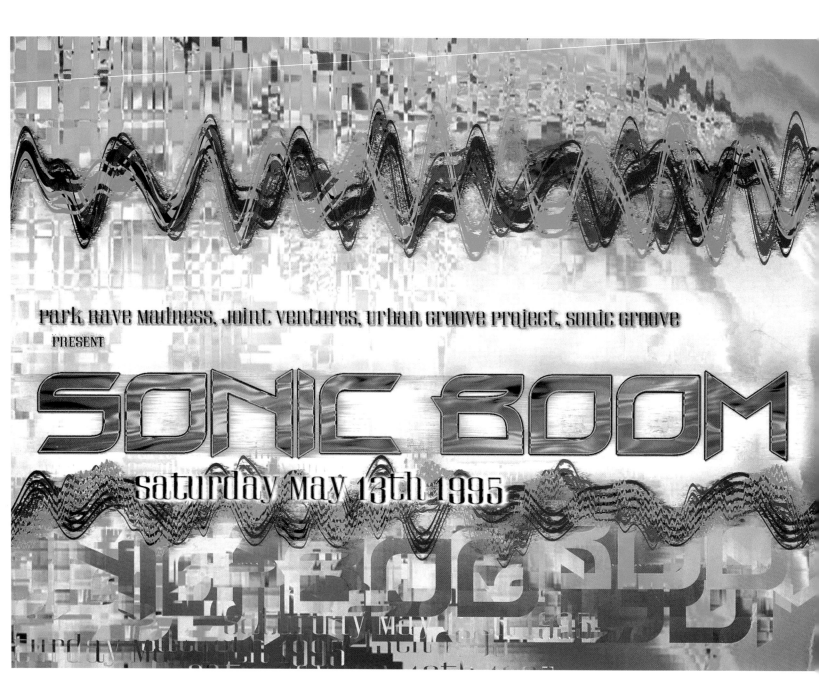

park rave madness, joint ventures, urban groove project, sonic groove

PRESENT

SONIC BOOM

saturday may 13th 1995

sonic boom brooklyn, ny
1995 | park rave | joint ventures | sonic groove
8.5 x 11 cmyk on glossy card
d: zeta-g

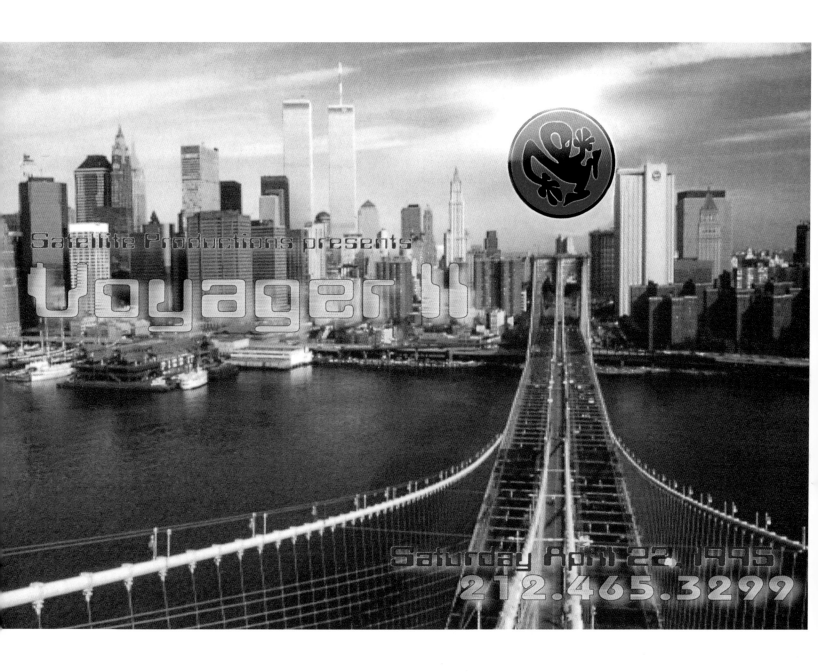

Satellite Productions presents

Voyager II

Saturday April 22, 1995
212.465.3299

voyager II brooklyn, ny
1995 | satellite
7 x 10 cmyk on glossy card
d: zeta-g

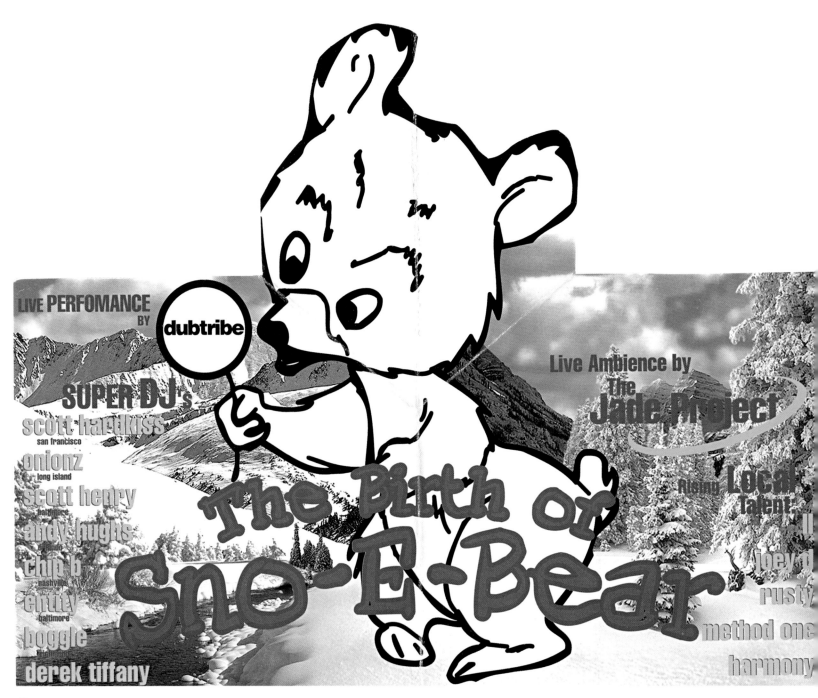

LIVE PERFOMANCE BY

dubtribe

SUPER DJ's

scott hardkiss
san francisco

onionz
long island

scott henry
baltimore

andy hughs
orlando

chip b
nashville

entity
baltimore

boggle
richmond

derek tiffany

Live Ambience by The **Jade Project**

rising **Local** Talent

ll

joey d

rusty

method one

harmony

The Birth of Sno-E-Bear

sno-e-bear was one of many "heroes" created to offer ravers a return ticket to their childhood. reminiscent of a pop-up book, this flyer conveyed the promoters' goal: to offer a lighthearted and carefree experience

the birth of sno-e-bear richmond
1995 | trancefused | pure love
8 x 10 die-cut foldout pop-up cmyk on glossy card
d: under design

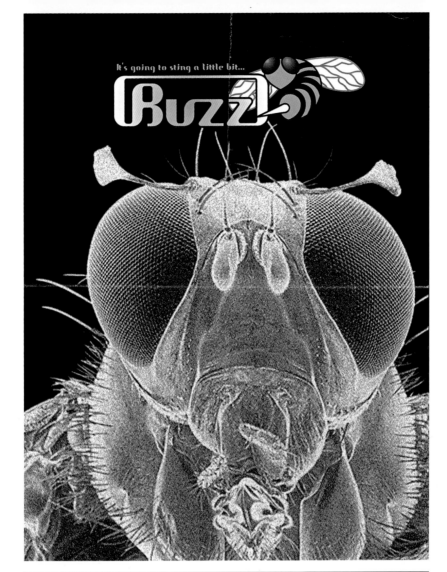

buzz washington, dc
1995 | buzz
3.5 x 11 cmyk on glossy card
d: under design

together new york
1995 | mello
3.5 x 7.5 cmyk on glossy card
d: studio x

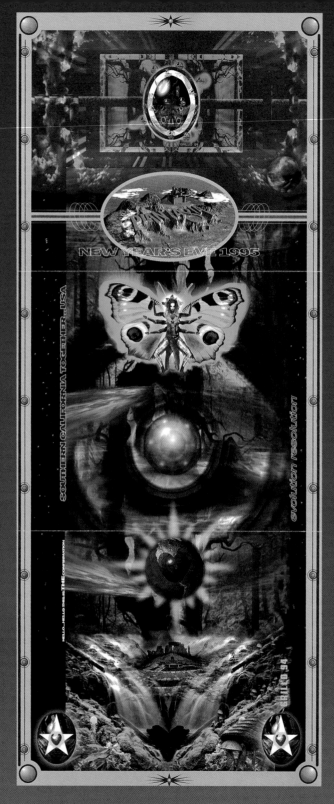

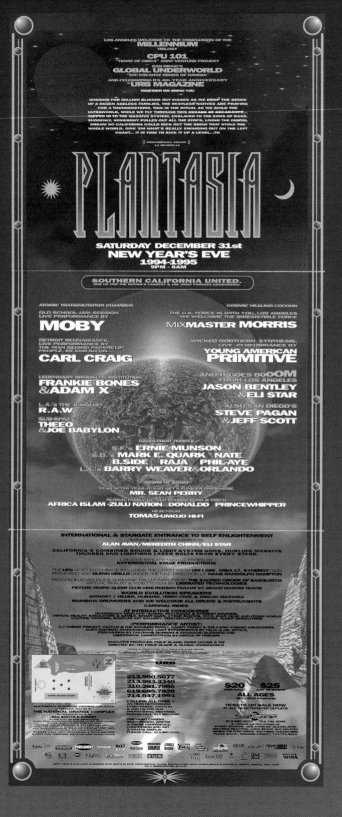

plantasia san bernardino, ca
1995 | cpu 101 | global underworld | urb
11 x 27 foldout cmyk on glossy text
d: paul rivas cover: glenn grillo logo: stimuli

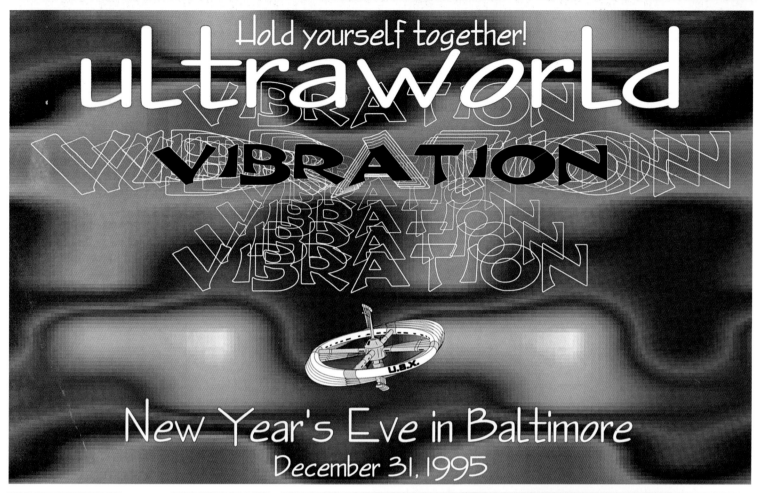

Hold yourself together!

ultraworld

VIBRATION

New Year's Eve in Baltimore
December 31, 1995

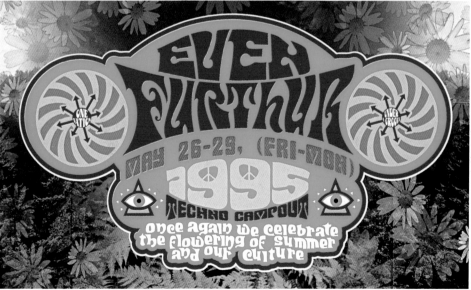

ibration baltimore
995 | ultraworld
x 9.5 cmyk on glossy card
: lonnie fisher

destiny 10 toronto
1995 | destiny productions | outer limits uk
5.5 x 7 booklet cmyk on glossy text
d: sol studios

even furthur midwest
1995 | drop bass | ripe | dave prince
4.5 x 7 mini-flyer cmyk on glossy card
d: cody hudson/43d

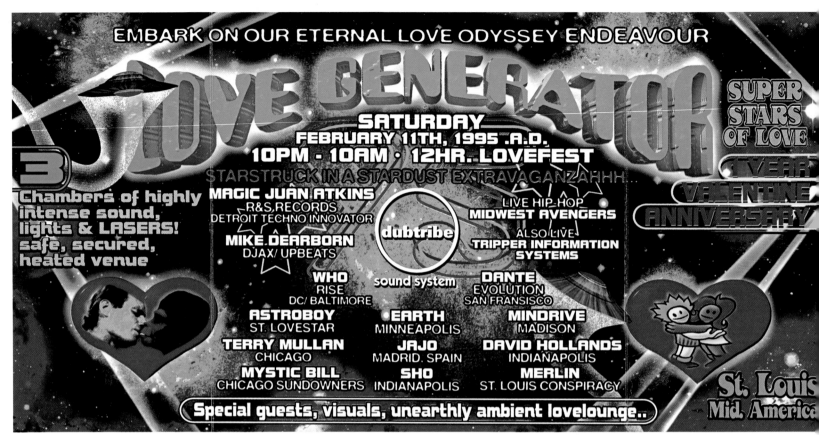

EMBARK ON OUR ETERNAL LOVE ODYSSEY ENDEAVOUR

LOVE GENERATOR

SUPER STARS OF LOVE

3

SATURDAY
FEBRUARY 11TH, 1995 .A.D.
10PM - 10AM · 12HR. LOVEFEST

1 YEAR VALENTINE ANNIVERSARY

STARSTRUCK IN A STARDUST EXTRAVAGANZAHHH...

Chambers of highly intense sound, lights & LASERS! safe, secured, heated venue

MAGIC JUAN ATKINS
R&S RECORDS
DETROIT TECHNO INNOVATOR

LIVE HIP-HOP
MIDWEST AVENGERS

MIKE DEARBORN
DJAX/ UPBEATS

dubtribe

ALSO LIVE
TRIPPER INFORMATION SYSTEMS

sound system

WHO
RISE
DC/ BALTIMORE

DANTE
EVOLUTION
SAN FRANSISCO

ASTROBOY
ST. LOVESTAR

EARTH
MINNEAPOLIS

MINDRIVE
MADISON

TERRY MULLAN
CHICAGO

JAJO
MADRID. SPAIN

DAVID HOLLANDS
INDIANAPOLIS

MYSTIC BILL
CHICAGO SUNDOWNERS

SHO
INDIANAPOLIS

MERLIN
ST. LOUIS CONSPIRACY

St. Louis
Mid. America

Special guests, visuals, unearthly ambient lovelounge..

Underground Peace Society
ups
Deliverance
April 15, 1995

d'licious
january 7, 1995 · memphis

love generator st. louis
1995 | superstars of love
10.875 x 5.375 gatefold cmyk on glossy card
d: free/a&a graphics

deliverance columbus, oh
1995 | underground peace society
4.25 x 5.25 die-cut cmyk on glossy card
d: spirit/a&a graphics

d'licious memphis
1995 | lil' june's galactic groove factory
5.5 x 8.5 cmyk on glossy card
d: pwr jr.

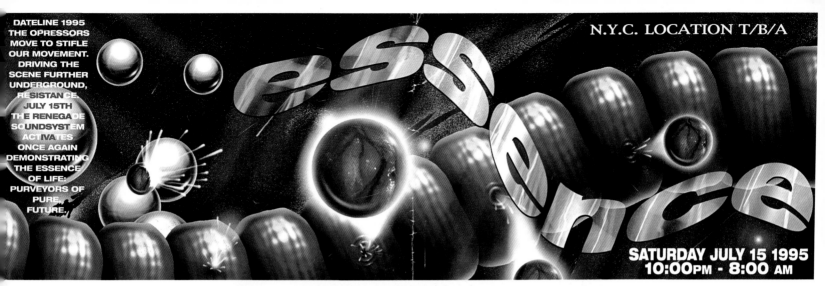

DATELINE 1995
THE OPRESSORS
MOVE TO STIFLE
OUR MOVEMENT.
DRIVING THE
SCENE FURTHER
UNDERGROUND,
RESISTANCE
JULY 15TH
THE RENEGADE
SOUNDSYSTEM
ACTIVATES
ONCE AGAIN
DEMONSTRATING
THE ESSENCE
OF LIFE:
PURVEYORS OF
PURE, FUTURE.

N.Y.C. LOCATION T/B/A

essence

SATURDAY JULY 15 1995
10:00PM - 8:00 AM

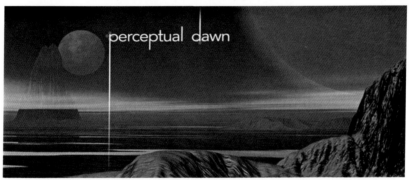

perceptual dawn

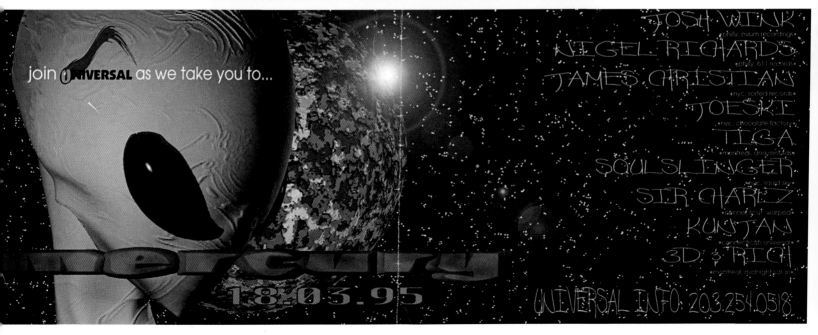

join UNIVERSAL as we take you to...

mercury
18.03.95

JOSH WINK
philly, ovum recordings

NIGEL RICHARDS
philly, 611 records

JAMES CHRISTIAN
nyc, sorted records

JOESKI
nyc, chocolate factory

TIGA
montreal, dnavrecords

SOULSLINGER
nyc, liquid sky

SIR CHARLEZ
connecticut, warped

KUNTAN
connecticut, universal

3D & RICH
montreal, midnight scene

UNIVERSAL INFO 203.254.0518

essence new york
995 | essence
1 x 17 foldout cmyk on glossy text
d: unknown

perceptual dawn los angeles
1995 | sw | mtx
2.5 x 6.5 cmyk on glossy card
d: stimuli

mercury queens, ny
1995 | universal
4.125 x 10.875 cmyk on glossy text
d: graFIX

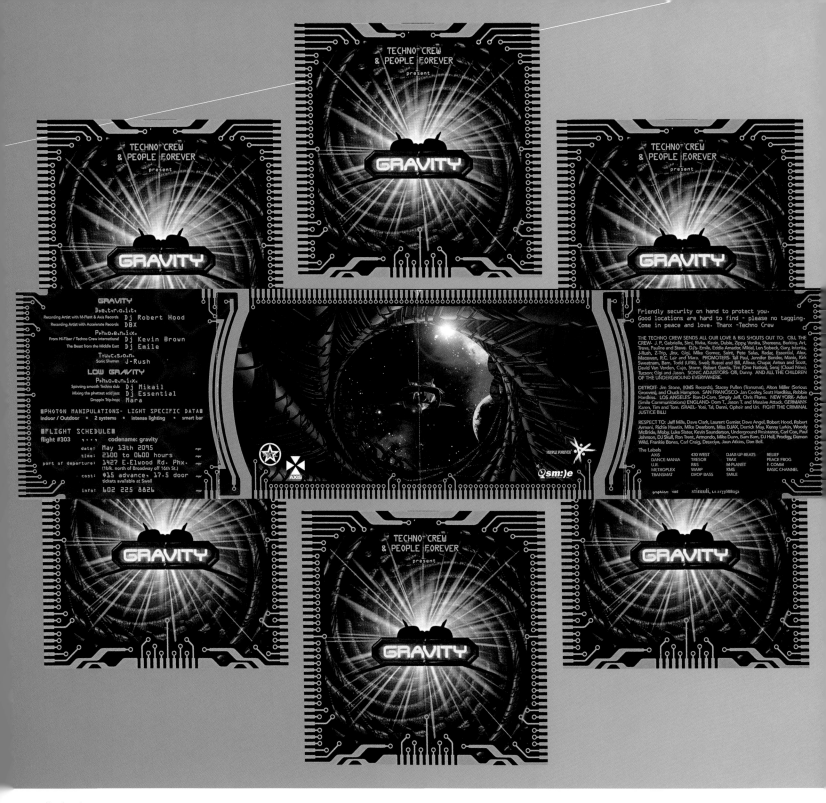

gravity phoenix
1995 | techno crew | people forever
4 x 16 foldout cmyk on high-gloss text
d: stimuli

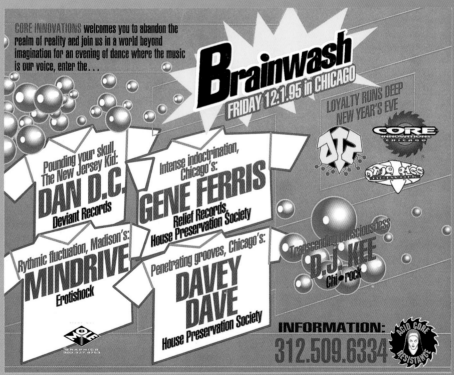

brainwash chicago
995 | core innovations
.25 x 5.5 cmyk on glossy card
*: mole graphics

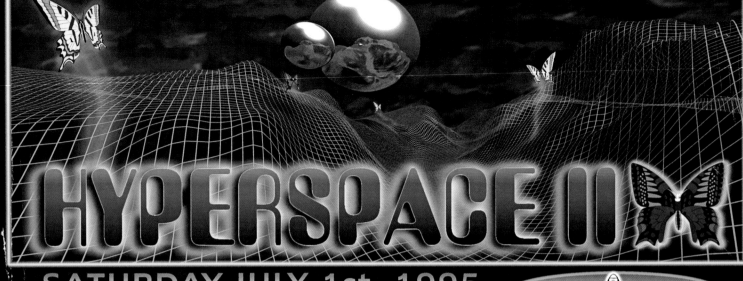

HYPERSPACE II

SATURDAY JULY 1st ,1995

A UNITED HOUSE CULTURE PRESENTATION

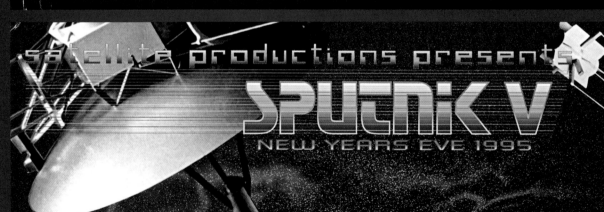

satellite productions presents

SPUTNIK V

NEW YEARS EVE 1995

404.908.7308
212.465.3299

lakewood exhibition center

ATLANTA GEORGIA

hyperspace II orlando, fl
1995 | united house culture
6 x 13 cmyk on glossy card
d: jaysen

sputnik V atlanta
1995 | satellite
7 x 13 cmyk on glossy card
d: zeta-g

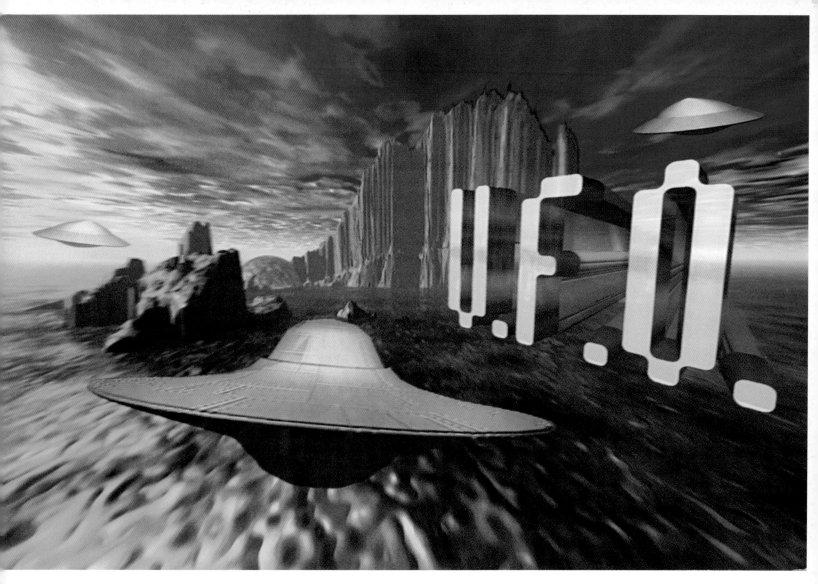

outer space is probably the most prevalent theme of rave culture—that of "rave as escape" from everyday experience on earth. it surfaced repeatedly in various forms, in party imagery centered on ideas like the existence of extraterrestrial beings, alien abductions, space travel, and otherworldly dimensions.

u.f.o. madison, wi
995 | erotishock | underground odyssey
.5 x 8 cmyk on glossy card
: e con

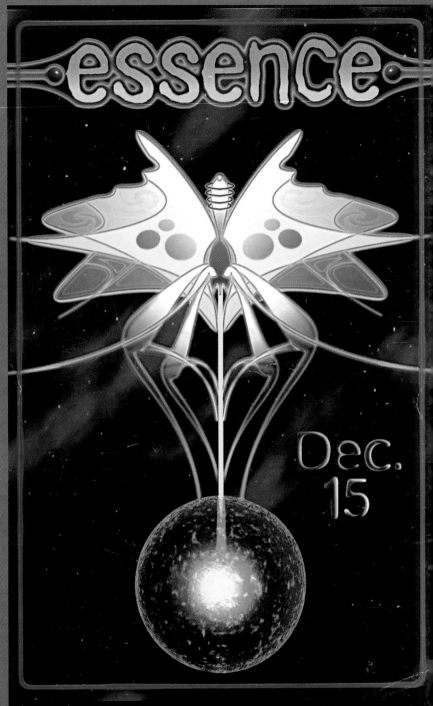

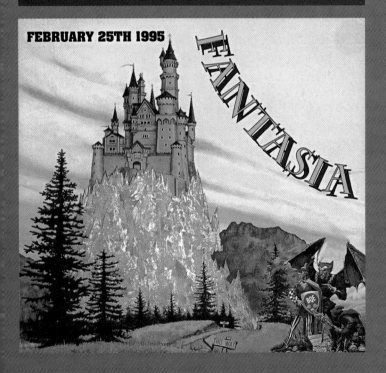

FEBRUARY 25TH 1995

FANTASIA

transcendance toronto
1995
6 x 6 black on red plastic
d: unknown

fantasia brooklyn, ny
1995 | brooklyn queens entertainment
7 x 7.5 cmyk on glossy card
d: arista

essence durham, nc
1995 | db productions
5 x 7.5 cmyk on glossy card
d: kali-yuga designs

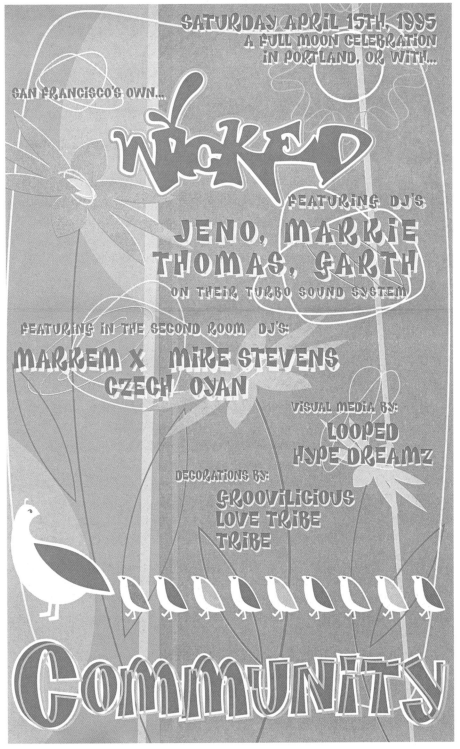

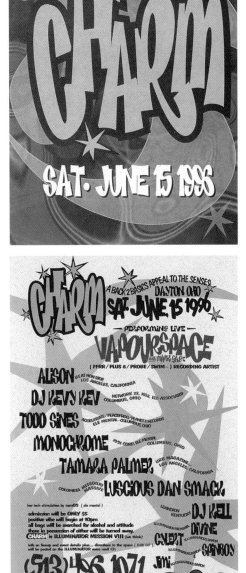

while some designers were looking to the future to create edgy work, others were drawing inspiration from the past, reintroducing hand-drawn text, sketches, and spot coloring with a modern twist, as these examples illustrate.

community portland, or
1995 l hype productions
5 x 8 blue/green/gold on card
d: mike friolo/groovin design

charm dayton
1996 l illuminators
5 x 9 silver/purple on card
d: kevy kev/kg2 graphix

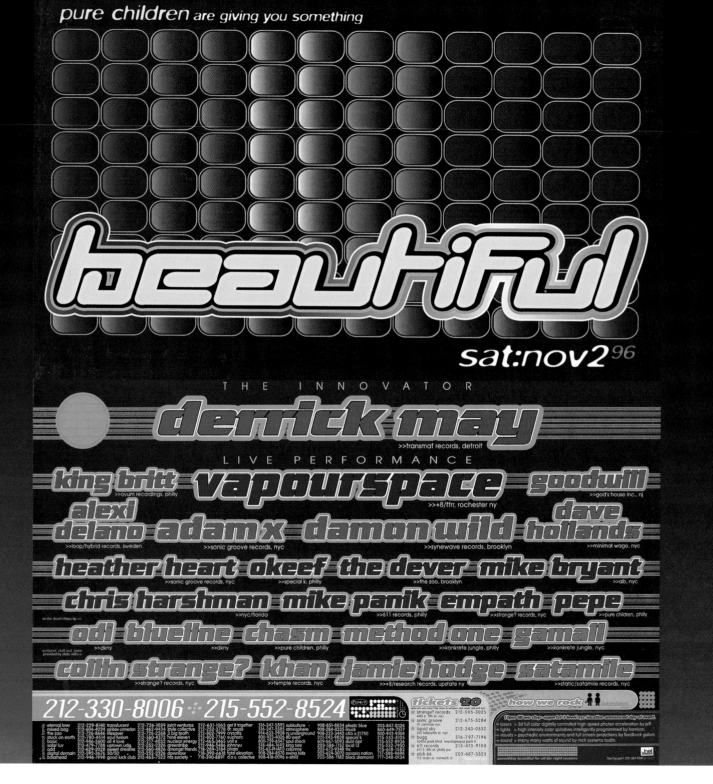

beautiful new york
1996 | pure children
8.5 x 11 cmyk/silver on glossy card
d: joel t/the earth program ltd.

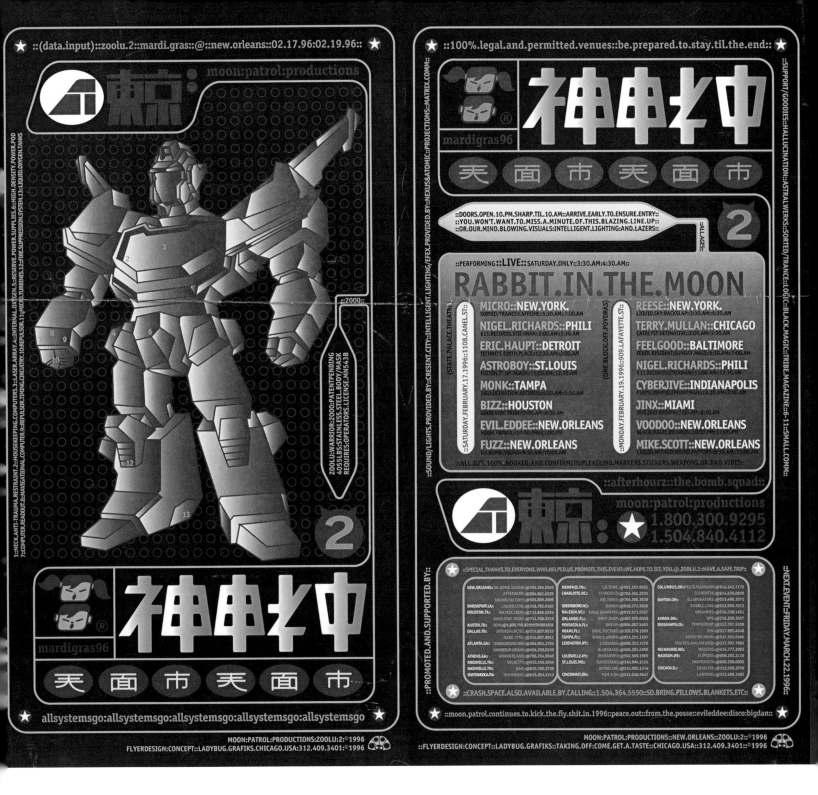

zoolu 2 new orleans
1996 | moon patrol (freebass society)
11 x 20.5 cmyk on glossy card
d: ladybug grafiks

dream
scape
may.11.1996
detroit

vinyl techs ▶

other stuff

75,000 watt sound wall
by maximum

intelligent lighting by eyegasm

detroit's first 3Dimensional
laser experience from lovelight (cleveland)

hypervisuals by eno-one animations nyc

main info
313.438.2494 ◀

info lines ▼

akron	ups	216.258.1037
chicago	catalyst	312.509.2910
cinn.	yum-yum	513.648.9647
cleveland	dreamer	216.238.1451
	psycholine	216.556.0899
	network23	614.780.8044
columbus	ele-mental	614.470.0929
	illuminator	513.496.1071
dayton	gear	313.676.1272
detroit	kemistry	317.767.5530
	stacked	317.767.7863
indy	underground	
	resistance	419.242.9019
toledo	transcendance	416.760.3281
toronto		

tickets ▼

clevel.	planB	513.222.7250
detroit	recordtime	810.775.1550
cleveland	deep records	216.383.3101
cinn	mojo	313.994.9338
ann arbor	riff raff	216.376.1644
akron	clubhead	513.665.9999
cinci	world record	614.297.7900
columbus		

dj trance
bassex, smile los angeles
scott henry
fever, sunday mass baltimore
feelgood
ultraworld, sunday mass baltimore
glenn underground
relief records, chicago
terry mullan
catalyst, definitive chicago
sleepy-c
deep, psychoactive records cleveland
stretch
calico cinci
scott zacharius
detroit
arash
illuminator records dayton

free sunrise afterhours all day sunday.may.12
flyer design by **kg2 graphix** 614.297.6487

⊖ in most cases early 3-D graphics were produced using crude modeling programs on computers with limited memory for rendering.

dream scape detroit
1996 | sooper sonic
5.5 x 8.5 cmyk on glossy card
d: kevy kev/kg2 graphix

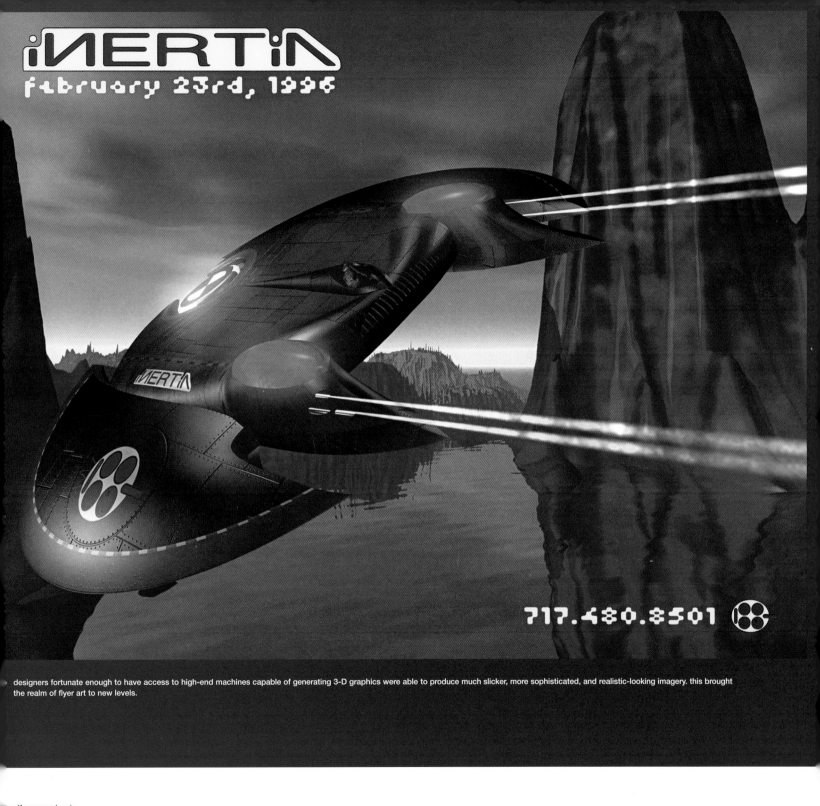

iNERTiA
february 23rd, 1996

iNERTiA

717.480.8501

designers fortunate enough to have access to high-end machines capable of generating 3-D graphics were able to produce much slicker, more sophisticated, and realistic-looking imagery. this brought the realm of flyer art to new levels.

inertia pennsylvania
996
5 x 11 cmyk on glossy text
studio x

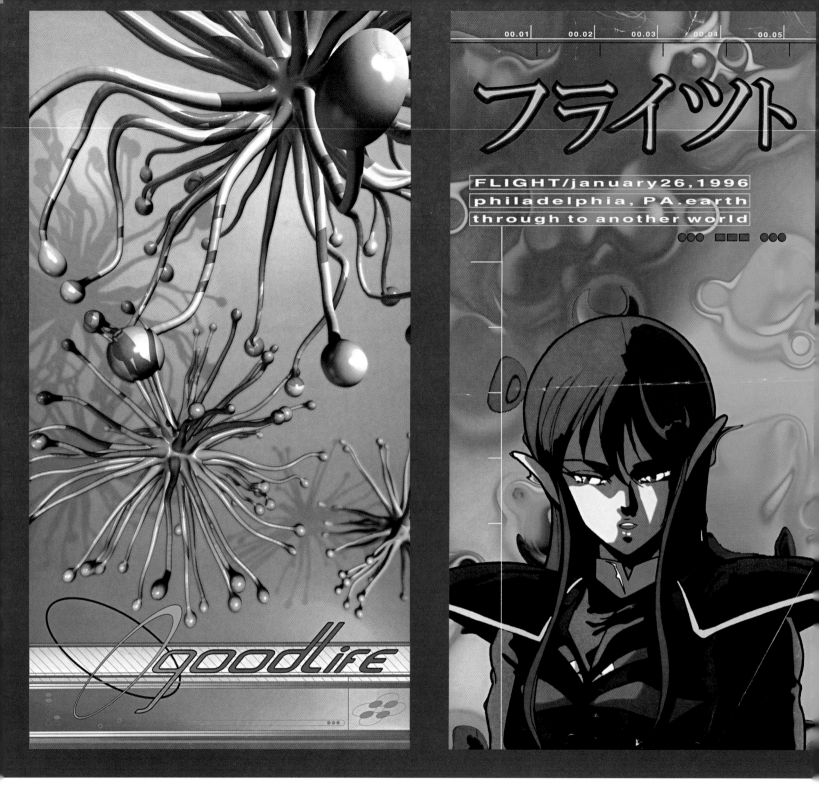

フライツト

FLIGHT/january26,1996
philadelphia, PA.earth
through to another world

goodlife

goodlife annapolis, md
1996 | sky brothers
8.25 x 15.25 cmyk/silver on glossy text
d: dots per minute

flight philadelphia
1996 | headstrong people
5.875 x 11.625 cmyk on glossy text
d: studio x

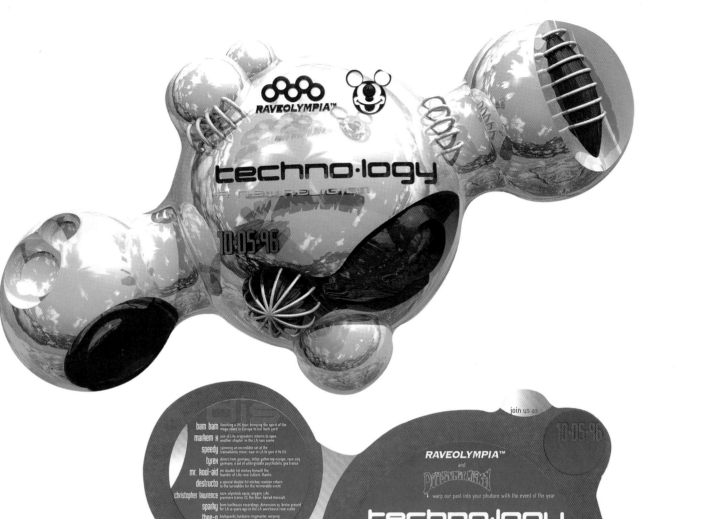

techno•logy los angeles
1996 | raveolympia | double hit mickey
7.25 x 14 die-cut cmyk/neon pink on glossy card
d: stimuli

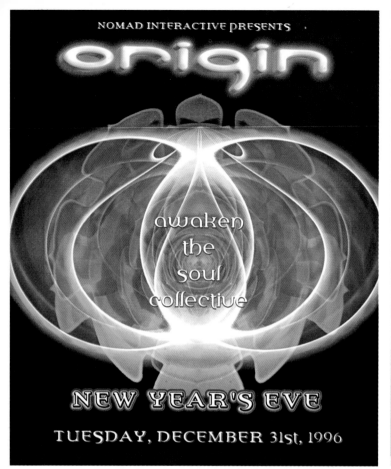

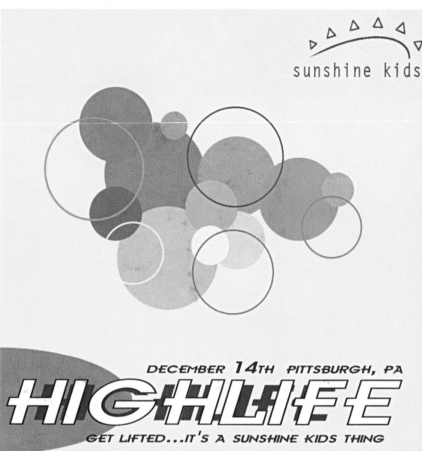

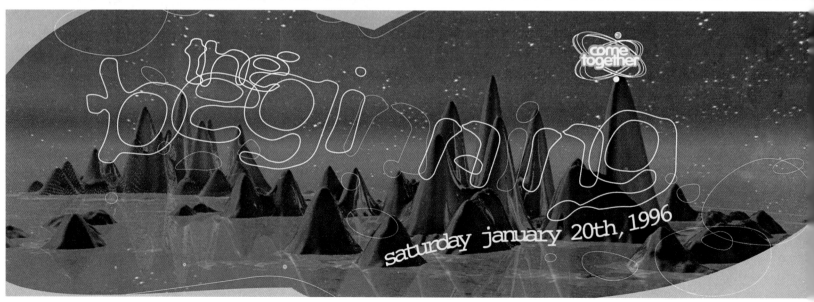

origin san francisco
1996 | nomad interactive
5 x 6 cmyk on glossy card
d: e con

highlife pittsburgh
1996 | sunshine kids
4 x 4 cmyk on glossy card
d: aleph laboratories

the beginning denver
1996 | come together
3 x 8.5 cmyk on glossy card
d: mole graphics

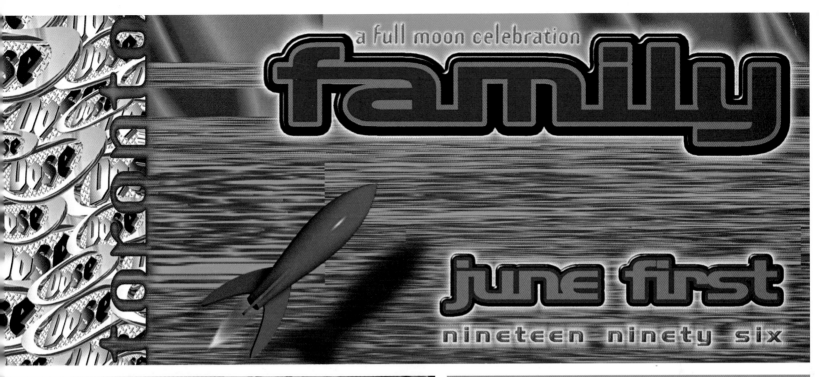

a full moon celebration

family

june first

nineteen ninety six

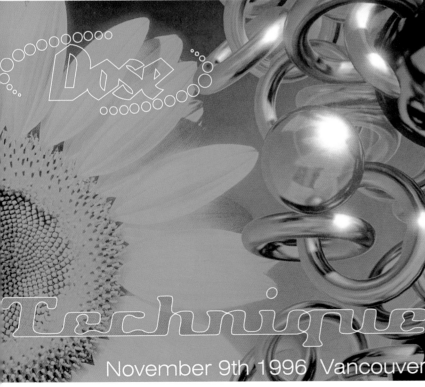

Dose

Technique

November 9th 1996 Vancouver

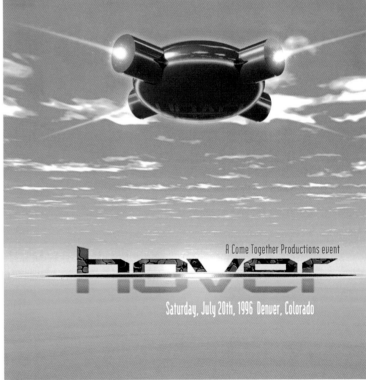

A Come Together Productions event

hover

Saturday, July 20th, 1996 Denver, Colorado

family toronto
1996 | dose
3.5 x 8.5 cmyk on glossy card
d: prototype

technique vancouver, bc
1996 | dose
5 x 8.5 foldout cmyk on glossy card
d: prototype

hover denver
1996 | come together
4.75 x 9.5 foldout cmyk on glossy card
d: mole graphics

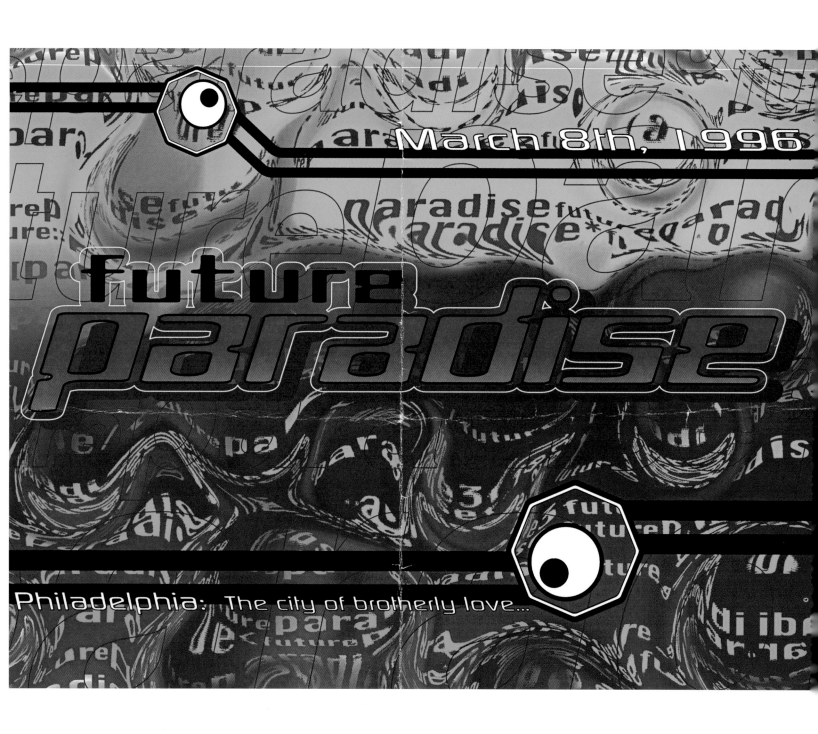

March 8th, 1996

future paradise

Philadelphia: The city of brotherly love...

future paradise philadelphia
1996 | headstrong people
9 x 12 cmyk on glossy text
d: studio x

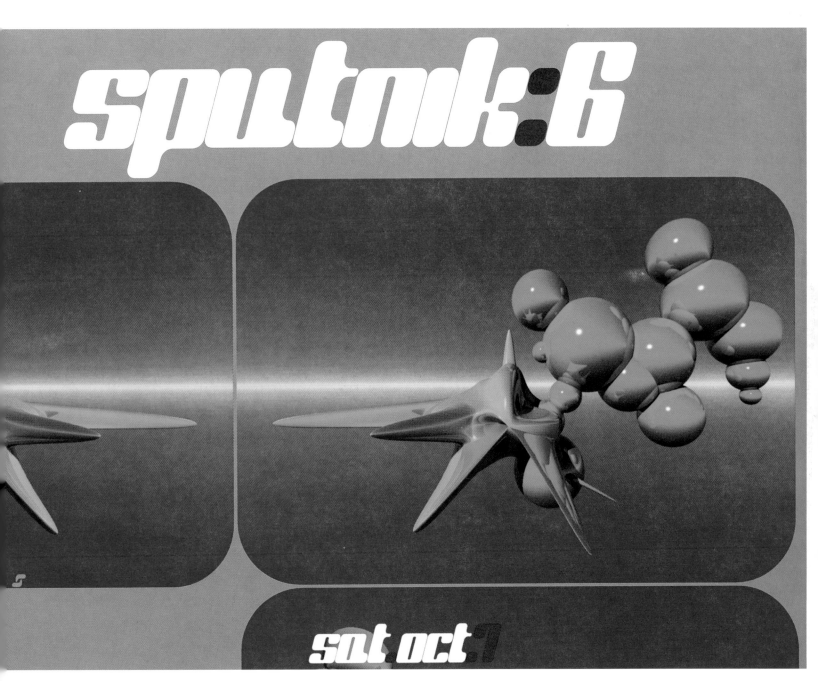

designs with too much information or bad graphic placement can be distracting to the reader. the designer of this flyer produced a "clean" look uncluttered by unnecessary text; the result is futuristic, fresh, and new.

sputnik 6 new york
996 | satellite
5 x 14 foldout cmyk/silver on glossy text
benno/shaun gough

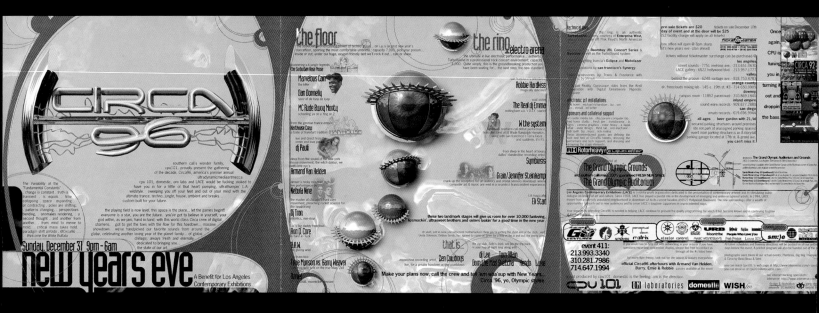

circa 96 los angeles
1996 | cpu101 | domestic | om laboratories
9 x 27 foldout cmyk/neon pink on glossy text
d: stimuli

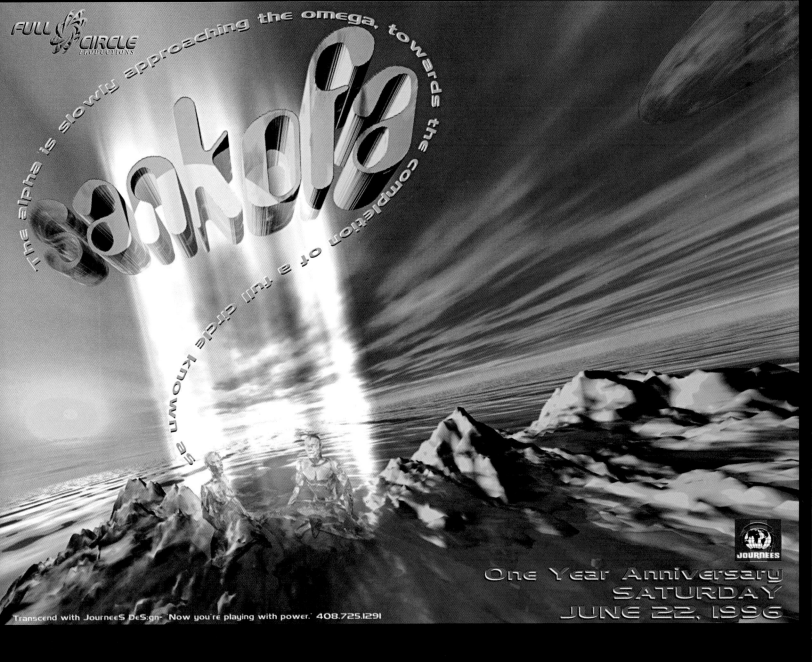

ankofa san francisco
996 | full circle
.5 x 11 cmyk on glossy card
: journees

SATURDAY

a festival celebrating the electronic dance culture

organic

growing here on our mother earth...

JUNE 22, 1996

SNOW VALLEY RESORT IN THE
SAN BERNADINO
NATIONAL FOREST

BLEEP! 96

organic san bernardino, ca
1996 | philip blaine | insomniac | chaotica | extreme
12 x 32 foldout cmyk on glossy text
d: roger parent/simon chan/bleep/a&a graphics

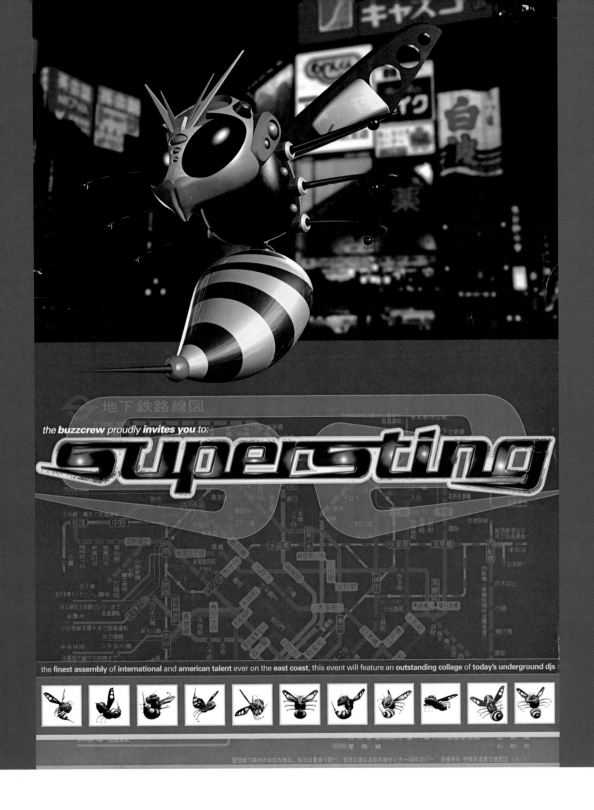

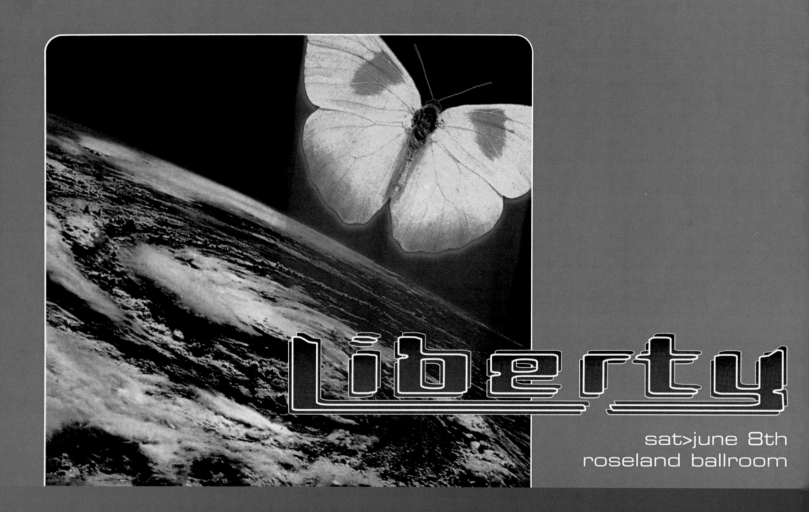

essence satellite essence satellite essence satellite essence s

liberty

sat>june 8th
roseland ballroom

liberty new york
1996 | satellite | essence
11 x 17 foldout cmyk/metallic blue on glossy text
d: joel t/the earth program ltd.

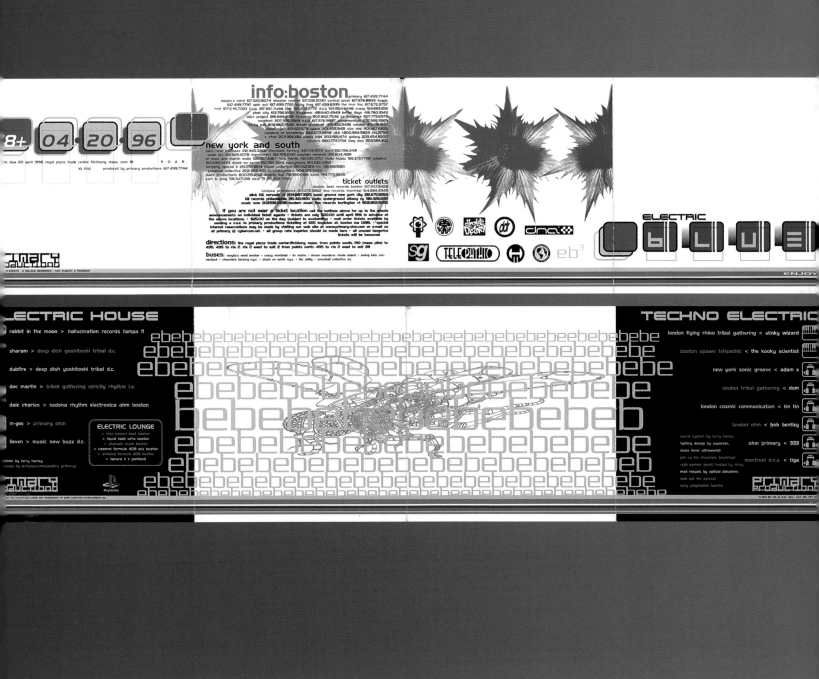

info:boston primary 617.499.7744

new york and south

ticket outlets

if you are not near a ticket location call the hotlines above for up to the minute announcements on individual ticket agents • tickets are only $20.00 until april 19th in advance at the above locations • $25.00 on the day (subject to availability) • mail order tickets available by sending a s.a.s.e. to primary productions ticketing at 695 boylston st, boston ma 02116 • special internet reservations may be made by visiting our web site at www.primary-ohm.com or e-mail us at primary @ cybercom.net. • all group rate inquiries should be made here • all unused tangerine tickets will be honoured

directions: the royal plaza trade center, fitchburg, mass. from points south 190 (mass pike) to 495, 495 to rte 2, rte 2 west to exit 2 from points north, 495 to rte 2 west to exit 28

buses: moyka's mind boston • crazy montreal • kc maine • dream wanderer rhode island • swing kids connecticut • chocolate factory n.y.c. • stuck on earth n.y.c. • the philly • snowball collective d.c.

18+ 04·20·96

ctric blue 20 april 1996 royal plaza trade centre fitchburg, mass. over 18
R O A R
10 P.M. produced by primary productions 617.499.7744

ELECTRIC BLUE

ENJOY

ELECTRIC HOUSE

rabbit in the moon > hallucination records tampa fl

sharam > deep dish yoshitoshi tribal d.c.

dubfire > deep dish yoshitoshi tribal d.c.

doc martin > tribal gathering strictly rhythm l.a.

dale charles > sedona rhythm electronica ohm boston

m-gee > primary ohm

lieven > music now buzz d.c.

ELECTRIC LOUNGE
> holy boston beat boston
> liquid todd wfnx boston
> pharaoh zoom boston
> caserec formula 409 dck boston
> shalako formula 409 boston
> takara k c portland

stem by terry hanley
design by jerkyspacebndyoptics primary]

TECHNO ELECTRIC

london flying rhino tribal gathering < slinky wizard

boston spawn telepathic < the kooky scientist

new york sonic groove < adam x

london tribal gathering < dom

london cosmic communication < tin tin

london ohm < bob bentley

sound system by terry hanley
lighting design by supercal. ohm primary < 333
(buzz fever ultraworld)
join us for chocolate breakfast
ryde sameer joeski hosted by milky montreal d.n.a. < tiga
mad visuals by optical delusions
look out for several
sony playstation booths

FLYER BY US @ IND_NYC_CAT.NO. PP1 04

electric blue fitchburg, ma
1996 | primary productions
6 x 24 foldout black/blue/gold/silver on card
d: paul slater/sara rundlett

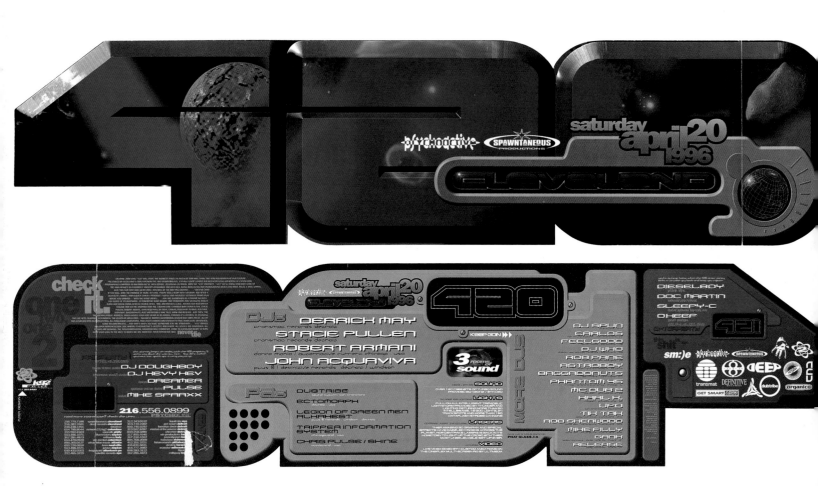

420 cleveland
1996 | psychoactive | spawntaneous
6.25 x 25 die-cut cmyk on glossy card
d: kevy kev/kg2 graphix

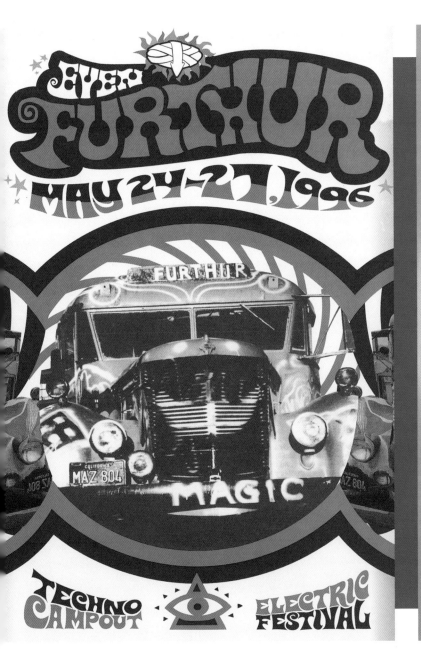

even furthur wisconsin
1996 drop bass network | communique | david prince
7.625 x 20 foldout orange/blue on matte card
d: cody hudson/43d

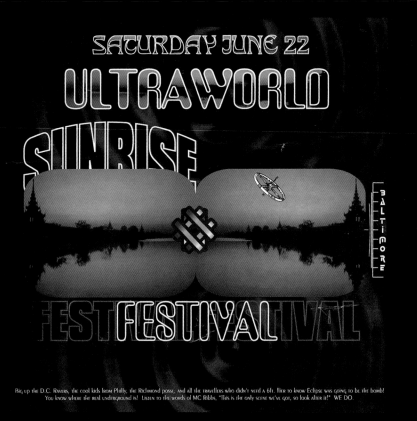

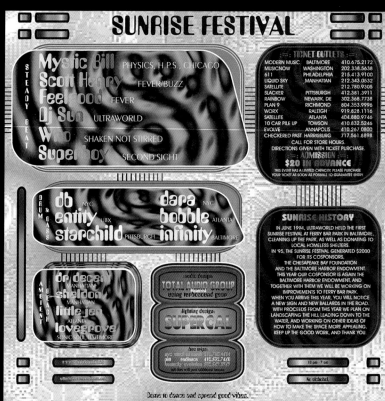

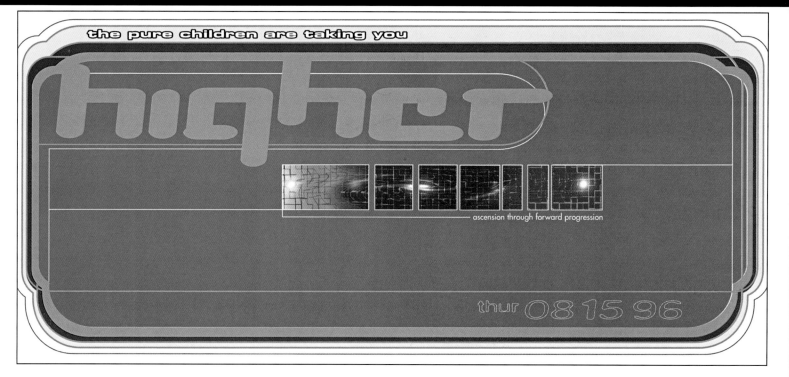

sunrise festival baltimore
1996 | ultraworld
9 x 9 cmyk on glossy text
d: lonnie fisher

higher new york
1996 | pure children
4 x 8 cmyk/silver on glossy card
d: joel t/the earth program ltd.

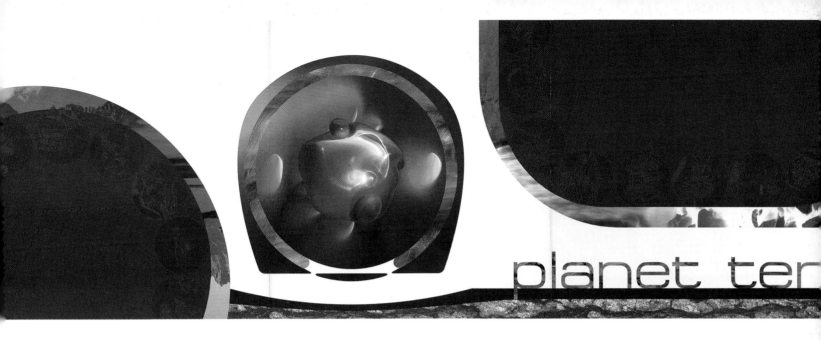

planet ter

when the printing budget would allow it, simple designs could be greatly enhanced by the use of costlier paper stocks and features such as fifth colors and foil stamping.

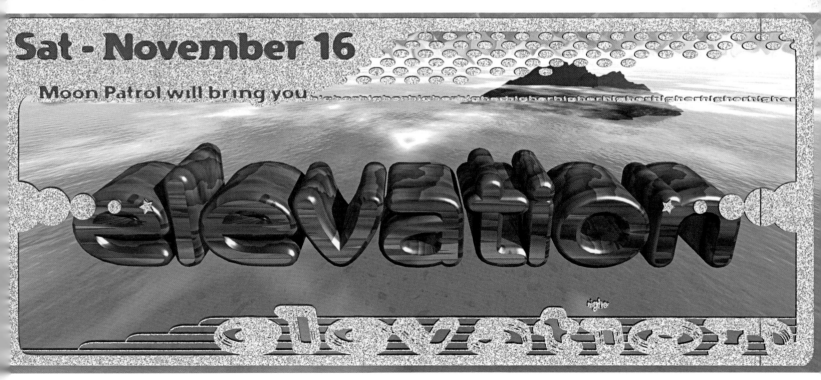

Sat - November 16

Moon Patrol will bring you...

elevation

planet ten los angeles
1996 | cpu101
0.5 x 27 foldout cmyk on matte card
d: stimuli

elevation houston
1996 | moon patrol
5.25 x 12 cmyk/glitter foil stamp on glossy card
d: kinetic design

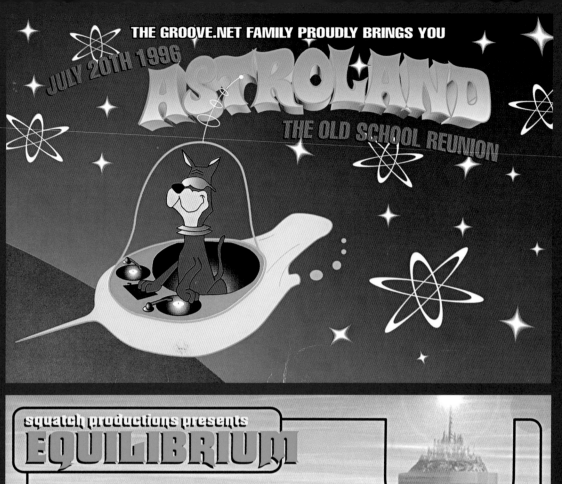

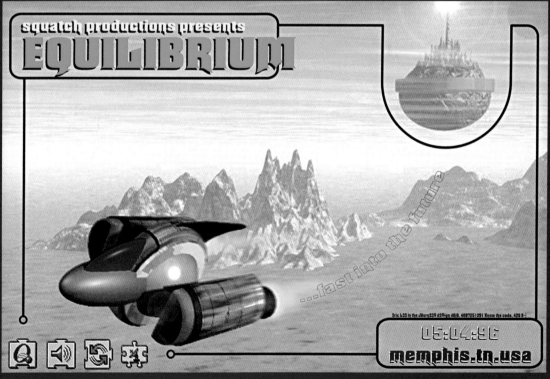

astroland dallas
1996 | groove.net family
5.5 x 8.5 cmyk on glossy card
d: a&a graphics

equilibrium memphis
1996 | squatch productions
5.625 x 8.625 cmyk on glossy card
d: journees

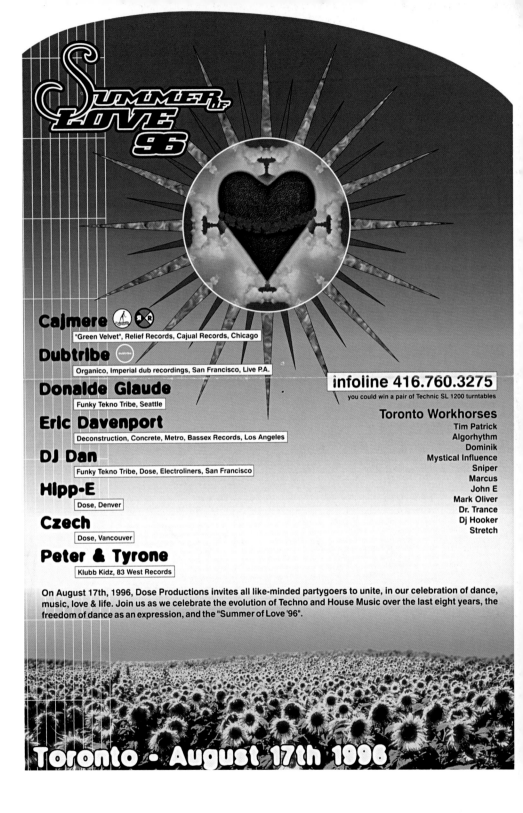

energize dayton
1996 | goodchill productions
5.25 x 15.25 black/neon green on glossy card
d: deep six

summer of love toronto
1996 | dose
11 x 17 die-cut foldout cmyk on glossy text
d: prototype

04.13.96

live transmissions
live transmissions

MARK GAGE AKA VAPOURSPACE

(I+8 RECORDS) Being his first performance in the United States in over a year, Mark will bring us the vibe only some of us can remember. Creator of 'Gravitational Arch of 10', the track that started the Syracuse underground dance scene. Mark has now become one of the world's most sought after producers. Mark has also done a massive amount of remix work and also makes up half of **Cusp** on Swim Records.

PROTOTYPE 909

(INSTINCT RECORDS, NYC) Heralded as the country's best live performance by many, this east coast trio produces the kind of mind-numbing trance that upstate has grown to expect. Their performance is sure to be a poly-rhythmic treat.

LIVE AMBIENT SET ALL NIGHT BY
 VISITOR (ROCHESTER, NY)

mars

:: sat >> april 13th 1996

Onondaga County War Memorial
Syracuse, NY

Kevin Saunderson (KMS, DETROIT) The Godfather of the techno scene, he is one of the original Detroit three who invented what we now know as Techno music. He is considered one of the world's greatest producers, let alone one of Europe's most in demand DJs.

Damon Wild (SINE WAVE, NYC) One of the pioneers of the NY sound. He has mastered the entire spectrum of underground trance music and is regarded as one of New York's finest underground producers. As with many at this event, it will be his upstate NY debut.

Johnny Vicious (VICIOUS MUSIK, NYC) Not only does he oversee the largest dance floor in NYC at the Roxy, but he is the power behind the infamous Vicious Musik record label. He has created tracks that clearly demonstrate the New York house sound. Believe this!

Scott&Robbie Hardkiss (HARDKISS MUSIC, SF) The world reknowned duo from San Francisco, and owners of the Hardkiss and Softkiss record labels. These eclectic remixers are the shapers of the San Francisco Sound, and are sure to provide an exciting set.

James Christian (X-SIGHT, STRICTLY RHYTHM, NYC) The illustrious DJ/producer from New York City returns to upstate New York to add the hard house tip that everyone loved at *Eclipse* last year.

Bad Boy Bill (MCM, CHICAGO) For his first time in New York, Chicago's mix-master will awe us with his mastery of the turntables. Some may know him through his mix tapes, others through his radio show. But there are times when you'll want to say, "Is he really doing that?"

Carlos (COC, SAN FRANCISCO) Returning to upstate New York, Carlos adds instant vibe at any party. Flaunting his wizardry of the Technics MK-1260's, he will be sure to put a smile on your face.

Hipp-E (DENVER, CO) All the way from the mid-west, Hipp-E has the ability to push the crowd to a new level and take it back again, all night long.

Scott Richmond (SATELLITE, NYC) Co-founder of the upstate New York rave scene and half owner of the prestigious Satellite Productions in NYC. Creator of such memorable events as *Sputnik 4* and the *Voyager* series, he is sure to add the upstate vibe that everyone has grown to love over the years.

Mr. Kleen (SATELLITE, NYC) The other half of Satellite Productions in NYC and a Co-founder of the upstate New York rave scene. Although he was NASA's original ambient DJ, he now adds a trance tip to any event. This event will be taking place on his birthday, so wish him a good one. Just don't ask him how old he is. :-)

Osheen (BLINDED, BOSTON) Boston's leading house man, he is quickly becoming one of the north-east's top DJ/producers.

David Hollands (MINIMAL WAGE, IN) He has DJed for over 10 years and has been a promoter for 4 years. His name is synonymous with the mid-west scene, and his music selection is influenced by Detroit Techno and Hard House.

Scotty Mars (KING SIZE, CT) As promoter/DJ/producer, Scotty has overseen Connecticut's underground dance music scene.

Geoff-E (FREIGHTYARD PROD, ALLENTOWN) The mastermind behind the Freightyard in Allentown, Geoff-E has become an upstate favorite.

Jordan Vesteyo (ADRENALIN, NY) As seen in Vancouver and Toronto, this upstate hard trance DJ is quickly becoming upstate's most sought after DJ. Jordan has been a favorite of ours since the days of Cloud 9.

Space (LAUNCH PAD, ALBANY) Owner of the Launch Pad in Albany, Space is a true pioneer of the upstate scene. Grandfather of Albany's rave scene, he has laid down the house tracks at such parties as the *Sputnik Reunion*, *Neptune*, and *Saturn*. Any upstate kid will tell you that Space has mastered the art of mixing.

Flex (CKY BABY, ROCHESTER) Resident at *Club Chameleon* and *Club Marcella*, Flex is one of the north-east's up and coming DJs. He has recently started throwing a series of events with the production company Cky Baby in Rochester.

Ross Gambuza (COUNTRY CLUB, SYRACUSE) An instrumental part of the Syracuse scene, some may remember him from *Screamers*, *Trini*, *Country Club*, or *Club 50*.

Daniel Reed (PHATO, SYRACUSE) The most recent addition to the Phato Crew, Daniel started spinning 2 years ago at Screamers, and is now a resident at Club Chameleon in Syracuse. He will be the resident at our upcoming minimal parties this summer.

> Come and party with PHATO PRODUCTIONS at the grande venue in Syracuse, NY - the gigantic Onondaga County War Memori. Located less than 5 hours from every major city in the north east, this journey will be the one worth taking...

> The fourth in a series of planet parties, **MARS** will be the largest undergr. dance event in Upstate New York this year, featuring an unparalleled lin up of the best DJs and producers from all over North America.

> Witness a metamorphosis as an extraordinary 100,000 square feet raw space is transformed into 2 **massive** arenas surrounded by 100,000 wa of clean power provided by one of Upstate's biggest and best sound companie

> Become entranced as an incomparable array of **24** Clay Packy Golden Sca fill the dance floors with vibrant color while pulsating argon lasers sweep acros the crowd.

> You bring the positive vibe!

> Doors open at 9pm. Please- No bottles, markers, weapons, or attitude.

> Directions to **MARS**
From NE and WEST of Syracuse > Take the NY State Thruway I-90 to Exit 36 (I-81). T. 81 South to Exit 18 (Harrison/Adams St. Exit). Follow the signs to the ONCENTER by making a right onto Harrison Street (a one way street). Go three blocks and make a ri on State Street. The address is 515 Montgomery Street. There is plenty of parking all around the building. **From New York City and points SOUTH of Syracuse >** From New York City and New Jersey take 80W to 380W (Poconos). Get on 81 North in Scranton. Take 81 North to Exit 18 (Harrison/Adams Street). Follow signs to the ONCENTER by making a left onto Harrison Street (a one way street). Go three blocks and make a right on State Stre. The address is 515 Montgomery Street. There are parking lots all around the building.

> Have a safe journey and we'll see you at **MARS**!

NE-RAVES AFTER HOURS AT CLUB CHAMELEON

DJ Mars	Craig D	Jimmy Hat	Obin	Chad Mitchell	Lettuce
planetary	12b!	ne-raves, vrave, ma	ne-raves, vrave	ne-raves, rom, buffalo	ne-raves, vrave
ne-raves, vrave, nj	ne-raves, vrave, nyc				

ROOM 2 >>

Jason Jordan	Ohm	Raymond Manuel	Daniel Reed
pure children, nyc	soul fresh, syracuse	phato, syracuse	phato, syracuse

mars syracuse, ny
1996 | phato
11 x 17 foldout cmyk/spot varnish on matte text
d: joel t/the earth program ltd.

uranus monticello, ny
1996 | photo
11 x 17 foldout cmyk/silver on matte text
: joel t/the earth program ltd.

he's back...
this time he's gonna let it shine...
on his very own island

SUNNY BEAR

June 15th • Richmond VA

DJs bringing in the sunshine...

Garth Wicked Crew, SF
This founding member of the Wicked Crew and originator of the San Francisco sound is making his first time Richmond appearance a memorable one — he's spinning an extended 3 hour set! — definitely a must see!

Joeski & Ryde
Chocolate Factory, NYC — Direct from the big apple, these two are known as the top house DJs this side of the states and will be tag-teaming a three hour set!

Goodwill
Zenith Productions, Delaware
Known for his cool vibes and smooth house — always a crowd favorite!

Joey D
Pure Love, Richmond
Pure Love's very own acid house master guaranteed to get a party pumping!

Heating it up with the drum & bass....

Snuggles & Slak
Chicago's Techstep Soldiers
Residents at "The Strictly Jungle Show" — the country's largest jungle radio program!

Kaos
Odysee records, UK
Journey into the future with Philly's master of mood texture!

Kid Konfusion
FunKrew, Richmond — Our city's own rising talent, rinsing it out with the rough styles!

Karl K
Philadelphia Hardstep Inc.
Making his first ever appearance in the Richmond area, Karl is sure to please with his unique style!

Slant 2Tuff, Washington DC
— As a resident at Buzz's Sting parties, Slant has become known as the master of smooth styles!

Method One
Trancefused, Richmond, & Odysee Records UK
Richmond's original jungle DJ, known for spinning the most futuristic styles!

Welcome in the early rays with a special outdoors afterhours on the river with....

Fil Latorre
Co-founder of Dirty, Clean, DC
One of DC's fastest rising talent!

Boggle
Pure Love, VA One of the East Coast's best kept secret!

Harmony
Insomnia, Richmond
Spinning a special acid jazz set!

sunny bear richmond
1996 | pure love | trancefused
6 x 12 foldout cmyk on glossy text
d: design machine

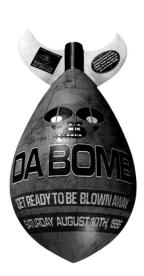
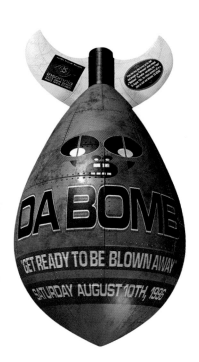
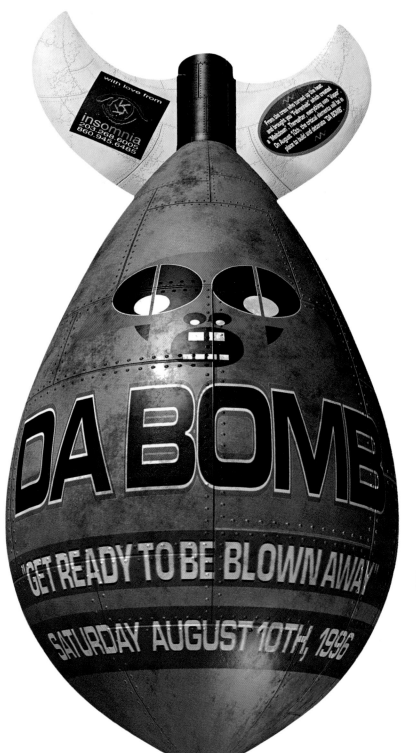
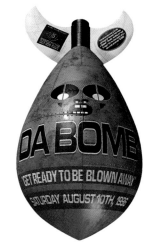
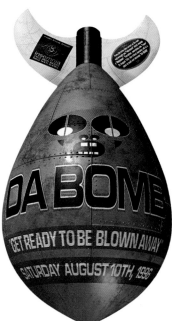

da bomb connecticut
996 | insomnia
.25 x 17 die-cut cmyk on glossy card
: dots per minute

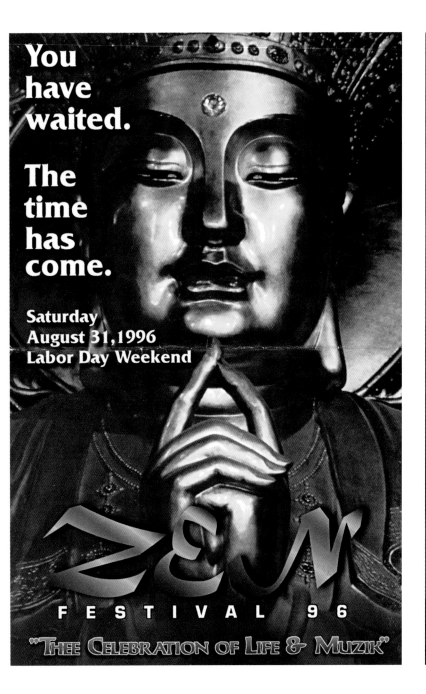

You have waited.

The time has come.

Saturday
August 31,1996
Labor Day Weekend

ZEN

FESTIVAL 96

"THEE CELEBRATION OF LIFE & MUZIK"

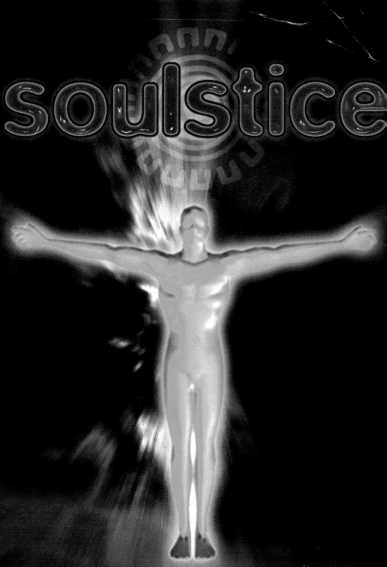

soulstice

Throughout the past, the winter solstice has been a time to celebrate marking the sun's high position in the sky. In ancient times many cultures have recognized this date as a time of festivity. The ancient eclectic Wiccan tradtion marked this date through celebrations of song and dance and all day and night vigils. The Chumash and the Zunis, native americans, relied on their high chief and sun priests to pull the sun back to earth through incantations and rituals. Now that we are in modern times we have ceased to recognize this ancient tradtion. L-dopah would like all to come out in body and spirit to see if our culture can unify through one force to once again compel the sun to return to it's high point in the sky.

zen festival 96 florida
1996 | zen festival
6.5 x 8.5 cmyk on glossy card
d: unknown

soulstice washington, dc
1996 | l-dopah productions
6 x 9 cmyk on glossy text
d: joel t/the earth program ltd.

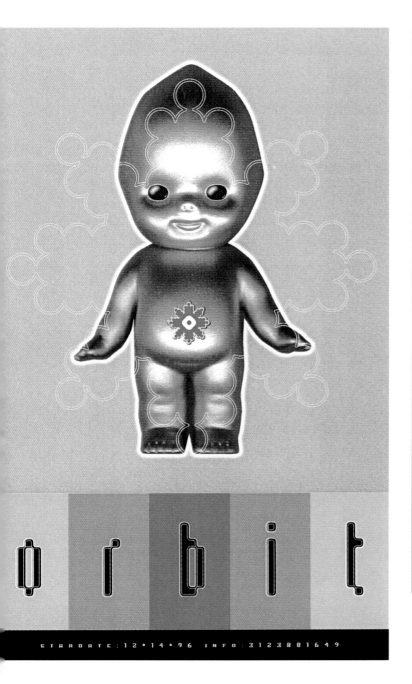

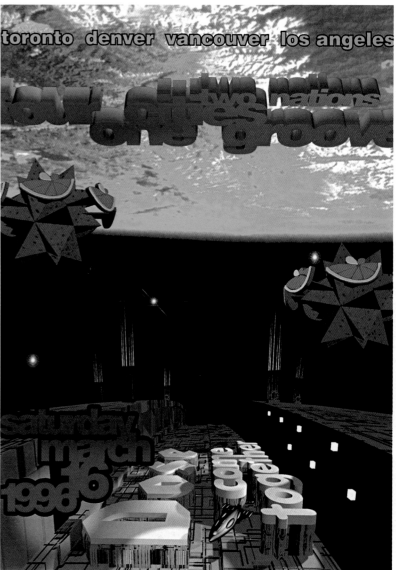

rbit chicago
96
75 x 8.875 cmyk on glossy card
dagmar design

241 toronto | denver | vancouver, bc | los angeles
1996 | dose | come together | fresh produce
6 x 8 booklet cmyk on glossy text
d: generator design

バズ

ハズ 13
WASHINGTON.DC
THE CAPITAL BALLROOM

On Friday, June 13, the Buzz Crew continues the Sting party series with a diverse selection of international techno, jungle/drum 'n' bass and trip-hop/acid jazz talent.

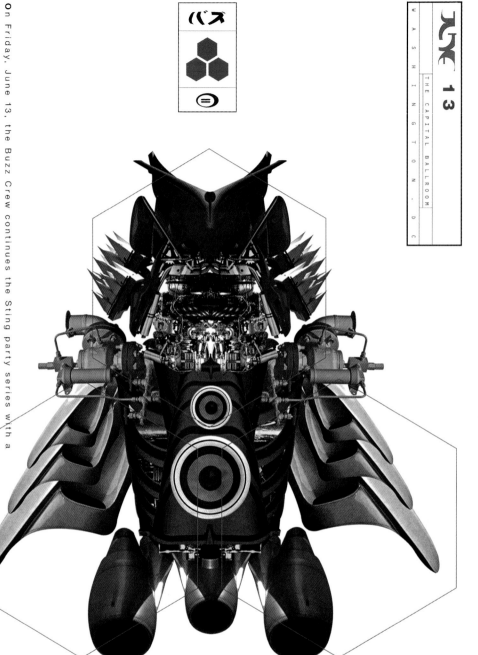

STING 9

sting 9 washington, dc
1997 | buzz
11 x 17 cmyk on glossy card
d: airline industries

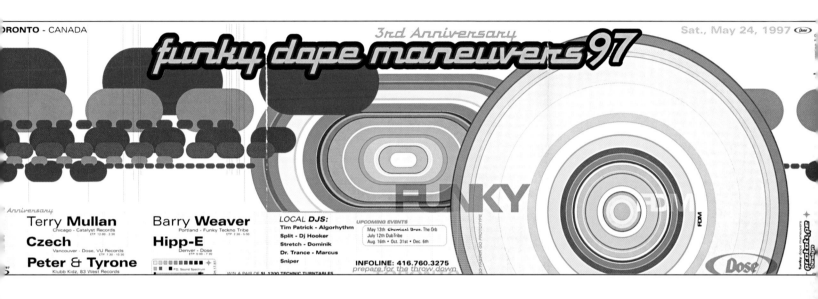

TORONTO - CANADA

3rd Anniversary

funky dope maneuvers 97

Sat., May 24, 1997

Anniversary

Terry Mullan
Chicago - Catalyst Records
ETP 12.00 - 2.30

Czech
Vancouver - Dose, VU Records

Peter & Tyrone
Klubb Kidz, 83 West Records

Barry Weaver
Portland - Funky Teckno Tribe
ETP 2.30 - 5.00

Hipp-E
Denver - Dose
ETP 5.00 - 7.30

LOCAL DJS:
Tim Patrick - Algorhythm
Split - Dj Hooker
Stretch - Dominik
Dr. Trance - Marcus
Sniper

UPCOMING EVENTS

May 13th Chemical Bros. The Orb
July 12th DubTribe
Aug. 16th • Oct. 31st • Dec. 6th

INFOLINE: 416.760.3275
prepare for the throw down

WIN A PAIR OF **SL-1200 TECHNIC TURNTABLES**

Dose

12.31.97

nky dope maneuvers 97 toronto
1997 | dose
x 15.5 cmyk on glossy card
prototype

eve gainesville, fl
1997 | hallucination records
5.5 x 17 cmyk on uv card
d: clrh2o studios

SMOOSHIE AND DIG DUG PRODUCTIONS BRING YOU SEPTEMBER 12TH 1997

Saturday September 20th 1997

organic

sonic denver
1997 | smooshie | dig dug
4.125 x 10.875 cmyk on uv card
d: factory

organic los angeles
1997 | kingfish | frequency | 1200 | insomniac
5.375 x 11 cmyk/spot varnish on matte card
d: roger parent/simon chan

galactic funk austin, tx

997 | gobi mass | atomic music | dimensional
1 x 17 foldout cmyk on glossy card
: joel t/guav/kon t/the earth program ltd.

jupiter denver

1997 | roofless
6 x 15 cmyk on glossy card
d: factory

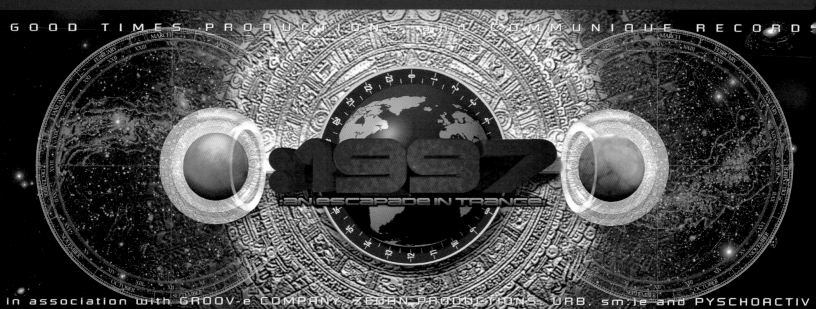

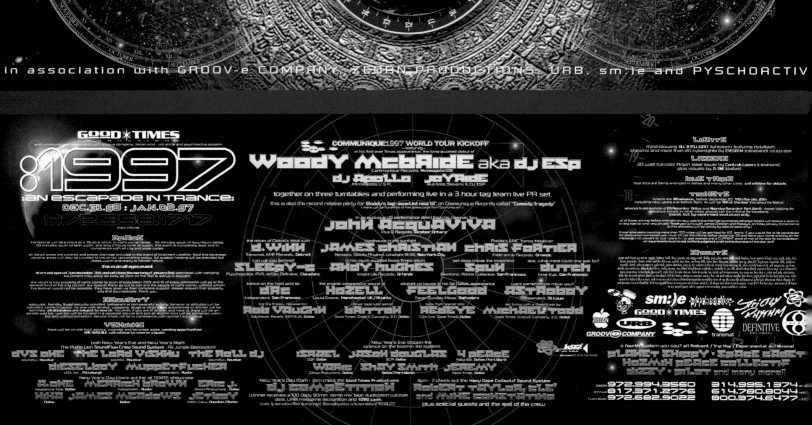

:1997 an escapade in trance texas
1997 | good times | communique records
6 x 26 cmyk on glossy card
d: kevy kev/kg2 graphix

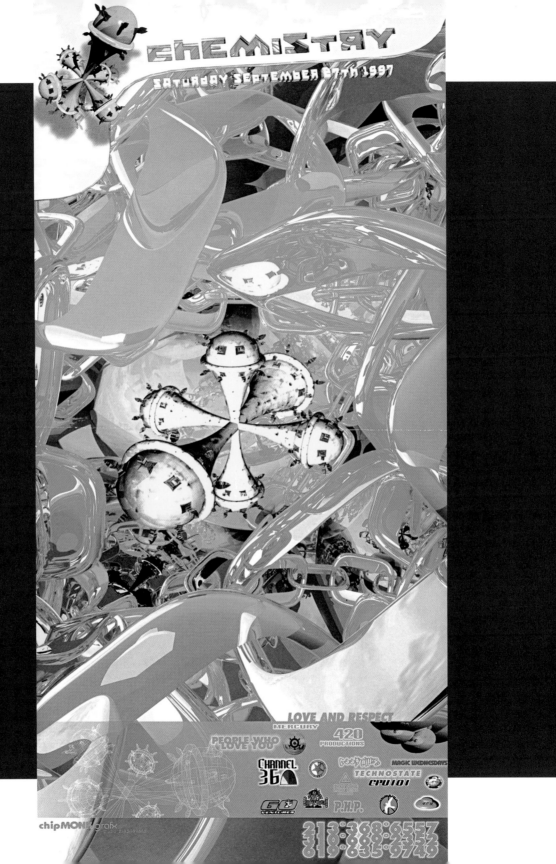

chemistry los angeles
997 | chemistry family
7.875 x 16 cmyk on glossy text
: chipmonk grafx

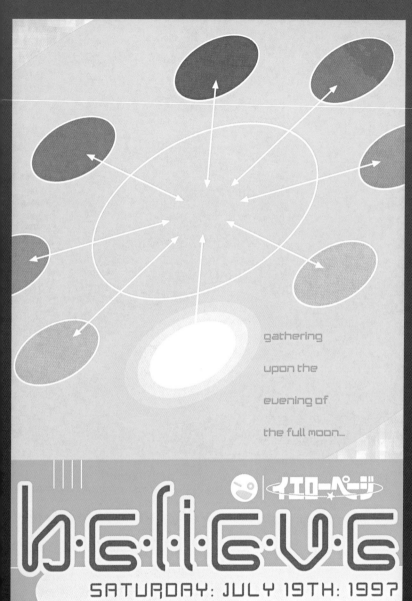

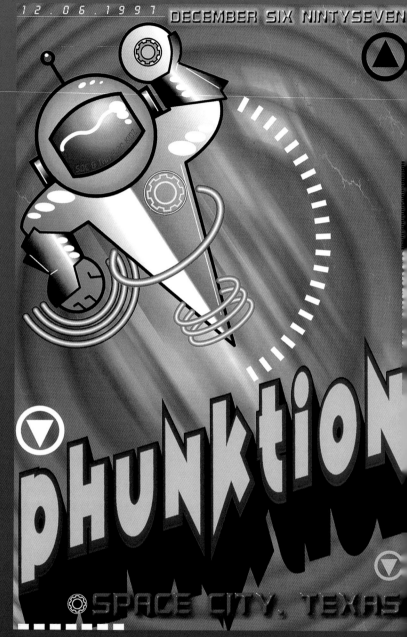

believe seattle
1997 | aeropage
5.5 x 8.5 blue/green on glossy card
d: phildesign

phunktion houston
1997 | soc & tha 4:20 kidz
5.5 x 8.5 cmyk on glossy card
d: noise

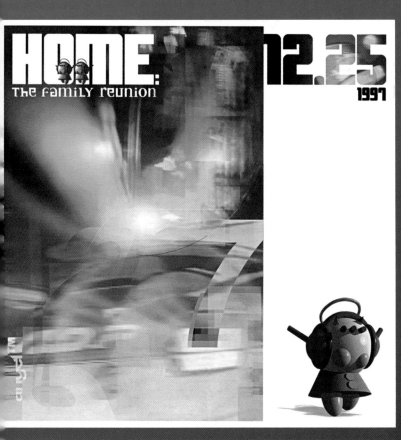

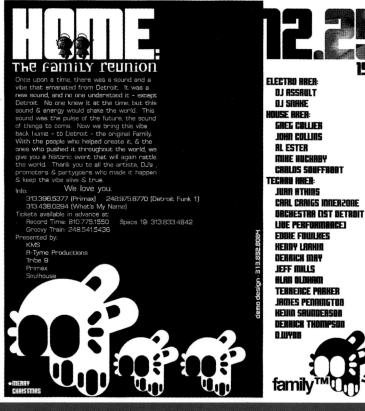

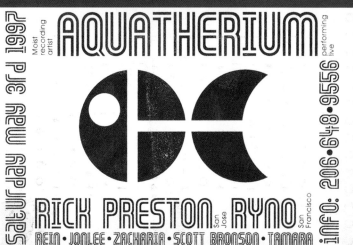

home detroit
1997 | kms | r-tyme | tribe 9 | primax | soulhouse
6.25 x 6.25 cmyk on glossy card
d: demo design

building blocks toronto
1997 | transcendance | alien visitation
3.5 x 5.75 cmyk/red foil stamp on glossy card
d: robin@techno.ca

aquatherium seattle
1997
3.75 x 6.125 foil stamp/embossing on glossy card
d: unknown

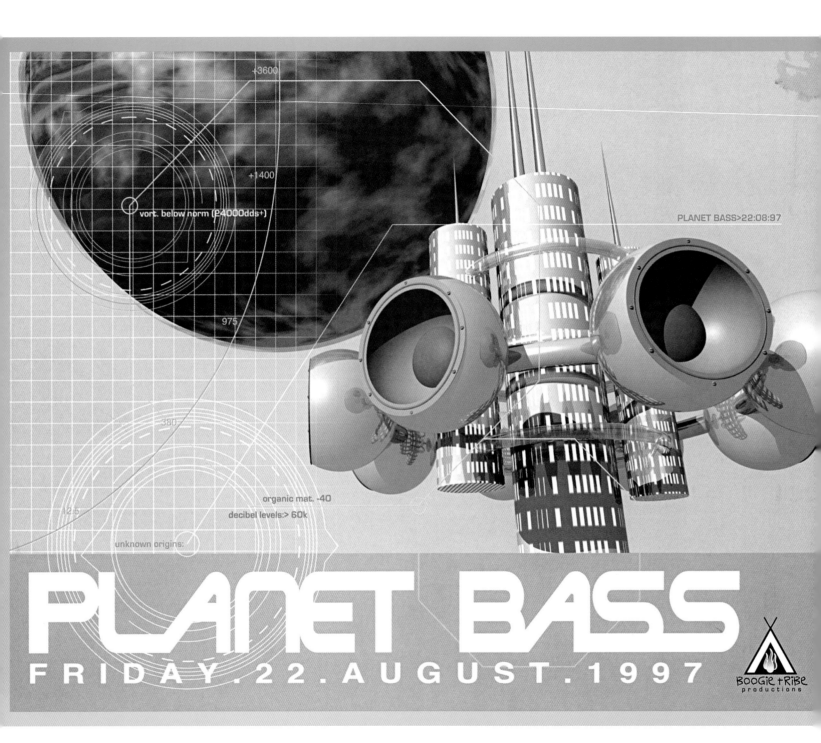

+3600

+1400

vort. below norm (24000dds+)

975

380

12.5

organic mat. -40

decibel levels:> 60k

unknown origins:

PLANET BASS>22:08:97

PLANET BASS
FRIDAY.22.AUGUST.1997

Boogie Tribe
productions

planet bass chicago
1997 | boogie tribe
8.5 x 11 cmyk on glossy text
d: wicker park creative mediums

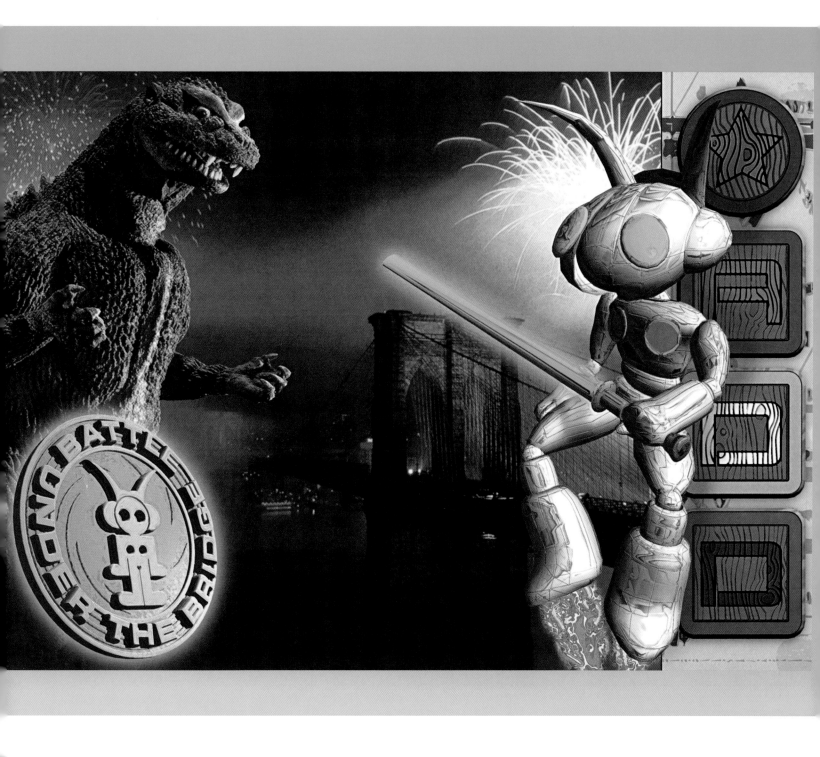

battle under the bridge brooklyn, ny
1997 | liquid sky | add
10 x 14 cmyk on glossy card
d: dirty design

encore (on•kor) *interj.*- [fr.] again, once more; *n.*- a demand for repetition or reappearance made by an audience, also a reappearance or additional performance in response to such a demand.

大プレゼン
chipMONKgrafx

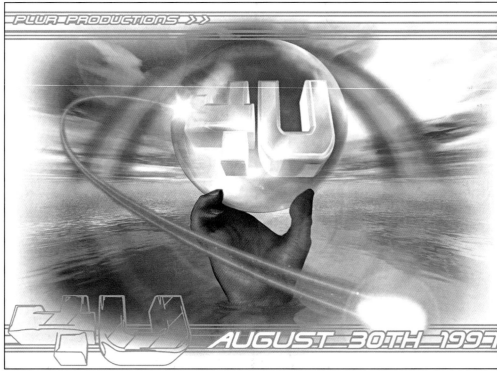

PLUR PRODUCTIONS >>

4-U

AUGUST 30TH 1997

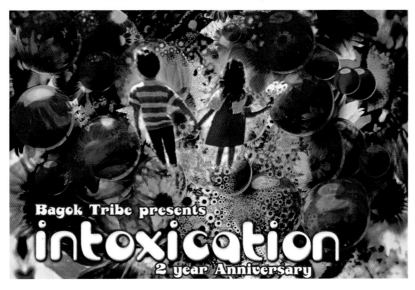

Bagok Tribe presents
intoxication
2 year Anniversary

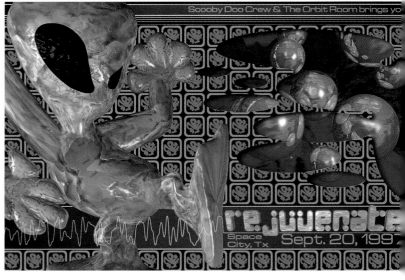

Scooby Doo Crew & The Orbit Room brings yo

re.juvenate
Space City, Tx
Sept. 20, 199

flyers from the latter years of the 90s often incorporate the best core ideas from every period of rave graphic style, combining photography, graffiti, hand-drawn text, and 3-D renderings to create richly layered designs. nowadays if a designer can dream up a visual concept, he or she can make it a reality.

encore southern california
1997 | go ventures
4.125 x 5.375 cmyk on glossy card
d: chipmonk grafx

4-U asbury park, nj
1997 | plur productions
11 x 17 foldout cmyk/silver on glossy text
d: mars graf-x

intoxication san francisco
1997 | bagok tribe
4 x 6 cmyk on card
d: e con

rejuvenate houston
1997 | scooby doo crew & orbit room
5.375 x 8.25 cmyk/silver/metallic blue on card
d: kinetic design

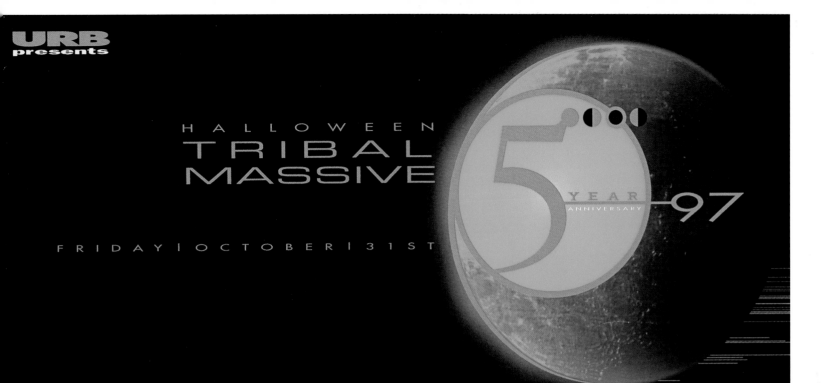

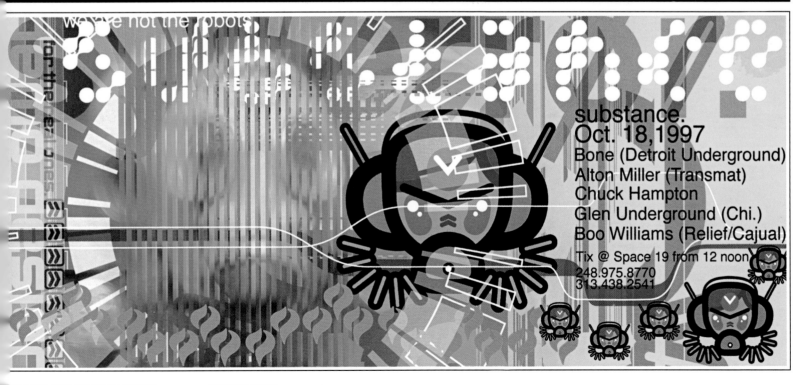

substance.
Oct. 18, 1997
Bone (Detroit Underground)
Alton Miller (Transmat)
Chuck Hampton
Glen Underground (Chi.)
Boo Williams (Relief/Cajual)

Tix @ Space 19 from 12 noon
248.975.8770
313.438.2541

halloween tribal massive san francisco
1997 | funky tekno tribe | urb
4.5 x 18.5 foldout cmyk/silver on glossy card
d: aya

substance detroit
1997 | tribe 9
3.375 x 7.5 cmyk on glossy card
d: demo design

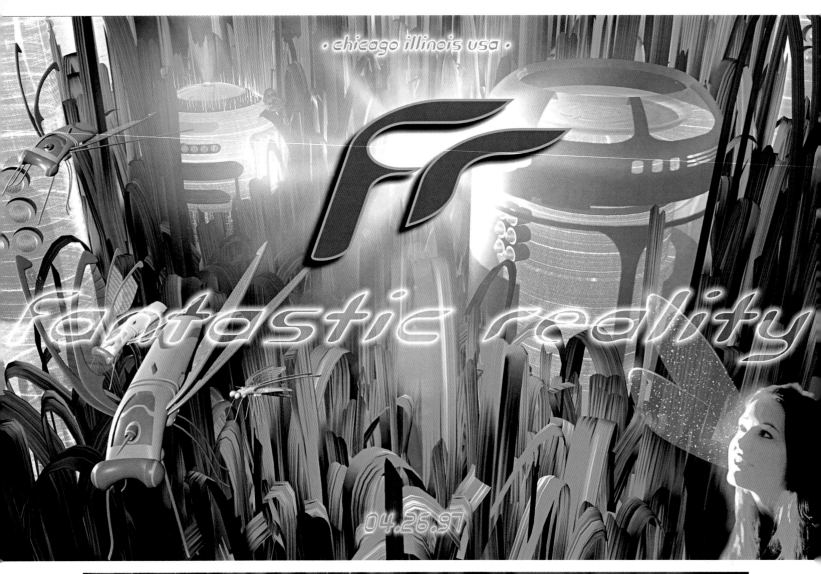

· chicago illinois usa ·

fantastic reality

04.26.97

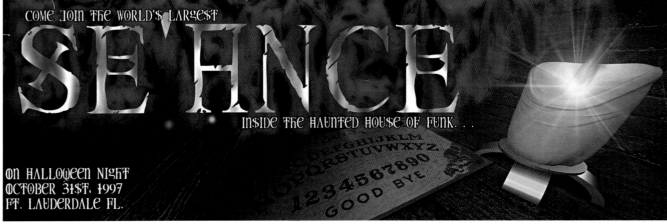

COME JOIN THE WORLD'S LARGEST

SEANCE

INSIDE THE HAUNTED HOUSE OF FUNK...

ON HALLOWEEN NIGHT
OCTOBER 31ST, 1997
FT. LAUDERDALE FL.

ABCDEFGHIJKLM
NOPQRSTUVWXYZ
1234567890
GOOD BYE

fantastic reality chicago
1997 | pure pleasure experience
10 x 16 cmyk on glossy card
d: chris gielow@brook stevens design/wicker park creative mediums

se'ance fort lauderdale, fl
1997 | str8-up funktionz
11 x 17 foldout cmyk on glossy text
d: clhr2o studios/porno graphics

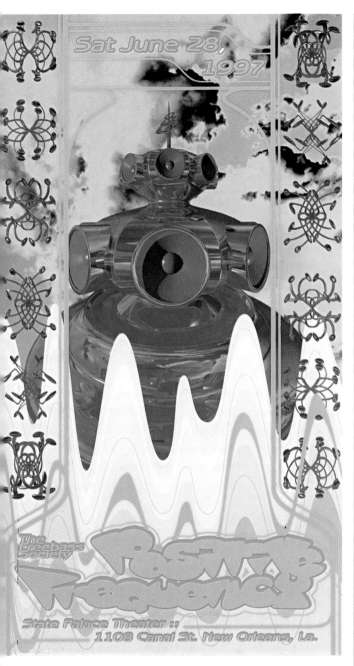

large events pose a real challenge to the flyer designer because of the sheer amount of information to be presented. to be at all useful, dense text must be organized and laid out in a flowing and easy-to-read way. sometimes the best way to approach the problem is to keep everything simple and elegant, as it has been in the "family affair" flyer at right, whose clean design allows the great lineup of talent to speak for itself.

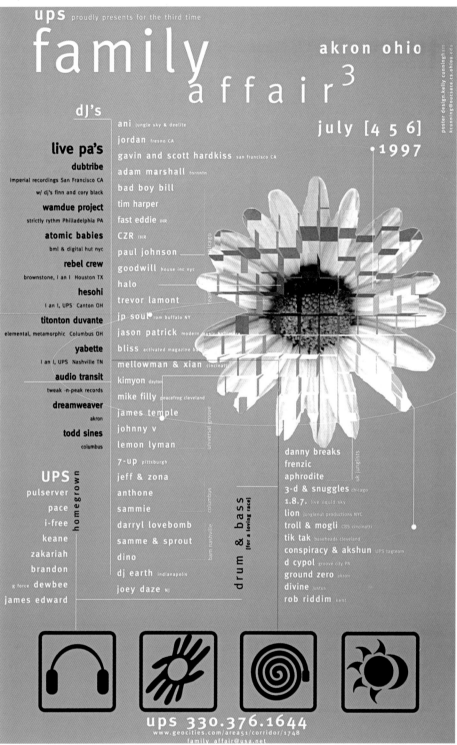

positive frequency new orleans
1997 | freebass society
6 x 11 cmyk/foil stamp on glossy card
d: kinetic design

family affair 3 akron
1997 | underground peace society
11 x 17 foldout cmyk on glossy text
d: kelly cunningham

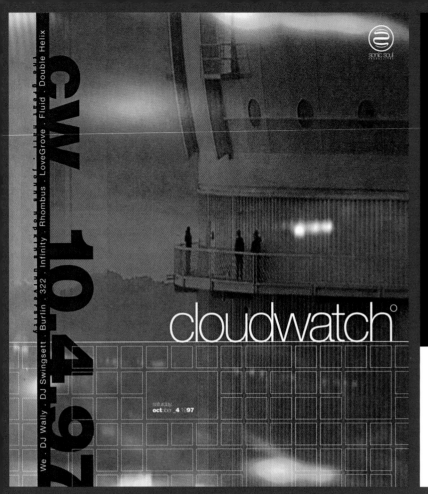

cloudwatch°

sonic soul
PRODUCTIONS

cloudwatch°
saturday . october 4th . 8pm - 4am

a night of experimental soundscapes, ambient atmospheres, and dubbed out rhythms.

performing live
asphodel recording artists:

We
(nyc)

with sonic soul djs
Infinity & **Rhombus**
and a special four turntable set by:
LoveGrove and **Fluid**

aural artistry by **Double Helix**

spinning jazzed-up house, abstract
beatz, and twisted drum 'n bass:
Liquid Sky / Ubiquity / Samz Jointz
recording artists:
DJ Wally & **DJ Swingsett**

Guidance / !! recording artist:
Kevin Yost

plus djs:
Burlin (1722, baltimore)
322 (vibe, baltimore)

admission is $12 . $2 off with jhu id . 18+ to enter with valid photo id . **please bring a canned good for the homeless.** this is not a rave, this is a multi-media freeform happening. come prepared to chill, feel free to bring blankets and pillows

6tes3byee779787

the great hall in the levering student union on the campus of johns hopkins university.

From North or South of Baltimore - take I95 to Baltimore, exit at 695 to Towson. Follow 695 to Charles St. ext. Follow Charles St. south to baltimore. Just past Loyola College (Coldspring Lane), Charles St. forks, stay to the right on Charles St. Follow to Art Museum Dr. (where the Baltimore Museum of Art is located) and turn right. Follow just past the museum and turn right into the JHU parking lot.

DESIGN:AIRLINE

a Sonic Soul Production, in co-ordination with jhu student group Vibe
info: 410-750-6121 or email: sonicsoul@earthlink.net

CW . We . DJ Wally . DJ Swingsett . 322 . Infinity . Rhombus . LoveGrove . Fluid . Double Helix

CW 10.4.97

saturday
october_4 1997

cloudwatch°

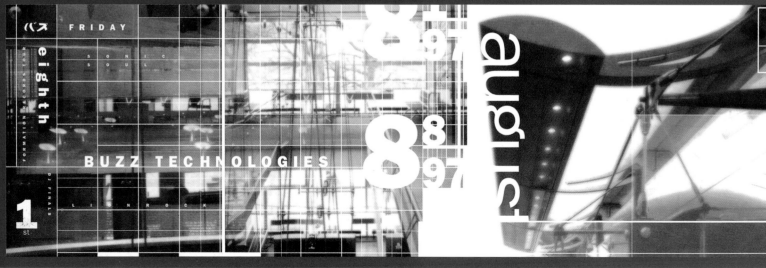

FRIDAY
eighth
FORMATION RECORDS TOUR
SONIC SOUL
BUZZ TECHNOLOGIES
DJ FINALS
LIGNROCK
1st

8 8 97

august

B N Z Z

cloudwatch maryland
1997 l sonic soul productions
4.75 x 5.5 cmyk on matte card
d: airline industries

buzz technologies washington, dc
1997 l buzz
4.25 x 14 cmyk on matte card
d: airline industries

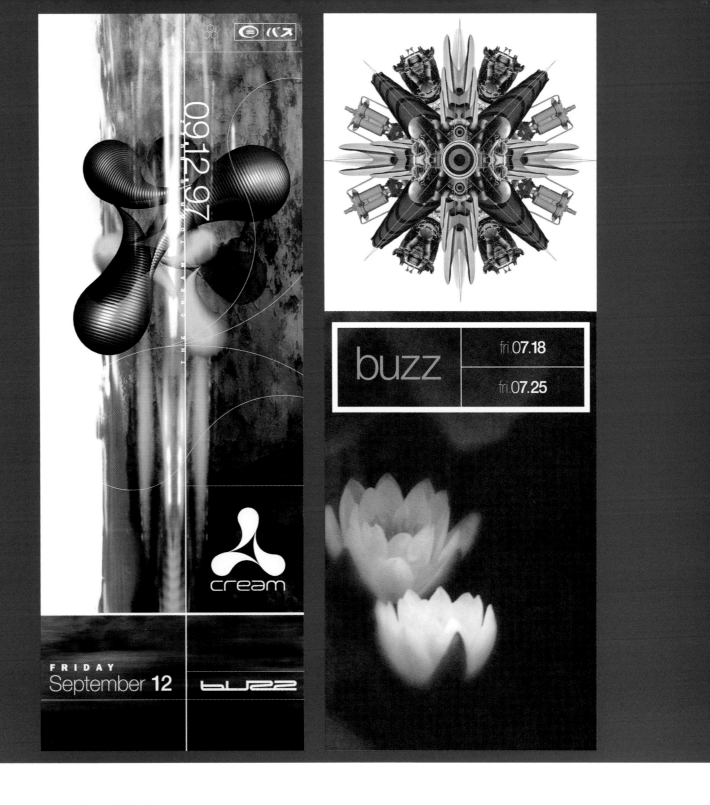

uzz washington, dc
97 | buzz
x 16 cmyk on glossy card
airline industries

buzz washington, dc
1997 | buzz
4.25 x 11 cmyk on matte card
d: airline industries

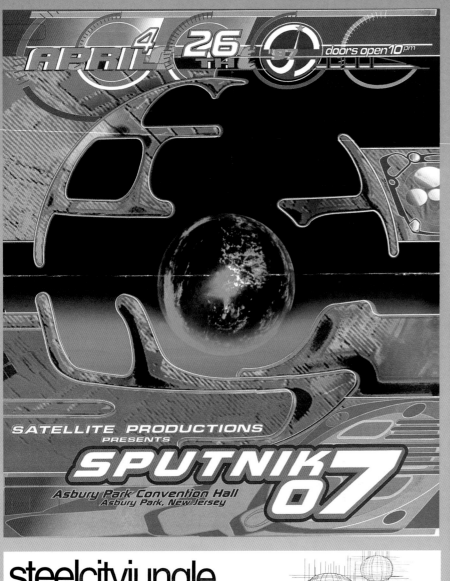

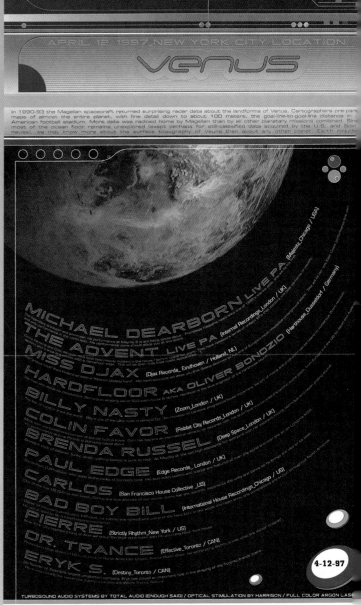

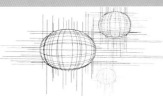

sputnik 07 asbury park, nj
1997 | satellite
9 x 10.625 foldout cmyk/gold on glossy text
d: boys + girls

venus new york
1997 | phato
11.5 x 15.875 foldout cmyk on matte text
d: dots per minute

steelcityjungle pittsburgh
1997 | udg inc.
2 x 9.625 photocopy on white card
d: dieselboy

TEENAGE WASTELAND

DROPBASS NETWORK
MUSHGROOVE
PAROTIC MUSIC

MILWAUKEE, WISCONSIN

8 PM WEDNESDAY DEC 31, 1997
TO
8 AM THURSDAY JAN 01, 1998

NEW YEARS EVE

For complete and specific event / ticket / direction information or questions call:

414-256-1733 414-548-1973 920-730-6157
773-509-6869 608-258-0003 612-659-6303

online information: http://www.execpc.com/~dropbass

Call 414-777-3998 for information about accomodations, parking, public transportation, and vending. Guest list submissions must also be made to this line prior to the event - don't just assume, you have to call ahead, no exceptions.

design: struggle inc. #0043

BIGGER, BOLDER and BETTER THAN EVER!
TEENAGE WASTELAND

ALL AGES · A MIDWEST NEW YEARS EVENT

Midwest is the birthplace [of] many styles of music; including beloved house, techno and [...] It's no coincidence there is a [number] of great producers who call Midwest home. The first wave of producers invented the music, the [...] followed and refined the [...] music taking it to the forefront. Now there exists a new breed of producers who are experimenting [with] sounds and taking the music to a whole new level. It sure is a [...] at time to be immersed in the techno community.

[...] this night we gather and [...] dance to honor this new [...] as they teach the old [...] dogs some new tricks...

MILWAUKEE · MADISON
CHICAGO · FOX VALLEY
MINNEAPOLIS
DETROIT · ST.LOUIS
INDIANAPOLIS
AND BEYOND

MAIN ROOM 01 · THIRD FLOOR
WHITE
TECHNO/HOUSE/TRANCE
A LARGE ARENA FILLED WITH A LARGE PRODUCTION AND EVEN LARGER MUSIC

PARIS · FRANCE
ERIK RUG aka DJ DAPHREEPHUNKATEK
Paper Recordings, Artefact
One of the worlds finest dj's comes across the Atlantic for his **first ever U.S. appearance!** Erik's credits include being the first dj to expose the French to house and techno back in the 80's. He planted the seeds for the Parisian house explosion through his nights at the then legendary Parisian rock club le Locomotive. This club is also where he schooled names like Laurent Garnier on the art of djing. New Years Eve it will be time for your lesson...homework guaranteed to live! As a house music producer Erik has made waves worldwide with his releases like "Don't Fuck With My Shit" and "Cut A Rug". This highly anticipated appearance will be very special indeed...

CHICAGO
MARK GRANT
cajual, guidance
As the dawn of the new year wakes, so will the soothing sounds of jazzy vocal house and the hectic swing of boogie down disco. Mark's latest mix CD "Taste of Cajual" influences your body to **get busy and move,** much like his performance the morning of 1998 will do.

KALAMAZOO
CHANCE McDERMOTT
Black nation, missile sativae, premier, parotic music
What would a Midwest event be without a little of that famous Detroit techno flavor? Expect hard experimental and funky chunks of techno from this producer and dj who's been making quite a name for himself lately.

CHICAGO
DAN EFEX
time unlimited
Since debuting at the DBN "One" event in 93 Dan's approach to djing has been similar to the music he plays - always going higher, never letting down. It's been a long time! Prepare for the return of this well traveled **Midwest trance architect.**

CHICAGO
DANNY the WILDCHILD
At midnight as we ring in the New Year this **turntable wizard** is going to step up and bounce the beats dj battle style. Danny has his sights set on next years DMC Mixing Championship and this will be his premier performance of how he plans to get that done. Watch, listen and learn!

OPENING SETS BY THE MIDWEST TRANCE DEVOTEE'S
STEVEN K MILWAUKEE, 91.7 WMSE, revolutions & DREW SUTHERLAND MILWAUKEE, massive magazine

CHECK THIS FREAKY STYLER! DJ Funk going hurt somebody with what he promises will be **his most standout performance yet.** Combining unreleased Funk cuts with crowd favorites you will taste the punches as he knocks you out. To finish off 1997 dj Funk will deliver his custom recorded NYE countdown of 10 seconds you will never forget!

DJ FUNK
Dance Mania, Aqua Boogie

MINNEAPOLIS
CHRIS SATTINGER
communique', subvoice, missile, synewave
This active duo has been featured on more labels than you can shake a stick at - many more than we've listed. And for good reason. Expect anything and everything from the hardest hardcore to the most psychotic breakbeats during their 1 1/2 hour live PA that will leave you speechless and running for cover!

MADISON
LESTER FITZPATRICK
relief records
missile, synewave, music man, episode, communique', subvoice
An avant garde fella who's experimentation on more sounds leads to a **unique twist on techno.** Dance floors always turn into sweaty getdowns when the machines are turned on for one of his much sought after live performances.

MADISON
ABS (ABSURD SENSING SYSTEM)
Strictly Rhythm, AM-PM, Aqua Boogie
The trio of Maze, Confusion and Motion are the cast of this live performance. They have been filling dance floors in windy city clubs for some time. Just for our pleasure they bring their sounds of speed garage and tracky disco to Milwaukee. It's a rare happening to see compositions like this live.

CHICAGO
CHAD MINDRIVE
erotishock, nice musique
A longtime Midwest favorite who has earned respect across the U.S. out on hype, but on his abilities alone. Known for his mix of infectious tech house and skills that are solid and smooth. A man who is true to the music.

CHICAGO
MC BIGGS
Hosting the introductions and countdown this personality with a mic who makes the **good times and good vibes** just seem to happen.

alternate room - 2nd floor
CLEAR
A SPECIALLY PREPARED ROOM FOR SOME LOCAL FAVORITES

JETHROX SYNERGY Milwaukee - Solid State, Matisse, Massive
KIMBERLY NIX Milwaukee - Drop Bass Network
JEDIDIAH D-ON Madison - UPS, Bass Continuum
FRANKIE VEGA D'ANGELO Madison
MADDGROOVE Chicago - Mushgroove, Incredibeats
DRUID
CREEPS Madison - Parotic Music
MARK LANCASTER Minneapolis - East Side Crack

ambient sanctuary - 2nd floor
REDRUM
A CHILLED OUT ENVIRONMENT FOR LOUNGING AND SCULPTURES OF NOISE FOR LISTENING

LOST IN TRANSLATION LIVE
Minneapolis
Burnt Hair, Fusetron, Carburetor Records
PARGO LIVE Madison - Splinter Sound System
DZAK Madison - Tool Box Tunes
NAGNAGNAG featuring TRIP BROTHER LIVE Chicago
ANONYMOUS and DAVROS Madison
ELTON JON DOORMOUSE LIVE Milwaukee
TJ RICHTER Milwaukee
Performance Artist / Freak Show

MAIN ROOM 02 · FIRST FLOOR
BLACK
HARDCORE / DRUM AND BASS
A DUNGEON LIKE AREA WITH A COLD DARK ATMOSPHERE AND HARD DEEP MUSIC

Chrome, Ghetto Safari, Gyration, Mille Plateaux, Riot Beats, Loop

FRANKFURT · GERMANY
PANACEA and PROBLEM CHILD
1st ever U.S. appearance! These two **top German producers / djs** giving you a dose of tech step cure all and then some. Their eerie brand of drum and bass is the soundtrack for the next millennium - an uncompromising hyper technical future of deep and dark atmospheres where chaos is a way of life. The roof is going to blow and one can only hope we will all make it out alive.

WALES · UNITED KINGDOM
SOMATIC RESPONSES
1st ever U.S. appearance! The active duo has been released on more labels than you can shake a stick at - many more than we've listed. And for good reason. Expect anything and everything from the hardest hardcore to the most psychotic breakbeats during their 1 1/2 hour live PA that will leave you speechless and running for cover!

CHICAGO
Q SYSTEM
Ghetto Safari, Forte, Kultbox, Stepwise
Six appearances as dj's for this occasion they debut they new live performance. As dj's they helped put Chi town on the drum and bass map and as producers they've helped the U.S. earn some of the international RESPECT it deserves.

CHICAGO
PHIL FREEART
3D and Snuggles
The big daddy with the inflatable pens and goofy toys. Smile and bring it on down to the happy hardcore only this party rocker could play. **The Midwest Merry Prankster.** (and he draws nice ladies too!)

CHICAGO
STOMP PATROL featuring SONIC BOOM and RICHIE WEL
Mushgroove's very own hardcore force. From the pit to the turntables this dj team destroys dance floors where ever they throw down.

SOUND:
White room by Badger of Milwaukee. Two Crown powered walls of sound totaling **40,000 Watts** with two Crown JBL bass bins and a dozen JBL line arrays forming the first wall, then in the middle of the room a delayed wall of Martin cabinets. This is an unprecedented all new sound design that will fill the room and then some Black room by GLS of Milwaukee. A turbo sound system comes to a Midwest event for the very first time! This system features ten Turbo TMS-3 mid/high cabinets and a half dozen Turbo 12x sub cabinets that utilize 24" woofers. Real bass like you've never heard at 25,000 watts of bass powered to turbo specifications with QSC Series 3 amps. Clear room & Redrum by SubKulture of Milwaukee. Crest Audio packs the punch to a dozen EV based Jr. Earthquake bass bins combined with JBL mid/highs. The second room system that rocks!

LIGHTS:
White room by Mark Martin of Chicago who comes to Milwaukee for the first time bringing with him an arsenal of lights that includes four Cyberlights, eight Trackspots, Dataflash and a few surprises. The uniquely installed lighting rig will feature Mark's custom designed programming that is sure to light up the night in an exciting way. Don't expect a blinding cheezy atmosphere - do expect a minimal yet effective tasteful light show. Black room by Badger and Headlights of Milwaukee. This room features four laser Emulators and six Viper lasers combined with lots of fog. The atmosphere will be deep and dark, just like the name of this room suggests. In the other rooms and hallways illumination will be an expression of your mental activities through Probeam oil lights and obnoxious amount of x-mas lights. Done by Headlights of course.

LASERS:
What sort of laser show could possibly lift the arena of the White room? How about a state of the art **"solid state" 30 Watt Nd: YAG aerial beam show.** Expect to go to awe or less than any other full scale rave event in the Midwest - guaranteed! A limited number of **pressit tickets** will be available to $20 at the following locations:

VISUALS:
Nationally recognized Optique Vid Tek (OVT) of Chicago will be providing a visual installation in the White room like nothing you have ever seen at one of our events. Their credits they have done numerous clubs and concert tours across the country and have even provided visuals for major motion pictures. OVT leaves witnesses stunned wherever they go! For us this night they plan to pull out all the stops for an eye popping visual experience. Look for multiple screens with live cutting edge mixes of video, a **live feed showing the dj's at work,** and a mind candy that includes several 16mm film loops and slides.

VENUE:
Teenage Wasteland takes place at a newly renovated large capacity downtown Milwaukee building. It features **four complete rooms of music** spread out over three different levels. The two main rooms are 27,000 and 10,000 square feet alone! There will be a large vending area, barn on every level, clean complete bathrooms facilities on every level, overlooks in the main room and also plenty of space to get away from it all if you want to.

LIQUIDS:
For every ones safety absolutely no carry-ins will be allowed. There is free water in the fountains by every bathroom and all of the bars will have reasonably priced nonalcoholic beverages. For those attending who are 21 and over with legal identification you can party rock-star style at every one of the bars - fully stocked for your pleasure! A separate wristband will allow you to purchase alcohol and the best part is you don't have to stay herded like cattle in a separate area - you can roam with everyone else.

OTHER:
Live radio broadcasting: Free radio BOB will be broadcasting to downtown Milwaukee all day and all night live from the site on 104.5 FM. Listen for updates, dj sets, interviews and general nonsense during the day or while you drive to the party. Call 414-296-1581 for programming information. **Massages:** The Bad Ass Coconut ladies giving out fingertip pleasures. **Giveaways:** Look for record giveaways from Drop Bass Network and Parotic Music. Some of the labels the dj's represent will also be giving away promotional material. At midnight watch the main stage for free stuff. Much More. As of the flyer printing many other things were in the works and will remain a surprise until the night of the event. You'll like what you see - that's our guarantee. .NET MEET: The second level of the venue will be the best place to meet. In the vending area there will be a MW-Raves table specifically set up with blank name tags and chairs. You can finally meet in person new on line friends or make contact with old ones. Scheduled meets are at 11:00 PM and 1:00 AM.

TICKETS:
As is always the case with our events, you don't have to waste your money to be at Teenage Wasteland. Expect to pay or less than any other full scale rave event in the Midwest - guaranteed! A limited number of **pressit tickets** will be available for $20 at the following locations: **Revolutions** - 524 N. Water St., Milwaukee 414-347-1141 (from Dec. 15th to Dec. 30th) **Nice Musique** - 702 E. Johnson St., Madison 608-250-6423 (from Dec. 15th to Dec. 24th) **Hot Jams** - 5012 Pulaski, Chicago 773-581-5262 (from Dec. 15th to Dec. 29th) With presale tickets you won't have to wait in the long cold lines at the door plus you will save yourself a few bucks, so take advantage of it.

teenage wasteland midwest
1997 | drop bass network | mushgroove | parotic
[.]125 x 14.5 foldout silver/green/orange on card
[design]: cody hudson/struggle inc.

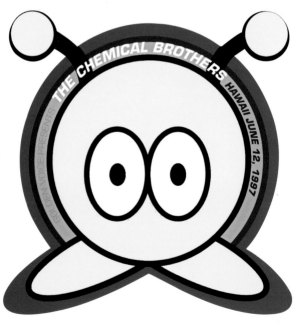

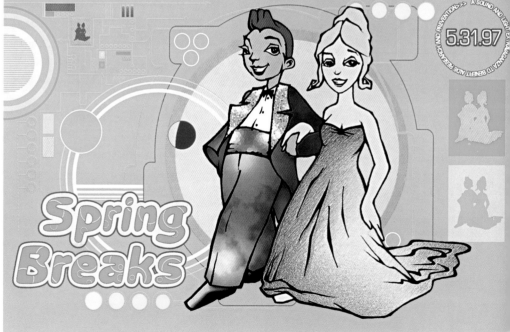

ru roll'n indianapolis
1997 | go ventures
5.875 x 12 die-cut cmyk on glossy card
d: beatnix/maxart

weebleworld! hawaii
1997 | golden voice
6.25 x 6.25 die-cut cmyk on glossy card
d: sidz creation

spring breaks (teaser) new york
1997 | amongst friends | soulfusion
5.25 x 8.25 cmyk on glossy card
d: kon t/the earth program ltd.

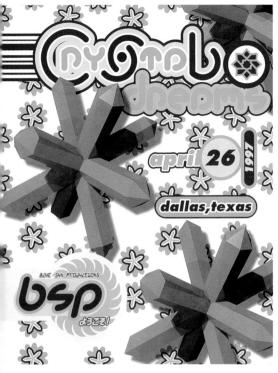

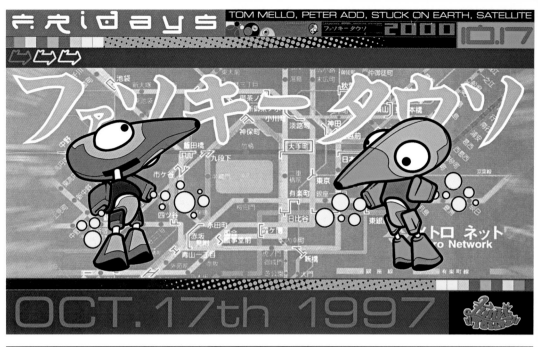

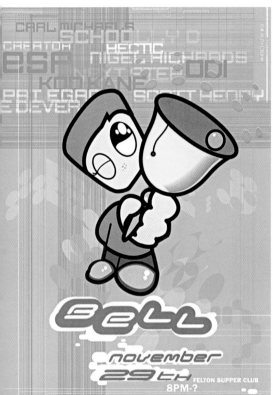

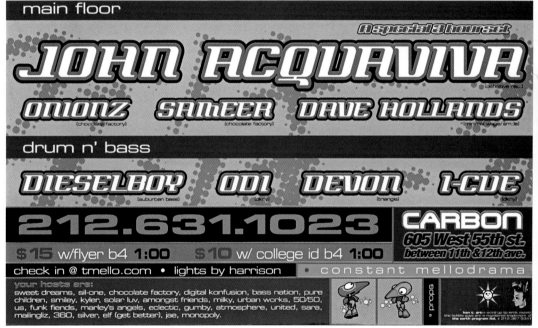

⊖ consistent with a rave designer's love of multiple influences, hand-drawn cartoon characters like those seen here have their roots in an affection for Japanese anime-style movies, comic books, and video games.

crystal dreams dallas
1997 | blue sun productions
11 x 17 foldout cmyk on glossy text
d: windog

funky town new york
1997 | tom mello | peter add | stuck on earth | satellite
6 x 10 cmyk/gold on glossy card
d: kon t/guav/the earth program ltd.

bell philadelphia
1997 | mouse
8 x 12 cmyk on glossy text
d: pink room

juggernaut san francisco
1997 | space children
4.625 x 19 foldout cmyk/neon red on glossy card
d: stimuli

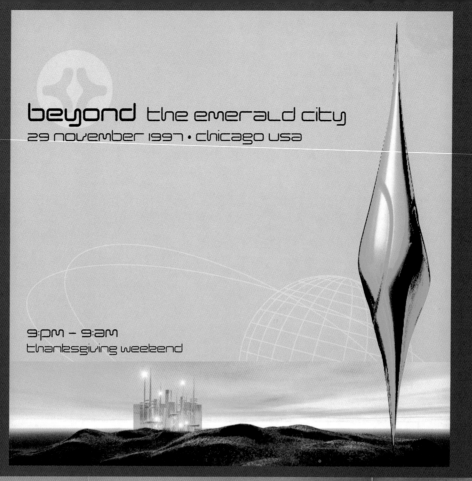

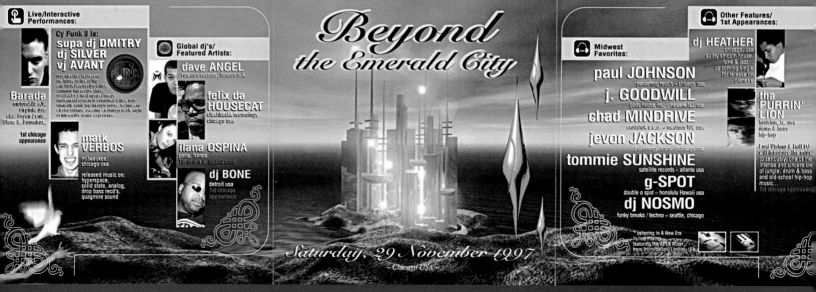

beyond the emerald city chicago
1996 | pure | vibeonauts | positive entity
6 x 17.625 foldout cmyk on glossy text
d: wicker park creative mediums

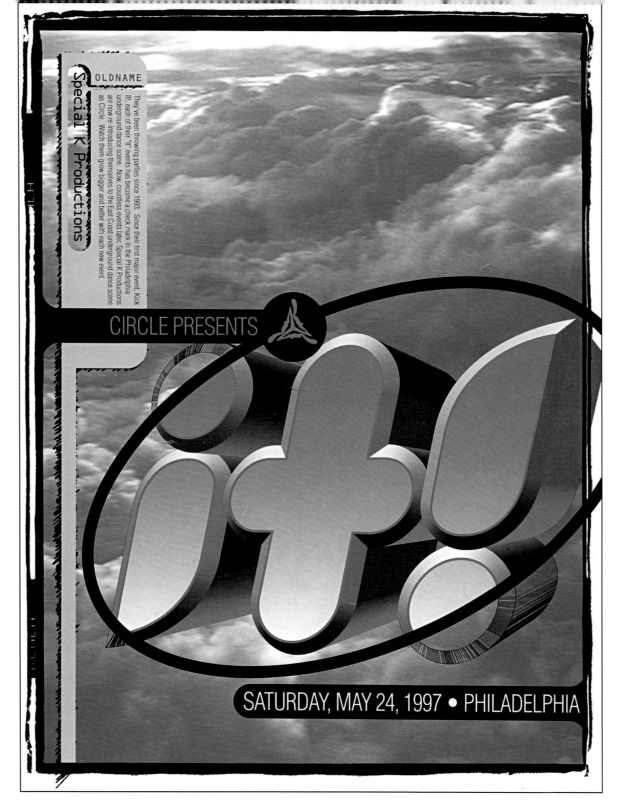

OLDNAME

Special K Productions

They've been throwing parties since 1993. Since their first major event, Kick It!, each of their "It" events has become a check mark in the Philadelphia underground dance scene. Now, countless events later, Special K Productions are now re-introducing themselves to the East Coast underground dance scene as Circle. Watch them grow bigger and better with each new event.

CIRCLE PRESENTS

SATURDAY, MAY 24, 1997 • PHILADELPHIA

it! philadelphia
1997 | circle
11 x 17 booklet cmyk on glossy text
d: under design

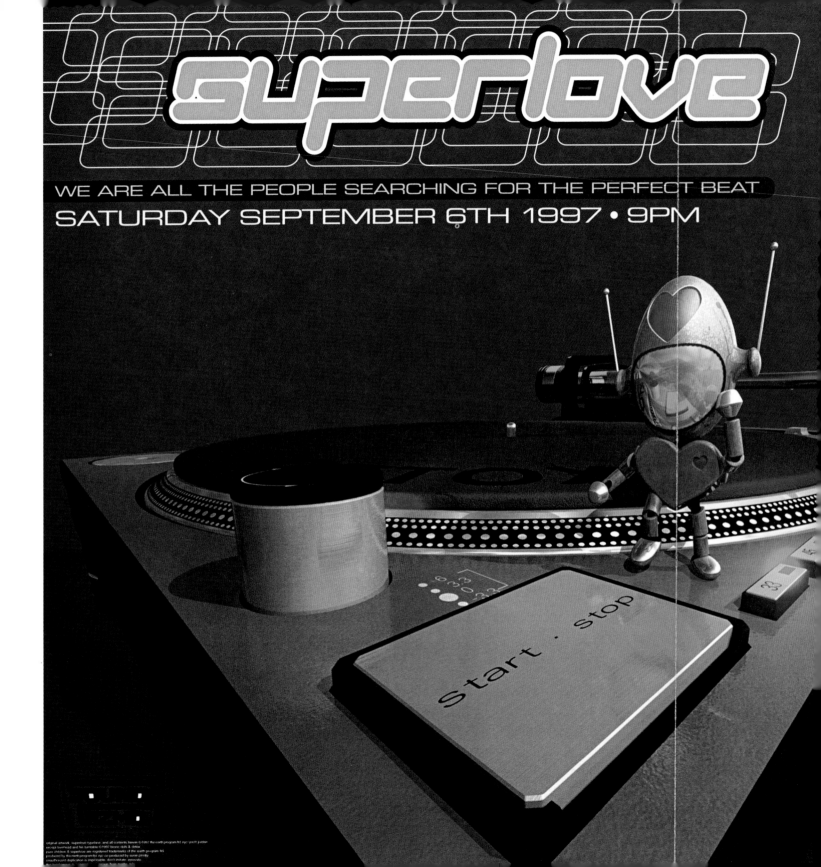

MAIN STAGE

HOOVERPHONIC
FIRST LIVE PERFORMANCE EVER IN AMERICA [Belgium]

ELECTRIC SKYCHURCH
EXCLUSIVE LIVE PERFORMANCE [Los Angeles]

KEN ISHII
FIRST LIVE PERFORMANCE EVER IN AMERICA [R&S/Medicine • Tokyo Japan]

SCOTT, ROBBIE & GAVIN HARDKISS
[Hardkiss Music • San Francisco]

PAUL VAN DYK
[MFS • Berlin Germany]

JOHN KELLEY
[Moontribe/Funky Desert Breaks • Los Angeles]

LIQUID TODD
[Solid State/KROQ • NYC]

PEPE
[Pure Children • Philly]

BASSMENT

LIVE PERFORMANCE [Astralwerks • UK] # μ-ZIQ

CIRCUIT BIBLE
LIVE PERFORMANCE [2012 • NYC]

ED RUSH & NICO
W/ MC RHYME TYME
[No U-Turn Records • UK]

SOUL SLINGER
[Jungle Sky Music • NYC]

Q-BURNS ABSTRACT MESSAGE
[Astralwerks • Florida]

TONY JUSTICE & WINTERMUTE
[Airbag Records • UK/LA]

CHASM
[Pure Children/Sound Gizmo • Philly]

KECH
[Stuck On Earth • NYC]

A. GRAM
[Diesel • NYC]

superlove new york
1997 l pure children
12 x 18 foldout cmyk/silver on matte text
d: joel t/the earth program ltd./zack detox/bionic dots

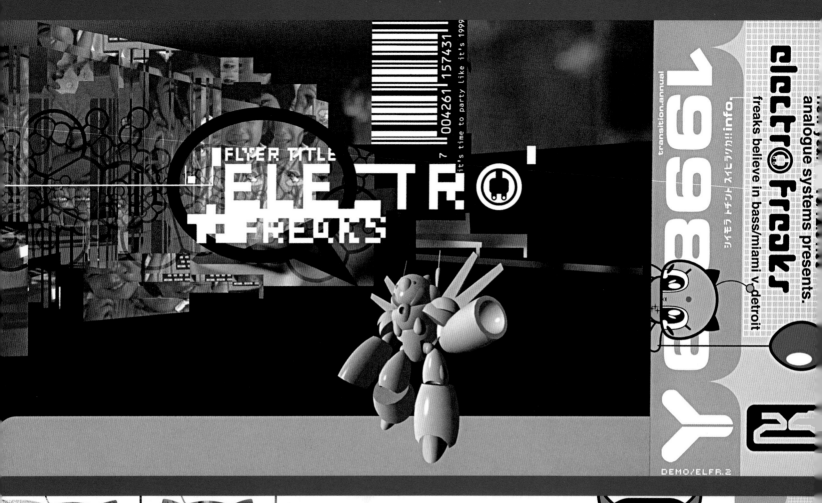

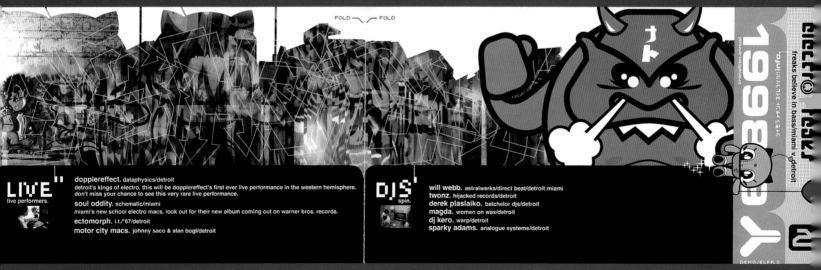

LIVE"
live performers.

dopplereffect. dataphysics/detroit
detroit's kings of electro. this will be dopplereffect's first ever live performance in the western hemisphere. don't miss your chance to see this very rare live performance.

soul oddity. schematic/miami
miami's new school electro macs. look out for their new album coming out on warner bros. records.

ectomorph. i.t./'67/detroit

motor city macs. johnny saco & alan bogl/detroit

DJS'
spin.

will webb. astralwerks/direct beat/detroit:miami

twonz. hijacked records/detroit

derek plaslaiko. batchelor djs/detroit

magda. women on wax/detroit

dj kero. warp/detroit

sparky adams. analogue systems/detroit

electrofreaks (flyer 1) detroit
1998 | analogue systems
6 x 16.5 foldout cmyk on glossy text
d: demo design

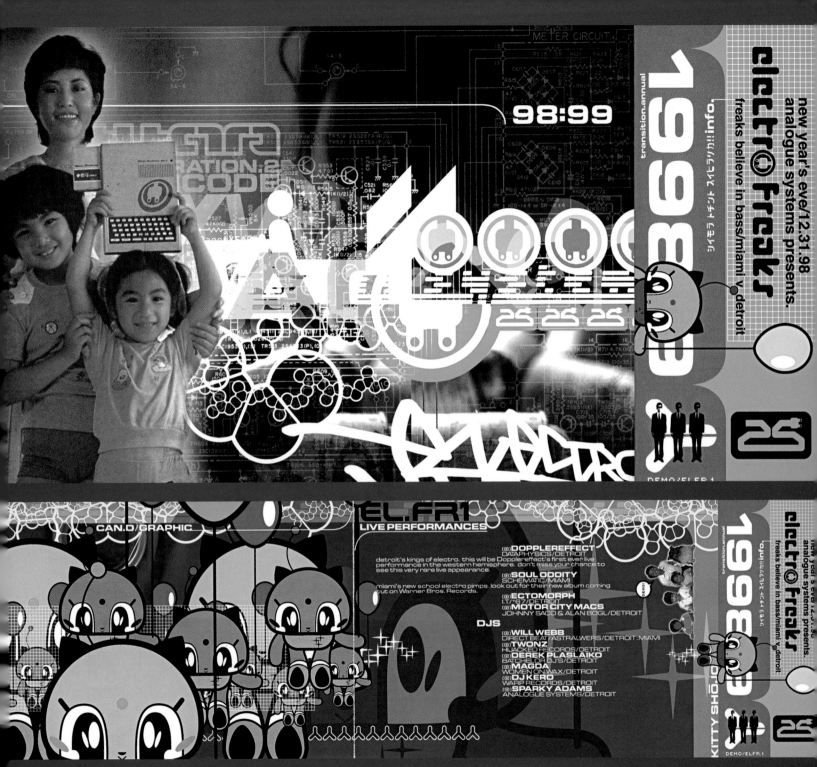

electrofreaks (flyer 2) detroit
...998 | analogue systems
... x 16.5 foldout cmyk on glossy text
...: demo design

space opening night philadelphia
1998 | club space
4.25 x 14 cmyk on uv card
d: bbbee design

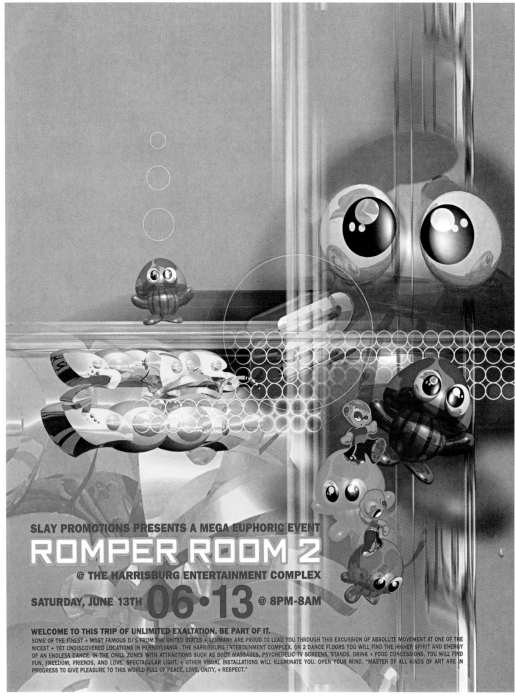

SLAY PROMOTIONS PRESENTS A MEGA EUPHORIC EVENT

ROMPER ROOM 2

@ THE HARRISBURG ENTERTAINMENT COMPLEX

SATURDAY, JUNE 13TH 06•13 @ 8PM-8AM

WELCOME TO THIS TRIP OF UNLIMITED EXALTATION. BE PART OF IT.

SOME OF THE FINEST + MOST FAMOUS DJ'S FROM THE UNITED STATES + GERMANY ARE PROUD TO LEAD YOU THROUGH THIS EXCURSION OF ABSOLUTE MOVEMENT AT ONE OF THE NICEST + YET UNDISCOVERED LOCATIONS IN PENNSYLVANIA - THE HARRISBURG ENTERTAINMENT COMPLEX. ON 2 DANCE FLOORS YOU WILL FIND THE HIGHER SPIRIT AND ENERGY OF AN ENDLESS DANCE. IN THE CHILL ZONES WITH ATTRACTIONS SUCH AS BODY MASSAGES, PSYCHEDELIC TV SCREENS, STANDS, DRINK + FOOD CONCESSIONS, YOU WILL FIND FUN, FREEDOM, FRIENDS, AND LOVE. SPECTACULAR LIGHT. + OTHER VISUAL INSTALLATIONS WILL ILLUMINATE YOU. OPEN YOUR MIND. "MASTER OF ALL KINDS OF ART ARE IN PROGRESS TO GIVE PLEASURE TO THIS WORLD FULL OF PEACE, LOVE, UNITY, + RESPECT."

earth denver
1998 | roofless
6 x 15 on glossy card
d: factory

romper room 2 harrisburg, pa
1997 | slay promotions
8.5 x 11 on glossy text
d: pink room

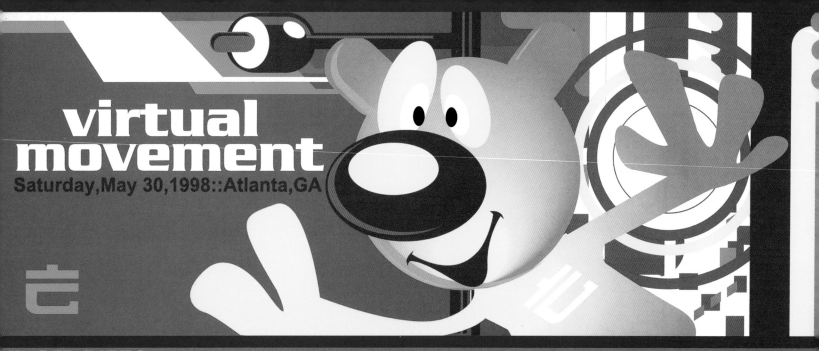

virtual movement atlanta
1998
4.25 x 11 cmyk on glossy text
d: digitaldiz design

love festival san diego/los angeles
1998 | chemistry family
7.875 x 16 cmyk on uv card
d: chipmonk grafx

stompy san francisco
1998 | stompy hi-fi players
2.375 x 6.875 black/blue/silver on glossy card
d: e con

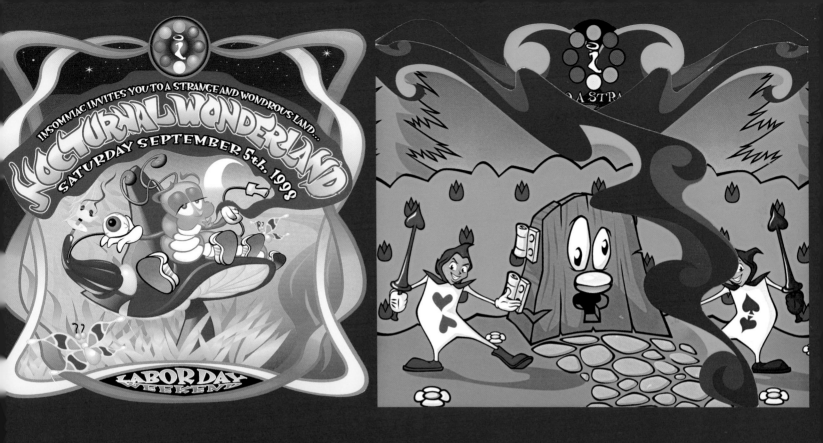

flyers for the nocturnal wonderland parties, and insomniac's flyers in general, are extremely colorful and creatively illustrated, plus make use of special dies for cutting the paper stock into unusual, unique shapes. this practice is less common on the east coast, where flyers are more apt to conform to standard paper sizes and proportions, and illustration styles are less whimsical and less cartoony.

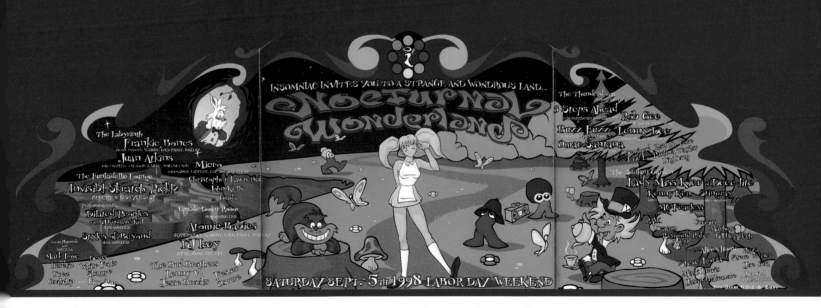

nocturnal wonderland (teaser) los angeles
1998 | insomniac
x 8.25 die-cut cmyk on glossy card
: third eye graphics

nocturnal wonderland los angeles
1998 | insomniac
5.75 x 18.5 die-cut foldout cmyk on glossy card
d: third eye graphics

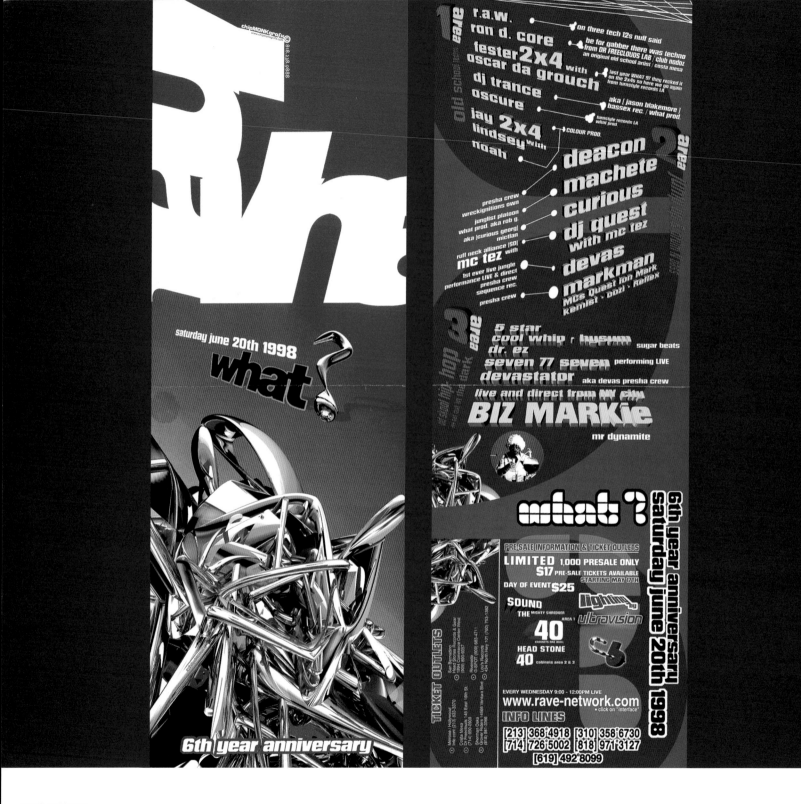

what? washington
1998 | what? productions
6.625 x 18.875 cmyk on glossy text
d: chipmonk grafx

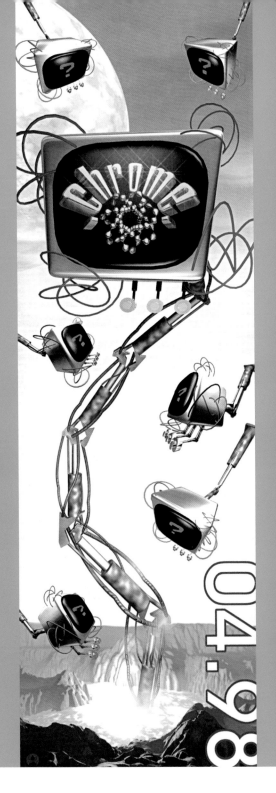

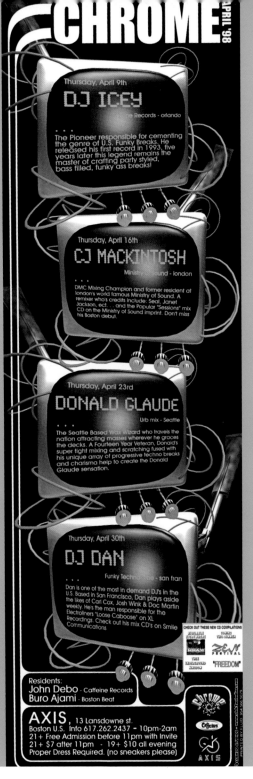

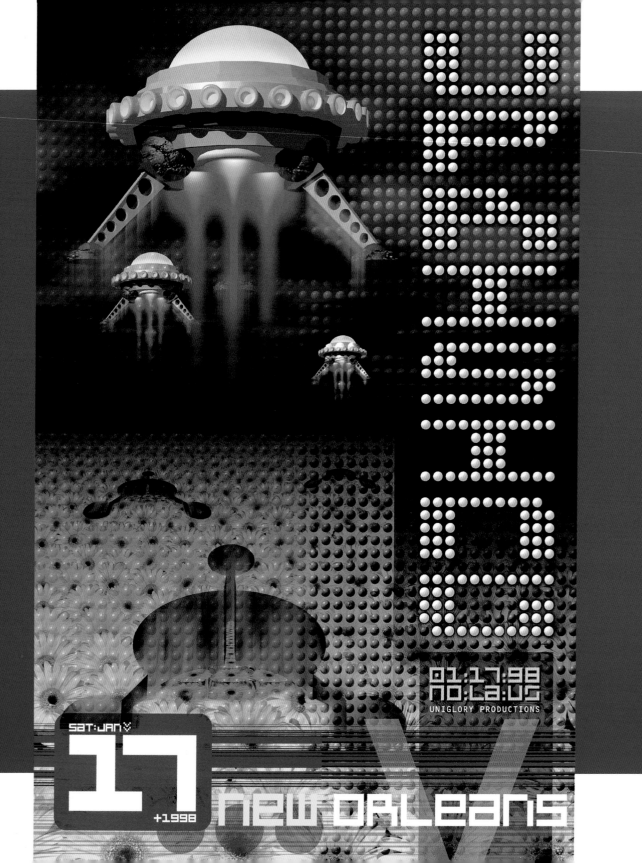

uprising new orleans
1998 | uniglory productions
11 x 17 cmyk on glossy card
d: kevy kev/kg2 graphix

a united

state of consciousness

united state of consciousness houston
1998 | afterdark productions
1.125 x 17.125 cmyk on glossy card
d: kinetic design

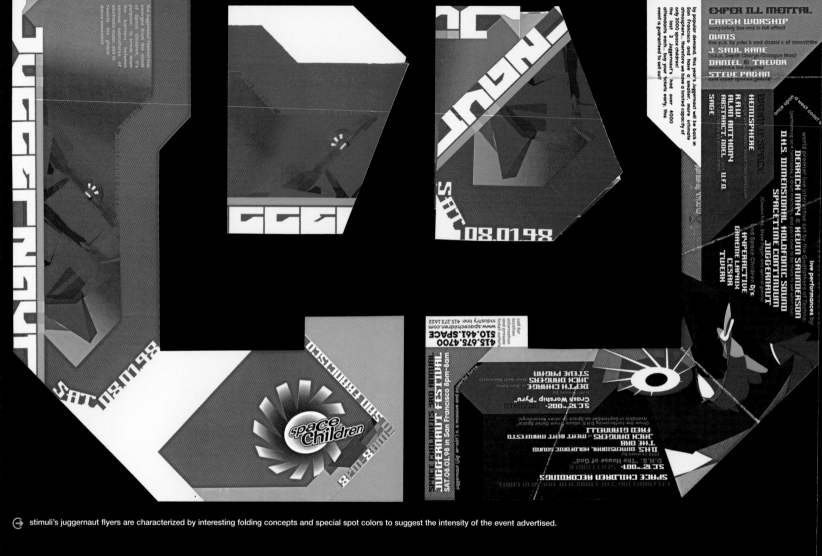

stimuli's juggernaut flyers are characterized by interesting folding concepts and special spot colors to suggest the intensity of the event advertised.

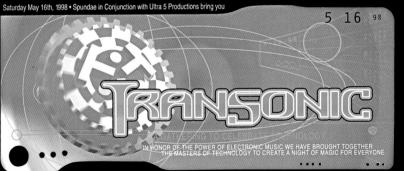

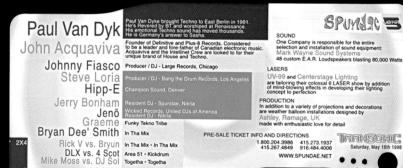

juggernaut san francisco
1998 | space children
8 x 9.25 die-cut foldout cmyk/silver/neon pink on glossy card
d: stimuli

transonic san francisco
1998 | spundae | ultra 5 productions
8.75 x 3.75 die-cut cmyk/silver on glossy card
d: elemental@nomad

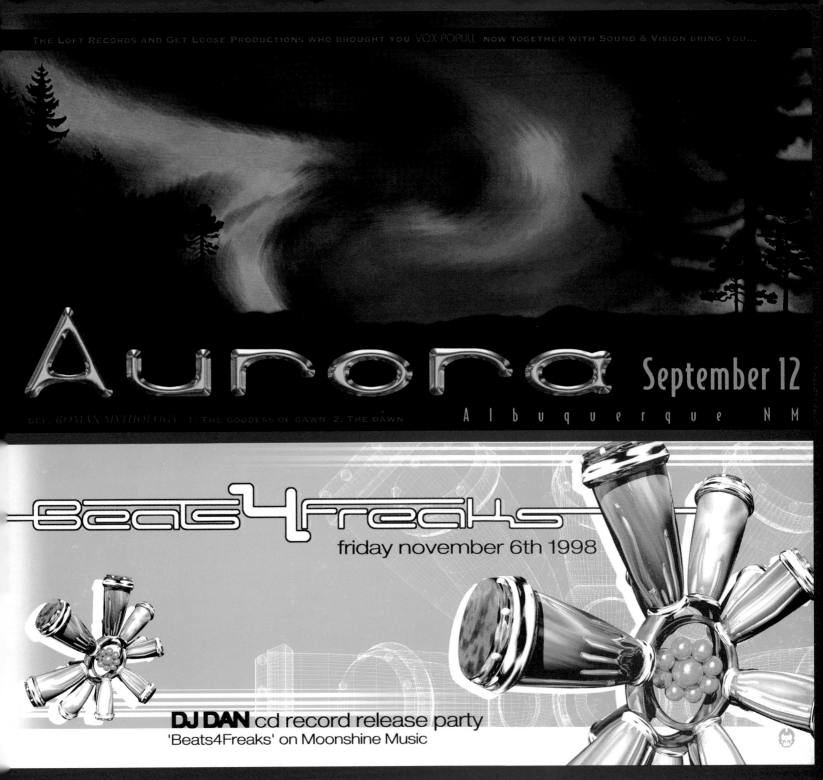

THE LOFT RECORDS AND GET LOOSE PRODUCTIONS WHO BROUGHT YOU VOX POPULI, NOW TOGETHER WITH SOUND & VISION BRING YOU...

Aurora

September 12
Albuquerque NM

DEF. ROMAN MYTHOLOGY 1. THE GODDESS OF DAWN 2. THE DAWN

Beats4freaks

friday november 6th 1998

DJ DAN cd record release party
'Beats4Freaks' on Moonshine Music

aurora albuquerque
1998 | the loft records | get loose productions | sound & vision
4.625 x 9.25 cmyk on glossy card
d: kenneth paul/nomad

beats 4 freaks los angeles
1998 | what? productions
4.25 x 11 black/neon green on glossy card
d: chipmonk grafx

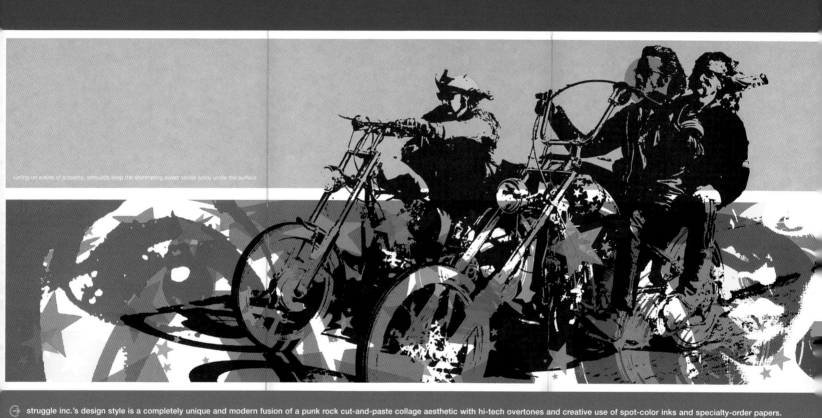

surfing on waves of screams, sensualists keep the shimmering sweet secret safely under the surface

struggle inc.'s design style is a completely unique and modern fusion of a punk rock cut-and-paste collage aesthetic with hi-tech overtones and creative use of spot-color inks and specialty-order papers.

sugar minneapolis
1998 | mile high
8 x 18.5 foldout silver/magenta/yellow/black on card
d: cody hudson/struggle inc.

as teardrops rise to meet the comfort of the dj, everyone's held breath is let go simultaneously - we all then levitate, smiling wildly,
feasting on one anothers happiness, oscillating wildly, licking the bittersweet joy off of each others soundburnt faces, dreaming wildly.

I like to get down.

new years eve · mile high · minneapolis

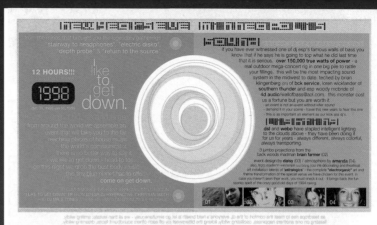

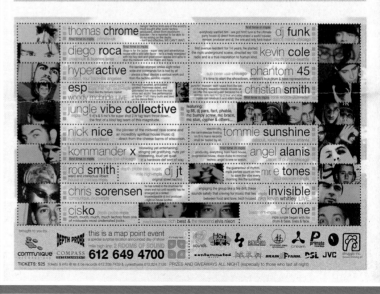

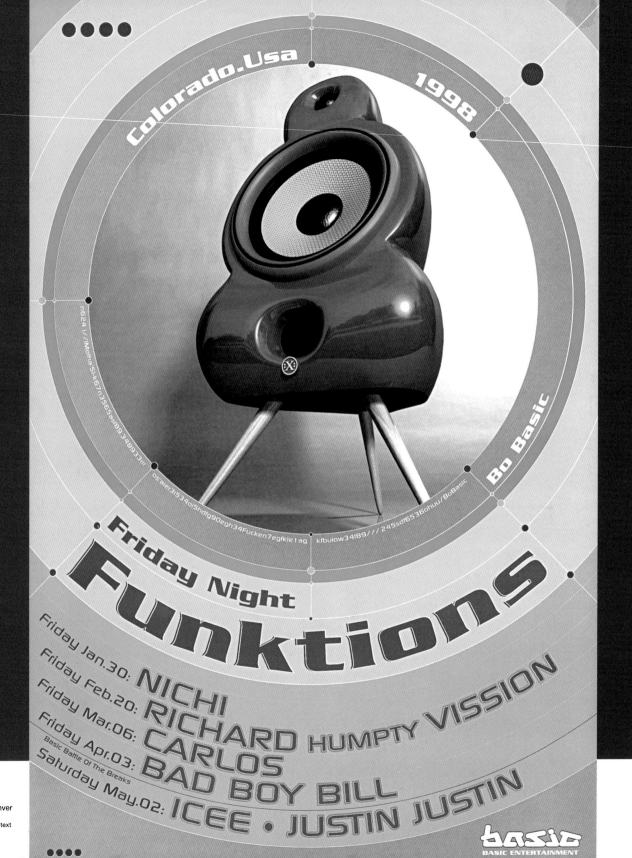

Colorado.Usa 1998

Bo Basic

Friday Night

Funktions

Friday Jan.30: NICHI
Friday Feb.20: RICHARD HUMPTY VISSION
Friday Mar.06: CARLOS
Friday Apr.03: BAD BOY BILL
Basic Battle Of The Breaks
Saturday May.02: ICEE • JUSTIN JUSTIN

friday night funktions denver
1998 | basic
12.25 x 18 cmyk/silver on matte text
d: dots per minute

basic
BASIC ENTERTAINMENT

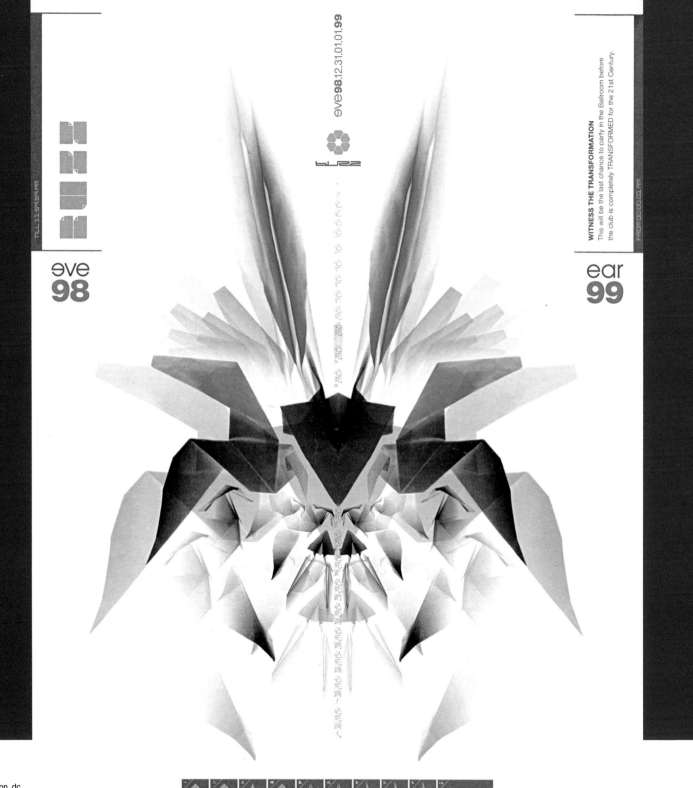

eve**98**.12.31.01.01.**99**

bUZZ

TILL 11.59.59 PM

eve
98

ear
99

必死
必死
必死
必死
必死
必死
必死
必死
必死

必死
必死蹈
必死蹈
必死蹈
必死蹈ノ
必死蹈人

This will be the last chance to party in the Ballroom before
the club is completely TRANSFORMED for the 21st Century.

FROM 00.00.01 AM

998 | buzz
.75 x 12 cmyk on glossy card
: airline industries

JAN

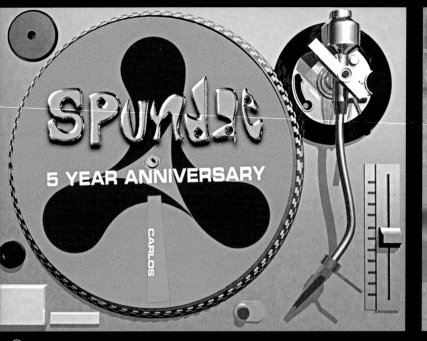

SPUNDAE
5 YEAR ANNIVERSARY
CARLOS

HARMONY PRESENTS
innercense
SAturDay, MaR. 7th 1998

this engaging spundae flyer features a turntable with a die-cut disk attached to it with a metal paper fastener so that it rotates; as the disk is spun, its cutout window reveals the names of the djs on the slip mat underneath

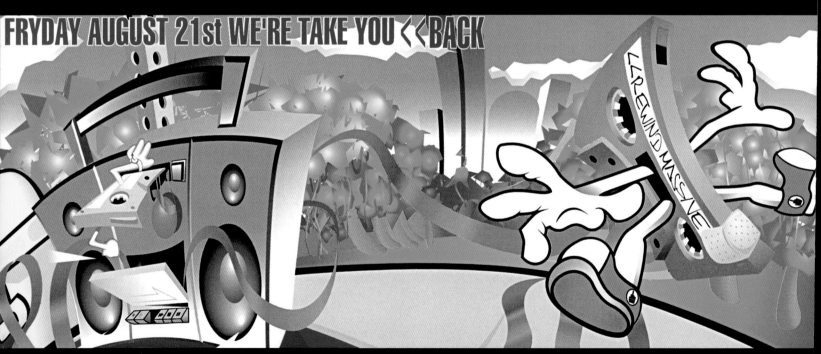

FRYDAY AUGUST 21st WE'RE TAKE YOU <<BACK

<<REWIND MASSIVE

spundae anniversary san francisco
1998 | spundae
7.375 x 5.875 die-cut cmyk on glossy card
d: nomad graphics

innercense petaluma, ca
1998 | harmony productions
3 x 4 cmyk on uv card
d: viberation

rewind massive los angeles
1998 | non-stop drum&bass
3.5 x 8.375 cmyk on uv card
d: third eye graphics

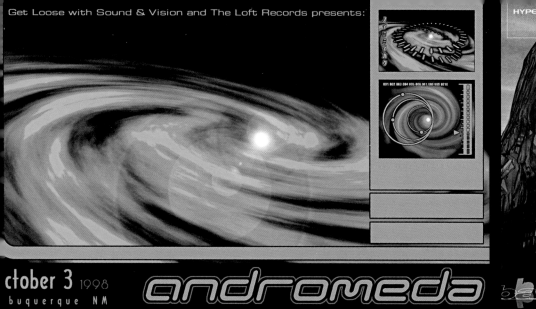

Get Loose with Sound & Vision and The Loft Records presents:

ctober 3 1998
buquerque NM

andromeda

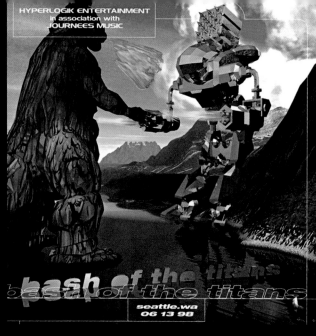

HYPERLOGIK ENTERTAINMENT
in association with
JOURNEES MUSIC

bash of the titans

seattle.wa
06 13 98

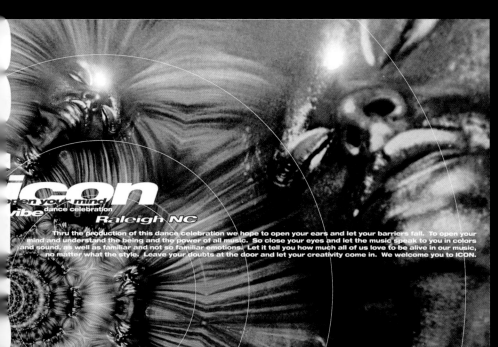

icon
open your mind
vibe dance celebration
Raleigh NC

Thru the production of this dance celebration we hope to open your ears and let your barriers fall. To open your
mind and understand the being and the power of all music. So close your eyes and let the music speak to you in colors
and sound, as well as familiar and not so familiar emotions. Let it tell you how much all of us love to be alive in our music,
no matter what the style. Leave your doubts at the door and let your creativity come in. We welcome you to ICON.

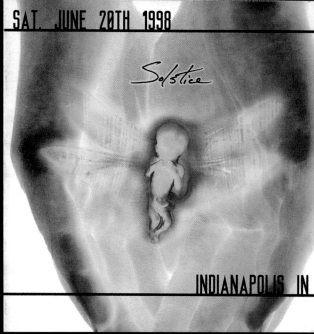

SAT. JUNE 20TH 1998

Solstice

INDIANAPOLIS IN

andromeda albuquerque
998 | get loose | sound & vision | the loft records
.875 x 7.375 cmyk/silver on glossy card
d: kenneth paul/nomad

bash of the titans seattle
1998 | hyperlogik entertainment | journees music
6 x 12 foldout cmyk on glossy card
d: INHouse design

icon raleigh, nc
1998 | catapillar productions
5.75 x 8.625 cmyk on glossy text
d: eric lee/nancy mues

solstice indianapolis
1998 | beatnix
4.25 x 8.5 cmyk on glossy card
d: beatnix designs

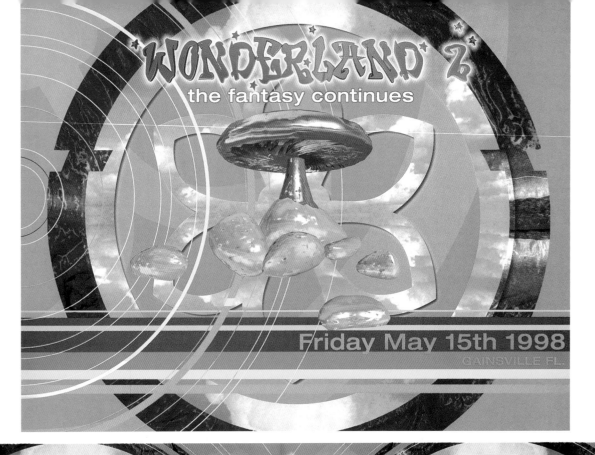

WONDERLAND 2
the fantasy continues

Friday May 15th 1998
GAINSVILLE FL.

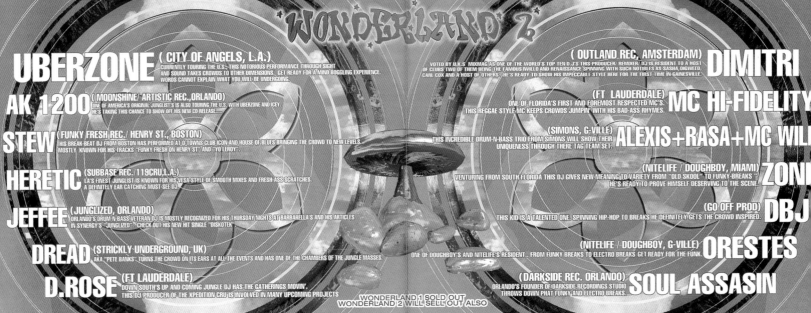

WONDERLAND 2

UBERZONE (CITY OF ANGELS, L.A.)
CURRENTLY TOURING THE U.S. THIS NOTORIOUS PERFORMANCE THROUGH SIGHT AND SOUND TAKES CROWDS TO OTHER DIMENSIONS. GET READY FOR A MIND BOGGLING EXPERIENCE. WORDS CANNOT EXPLAIN WHAT YOU WILL BE UNDERGOING.

AK 1200 (MOONSHINE/ ARTISTIC REC., ORLANDO)
ONE OF AMERICA'S ORIGINAL JUNGLIST'S IS ALSO TOURING THE U.S. WITH UBERZONE AND ICEY. HE'S TAKING THIS CHANCE TO SHOW OFF HIS NEW CD RELEASE......

STEW (FUNKY FRESH REC./ HENRY ST., BOSTON)
THIS BREAK-BEAT DJ FROM BOSTON HAS PERFORMED AT O-TOWNS CLUB ICON AND HOUSE OF BLUES BRINGING THE CROWD TO NEW LEVELS. MOSTLY KNOWN FOR HIS TRACKS "FUNKY FRESH ON HENRY ST" AND "YO LEROY".

HERETIC (SUBBASE REC./119CRU,L.A.)
L.A.'S FINEST JUNGLIST IS KNOWN FOR HIS VESA-STYLE OF SMOOTH MIXES AND FRESH-ASS SCRATCHES. A DEFINITELY EAR CATCHING MUST-SEE DJ.

JEFFEE (JUNGLIZED, ORLANDO)
ORLANDO'S DRUM-N-BASS VETERAN DJ IS MOSTLY RECOGNIZED FOR HIS THURSDAY NIGHTS AT BARBARELLA'S AND HIS ARTICLES IN SYNERGY'S "JUNGLIZED". CHECK OUT HIS NEW HIT SINGLE "DISKOTEK"

DREAD (STRICKLY UNDERGROUND, UK)
AKA "PETE BANKS" TURNS THE CROWD ON ITS EARS AT ALL THE EVENTS AND HAS ONE OF THE CHAMBERS OF THE JUNGLE MASSES.

D.ROSE (FT LAUDERDALE)
DOWN SOUTH'S UP AND COMING JUNGLE DJ HAS THE GATHERINGS MOVIN'. THIS DJ PRODUCER OF THE XPEDITION CRU IS INVOLVED IN MANY UPCOMING PROJECTS

(OUTLAND REC, AMSTERDAM) **DIMITRI**
VOTED BY U.K.'S MIXMAG AS ONE OF THE WORLD'S TOP TEN D.J.'S THIS PRODUCER/ REMIXER/ DJ IS RESIDENT TO A HOST OF CLUBS TWO OF THEM BEING THE FAMOUS IWILLO AND RENAISSANCE SPINNING WITH SUCH NOTIBLES AS SASHA, DIGWEED, CARL COX AND A HOST OF OTHERS. HE'S READY TO SHOW HIS IMPECCABLE STYLE HERE FOR THE FIRST TIME IN GAINESVILLE.

(FT LAUDERDALE) **MC HI-FIDELITY**
ONE OF FLORIDA'S FIRST AND FOREMOST RESPECTED MC'S. THIS REGGAE STYLE MC KEEPS CROWDS JUMPIN' WITH HIS BAD-ASS RHYMES.

(SIMONS, G-VILLE) **ALEXIS+RASA+MC WIL**
THIS INCREDIBLE DRUM-N-BASS TRIO FROM SIMONS WILL SHOW THEIR UNIQUENESS THROUGH THERE TAG TEAM SET.

(NITELIFE / DOUGHBOY, MIAMI) **ZONI**
VENTURING FROM SOUTH FLORIDA THIS DJ GIVES NEW MEANING TO VARIETY FROM "OLD SKOOL" TO FUNKY-BREAKS HE'S READY TO PROVE HIMSELF DESERVING TO THE SCENE.

(GO OFF PROD) **DBJ**
THIS KID IS A TALENTED ONE. SPINNING HIP-HOP TO BREAKS HE DEFINITELY GETS THE CROWD INSPIRED.

(NITELIFE / DOUGHBOY, G-VILLE) **ORESTES**
ONE OF DOUGHBOY'S AND NITELIFE'S RESIDENT.. FROM FUNKY BREAKS TO ELECTRO BREAKS GET READY FOR THE FUNK.

(DARKSIDE REC. ORLANDO) **SOUL ASSASIN**
ORLANDO'S FOUNDER OF DARKSIDE RECORDINGS STUDIO THROWS DOWN PHAT FUNKY AND ELECTRO BREAKS.

WONDERLAND 1 SOLD OUT
WONDERLAND 2 WILL SELL OUT ALSO

wonderland 2 gainesville, fl
1998
8.625 x 21.75 foldout cmyk/neon orange on glossy card
d: unknown

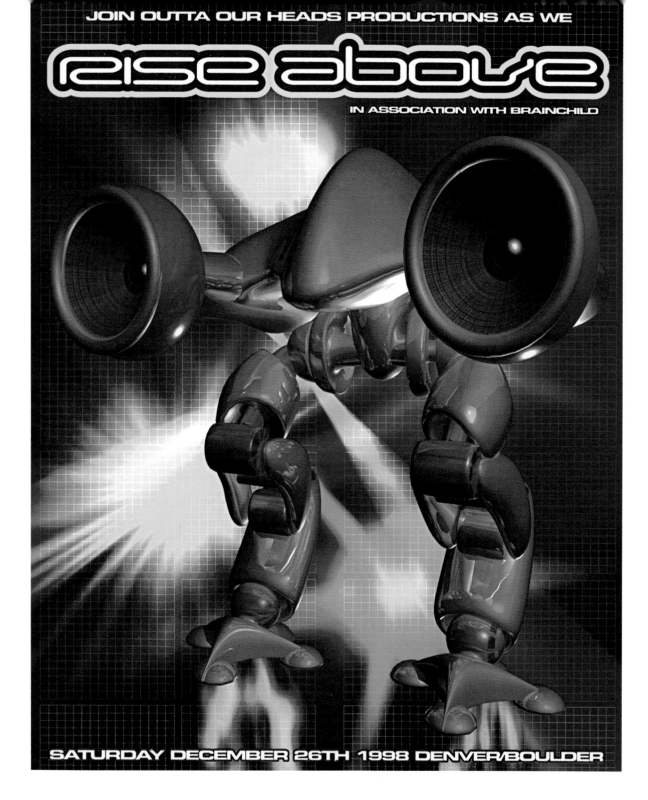

WITNESS AND BEHOLD:
mad antiks and acrobatiks of the
ROCK STEADY CREW
plus Featuring EZ Rock & Asia One
Renegades · Rock Force · Style Elements

OLD SKOOL VW BUS & BUG SHOW
swinging from a trapeze high above the dance floor:

ROCKY & DINA'S PSYCHEDELIK CIRKUS
scream in amazement as slickrick sets himself on fire and gets funky!

THE REAL BURNING MAN
returning from the very first narnia 1992
from the original Woodstock and Rainbow Family **FANTUZI**

RAINBOW FAMILY DRUMMERS
PLUS **SHIVA'S EROTIC**
Trip Upon **DANCE PROCESSION**

SOUTHERN CALI SKATE EXPO world industries, blind, volcom, girl, neighborhood

LIVE AEROSOL ARTS EXHIBITION
Uli Crew continues BODE WARZ LIVE!

PLUS STILT WALKERS, JUGGLERS, CONTORTIONISTS,
PSYCHICS, MAGICIANS, RITUAL PIERCING,
LOVE POTIONS & KISSING BOOTHS, BODY PAINTING, HENNA,
TATTOO & BODY MANIPULATION, EXOTIC & EROTIC FOOD FAIR,
PLUS MUCH MUCH MORE!

Future Fiction Freak Fest:
starring: Rocky Raccoon, Dinalishus, Airick Heater
Jason Jizzum, House of Sugar Twist, Boom Boom,

YOU SEE MY HONEY BLOSSUM NARNIA IS THEE ENTERNAL BATTLE AGAINST THE FORCES OF WACKNESS, WHERE ONLY LOVE CAN CONQUER ALL!

Presale Tickets on Sale August 7th
Buy Presale! Save Loot & Avoid Long Lines
only 20$ till 8pm August 28

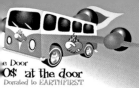
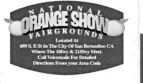

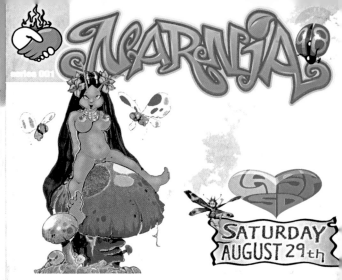

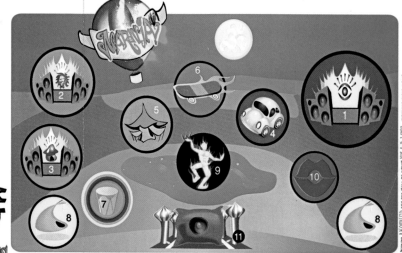

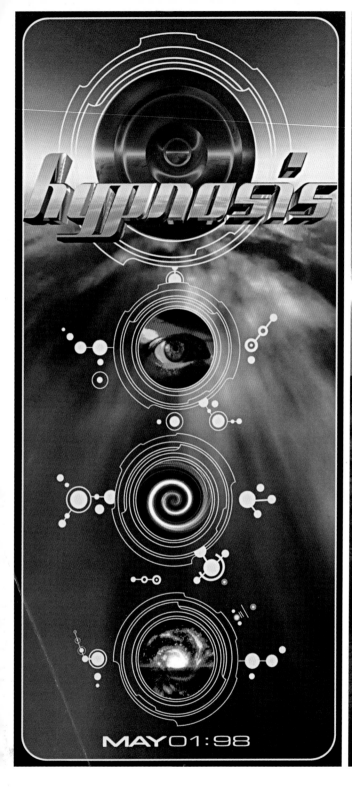

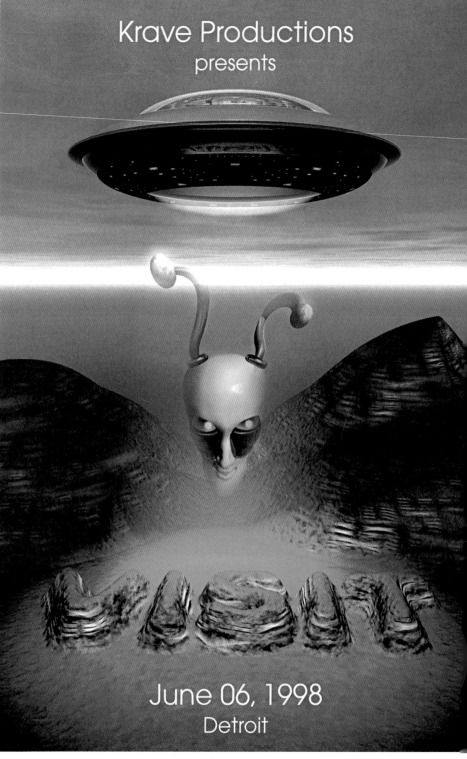

hypnosis upstate new york
1998 | hypnotic
5.875 x 12.75 cmyk on glossy text
d: mars graf-x

visit detroit
1998 | krave productions
6.625 x 9.125 cmyk on glossy card
d: wicker park creative mediums

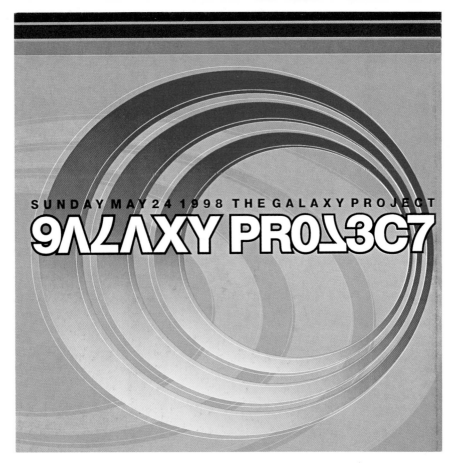

here, the earth program pushed the boundaries of typography by using numerals in place of some of the letters in the event's title, a design concept that turns the title itself into a modern, eye-catching logo.

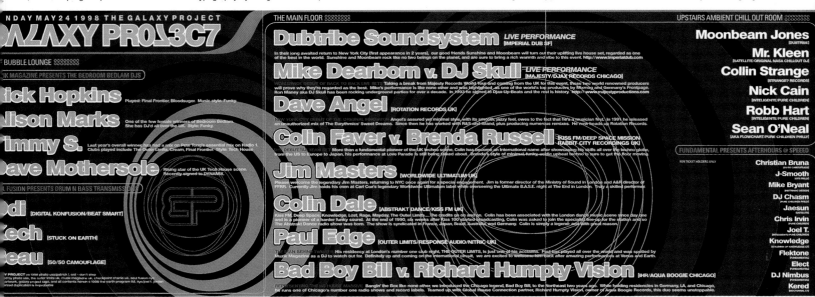

alaxy project new york
998 | photo productions
x 24 foldout cmyk/silver on matte text
joel t/the earth program ltd.

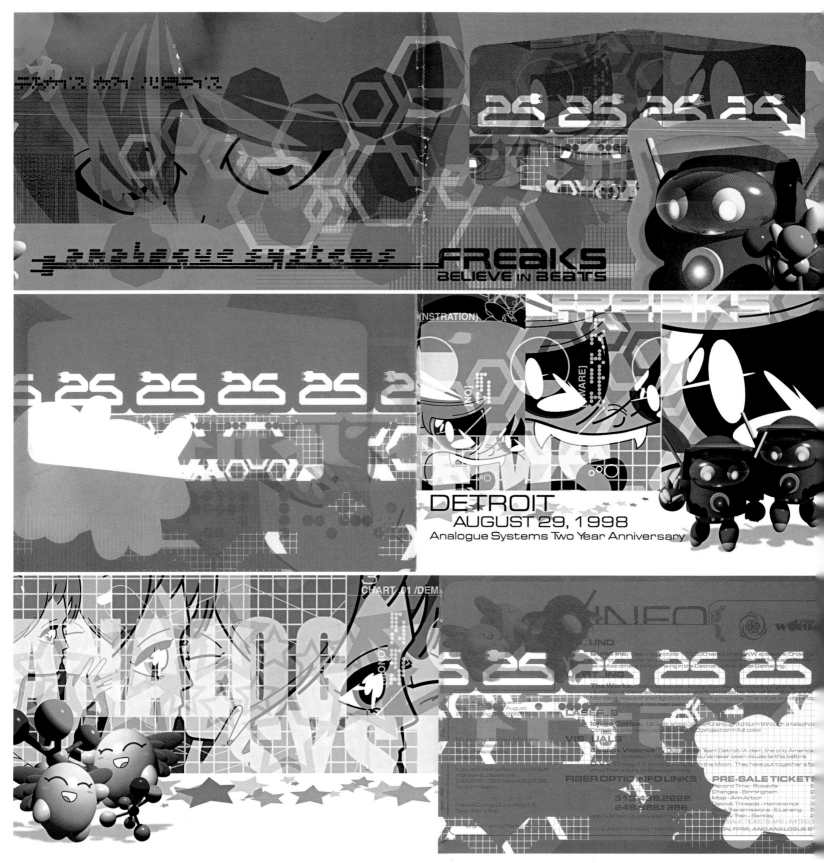

analogue systems

FREAKS
BELIEVE IN BEATS

DETROIT
AUGUST 29, 1998
Analogue Systems Two Year Anniversary

CHART 01 /DEM

the "freaks believe in beats" flyer shown on the facing page and below at left features an incredible array of layered photography, typography, and original iconic character illustrations. produced as a saddle-wired (bound in the center with staples) booklet, this piece is extraordinary for its tasteful design, costly printing techniques, specialty paper, vellum, foil stamping, and die-cutting.

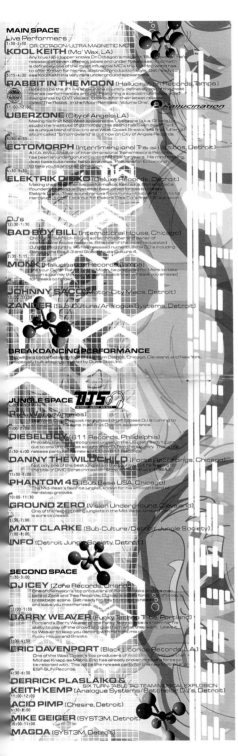

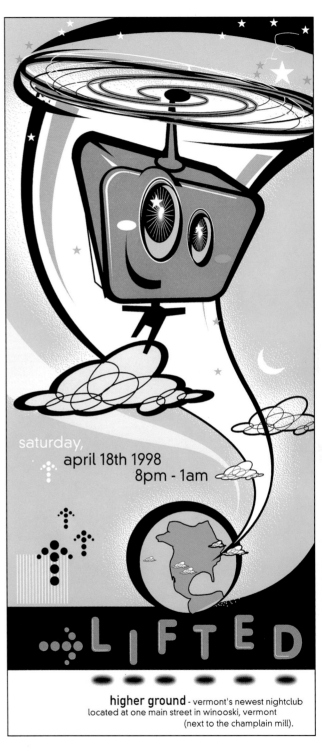

freaks believe in beats detroit
1998 | analogue systems
5 x 19 die-cut booklet foil stamp/cmyk/blue on glossy text and vellum
d: demo design

lifted winooski, vt
1998 | capacitor sounds | higher ground crew
4.125 x 5.5 cmyk on glossy card
d: capacitor design network

beatseed chicago
1998 | pure | funky buddha lounge
4 x 5 cmyk on glossy card
d: wicker park creative mediums

lifted winooski, vt
1998 | capacitor sounds | higher ground crew
8.5 x 22 cmyk on glossy card
d: capacitor design network

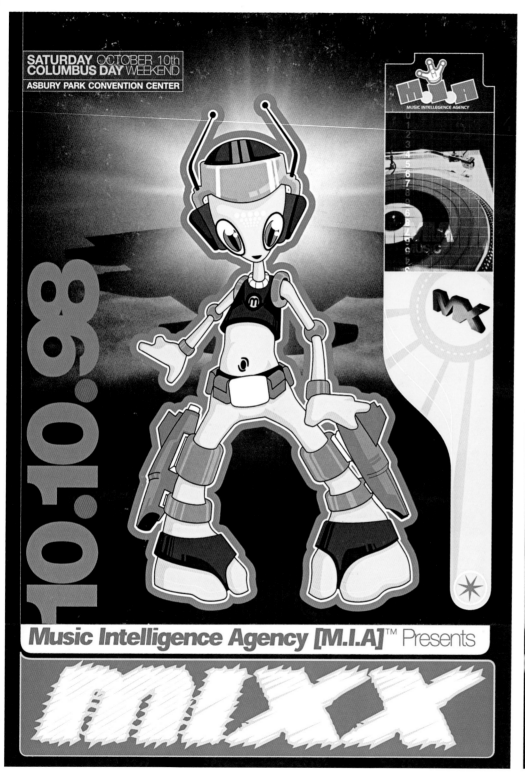

SATURDAY OCTOBER 10th
COLUMBUS DAY WEEKEND
ASBURY PARK CONVENTION CENTER

10.10.98

Music Intelligence Agency [M.I.A]™ Presents

mixx

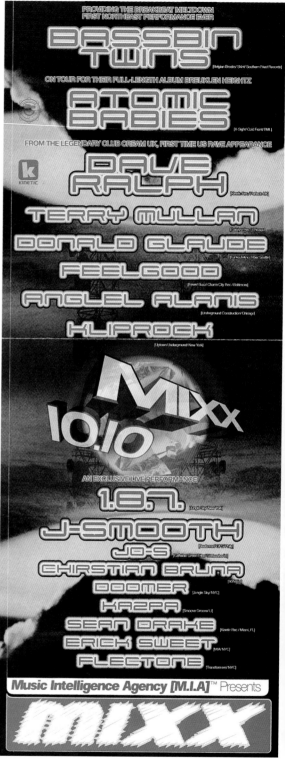

PROVIDING THE BREAKBEAT MELTDOWN
FIRST NORTHEAST PERFORMANCE EVER
BASSBIN TWINS
[Belgian Breaks / Skint / Southern Fried Records]

ON TOUR FOR THEIR FULL-LENGTH ALBUM BREUKLEN HEIGHTZ
ATOMIC BABIES
[X-Sight / Cold Front / TMI]

FROM THE LEGENDARY CLUB CREAM UK, FIRST TIME US RAVE APPEARANCE
DAVE RALPH
[Kinetic Rec / Perfecto UK]

TERRY MULLAN
[Catalyst Rec / Chicago]

DONALD GLAUDE
[Fun Key Tekno / Tribe / Seattle]

FEELGOOD
[Fever / Buzz / Charm City Rec / Baltimore]

ANGEL ALANIS
[Underground Construction / Chicago]

KLIPROCK
[Uptown Underground / New York]

MIXX 10.10

AN EXCLUSIVE LIVE PERFORMANCE
1.8.7.
[Jungle Sky / New York]

J-SMOOTH
[boutward / 1875 / PNJ]

JO-S
[caffeine Green Tribe / St Maarten U]

CHRISTIAN BRUNA
[NRG U]

DOOMER
[Jungle Sky / NYC]

KAZPA
[Smoove Groove / LI]

SEAN DRAKE
[Kinetic Rec / Miami, FL]

ERICK SWEET
[MIA/NYC]

FLESTONE
[Transformers / NYC]

Music Intelligence Agency [M.I.A]™ Presents

mixx

mixx asbury park, nj
1998 | music intelligence agency
8.5 x 22 foldout cmyk/metallic blue on glossy text
d: kon t/artificial

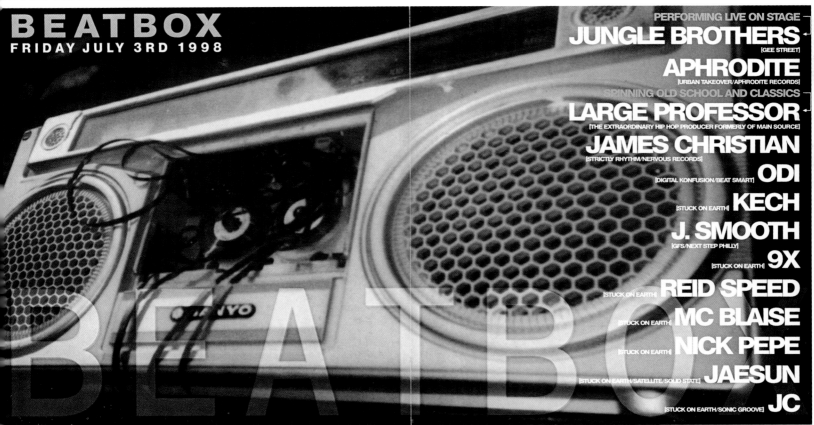

PERFORMING LIVE ON STAGE

JUNGLE BROTHERS
[GEE STREET]

APHRODITE
[URBAN TAKEOVER/APHRODITE RECORDS]

SPINNING OLD SCHOOL AND CLASSICS

LARGE PROFESSOR
[THE EXTRAORDINARY HIP HOP PRODUCER FORMERLY OF MAIN SOURCE]

JAMES CHRISTIAN
[STRICTLY RHYTHM/NERVOUS RECORDS]

ODI
[DIGITAL KONFUSION/BEAT SMART]

KECH
[STUCK ON EARTH]

J. SMOOTH
[GFS/NEXT STEP PHILLY]

9X
[STUCK ON EARTH]

REID SPEED
[STUCK ON EARTH]

MC BLAISE
[STUCK ON EARTH]

NICK PEPE
[STUCK ON EARTH]

JAESUN
[STUCK ON EARTH/SATELLITE/SOLID STATE]

JC
[STUCK ON EARTH/SONIC GROOVE]

beatbox new york
1998 l stuck on earth l g.e.m. l 360°
9 x 18 foldout cmyk on matte text
d: joel t/the earth program ltd.

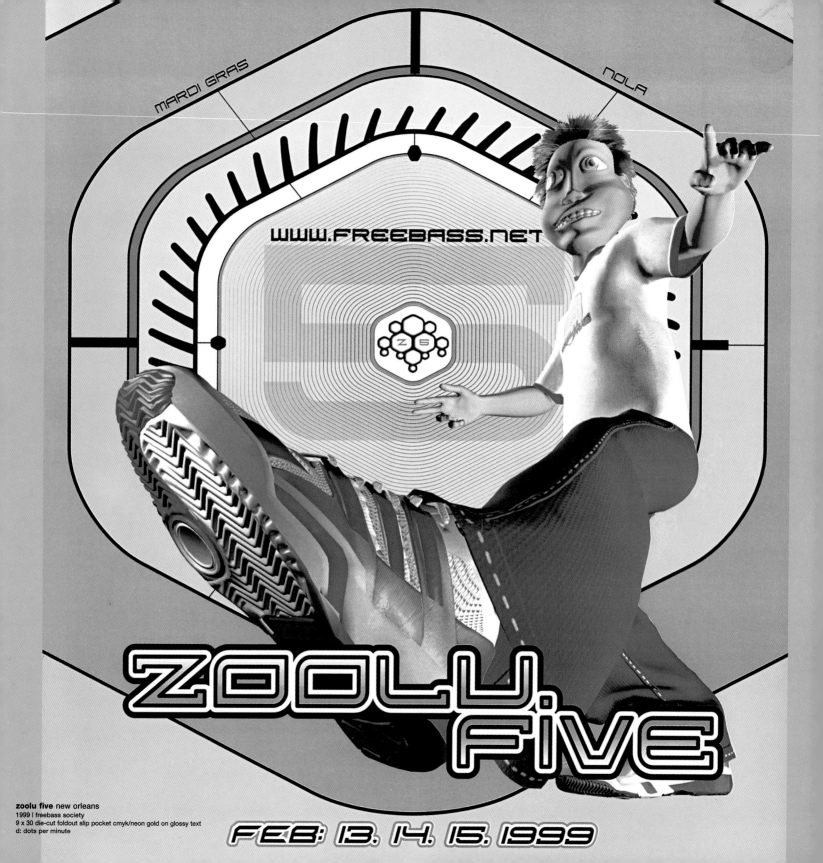

MARDI GRAS

NOLA

WWW.FREEBASS.NET

ZOOLU FIVE

zoolu five new orleans
1999 | freebass society
9 x 30 die-cut foldout slip pocket cmyk/neon gold on glossy text
d: dots per minute

FEB: 13. 14. 15. 1999

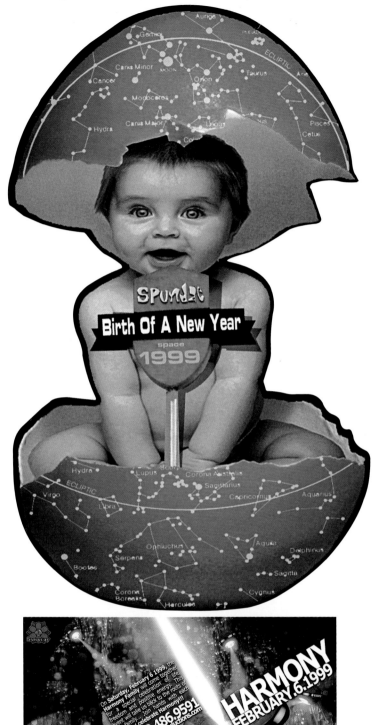

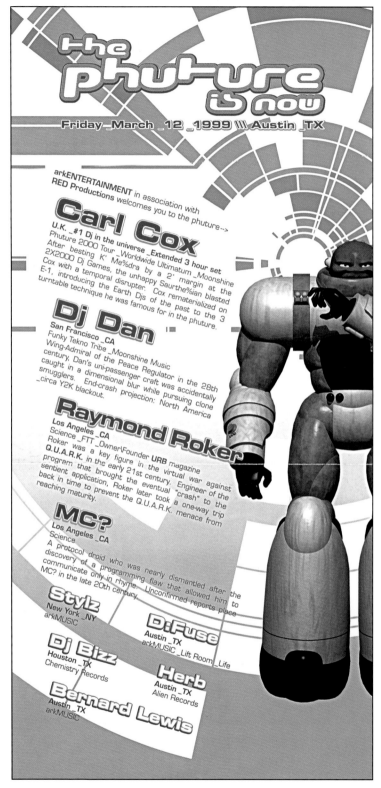

spundae birth of a new year san francisco
1999 | spundae
4.75 x 7.75 die-cut cmyk on glossy card
d: peter b@spundae

harmony oakland
1999 | harmony productions
3.25 x 5.5 cmyk on uv card
d: viberation

the phuture is now austin, tx
1999 | ark entertainment | red productions
7 x 14 foldout cmyk/silver on glossy text
d: gog and magog

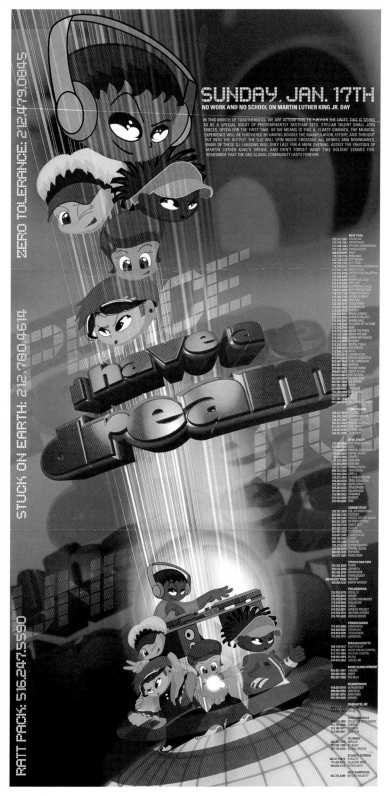

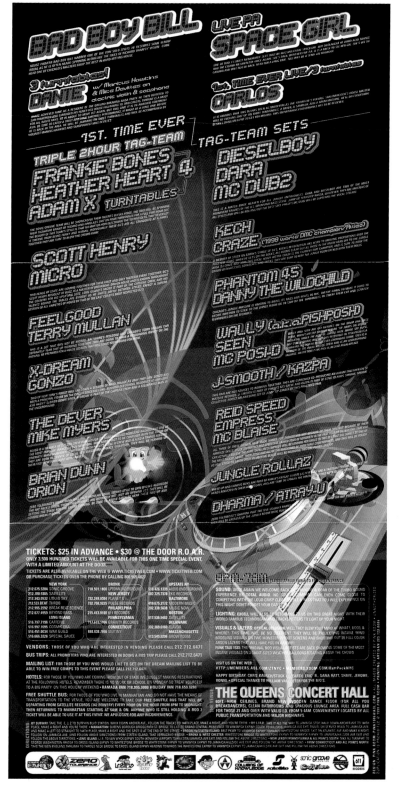

i have a dream new york

1999 | stuck on earth | zero tolerance | ratt pack

12 x 24 foldout cmyk on glossy text

d: pink room

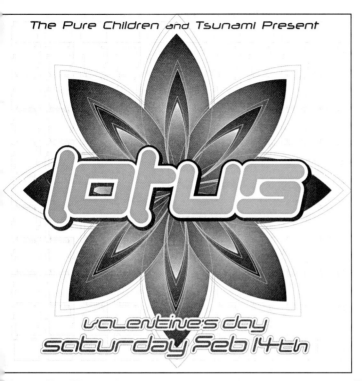

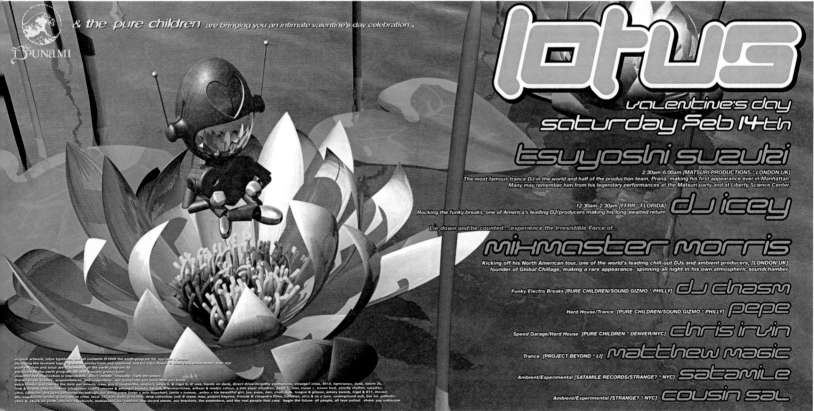

lotus **new york**
1998 | pure children | tsunami
7 x 14 foldout cmyk on matte text
d: joel t/the earth program ltd./zack detox/bionic dots

bittersweet **toronto**
1999 | syrous
6.5 x 18 die-cut foldout cmyk on glossy card
d: prototype

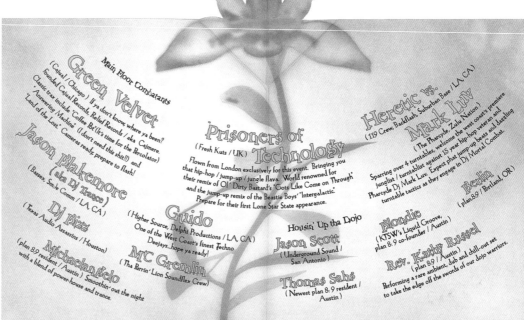

Saturday January 30th 1999

MORE THAN LIFE

命よりもまた愛よりも

MORE
THAN
LOVE

Silicon Hills
Austin TX

Main Floor Combatants

Green Velvet
(Cajual / Chicago) If ya don't know where ya been?
Founded Cajual Records, Relief Records / aka Cajmere.
Classic trax include "Coffee Be(lk's time for the Percolator)"
"Answering Machine" (I don't need this shit!!) and
"Land of the Lost." Cameras ready, prepare to flash!

Jason Blakemore
(aka DJ Trance)
(Bassex Smile Comm / LA CA)

DJ Pizz
(Texas Audio Assassins / Houston)

Michaelangelo
(plan 8:9 resident / Austin) Smoothin' out the night
with a blend of power-house and trance.

Prisoners of Technology
(Fresh Kuts / UK)
Flown from London exclusively for this event. Bringing you
that hip-hop / jump-up / jungle flava. World renowned for
their remix of Ol' Dirty Bastard's "Gots Like Come on Through"
and the jump-up remix of the Beastie Boys' "Intergalactic."
Prepare for their first Lone Star State appearance.

Guido
(Higher Source, Delphi Productions / LA CA)
One of the West Coast's finest Techno
Deejays...hope ya ready!

MC Gremlin
(Tha Rurrin' Lion Sound/Hex Crew)

Housin' Up tha Dojo

Jason Scott
(Underground Sound /
San Antonio)

Thomas Sahs
(Newest plan 8: 9 resident /
Austin)

Heretic vs. Mark Luv
(119 Crew, Backlash, Suburban Base / LA CA)
(The Pharcyde, Zulu Nation)
Sparring over 4 turntables, welcome the west coast's premiere
junglist / turntablist against 15 year hip-hop veteran and
Pharcyde DJ Mark Luv. Expect phat jump-up beats and dazzling
turntable tactics as they engage in DJ Mortal Combat.

Berlin
(plan 8:9 / Portland, OR)

Blondie
(KTSW's Liquid Groove,
plan 8: 9 co-founder / Austin)

Rev. Kathy Russel
(plan 8:9 / Austin)
Performing a rare ambient, dub and chill-out set
to take the edge off the swords of our dojo warriors.

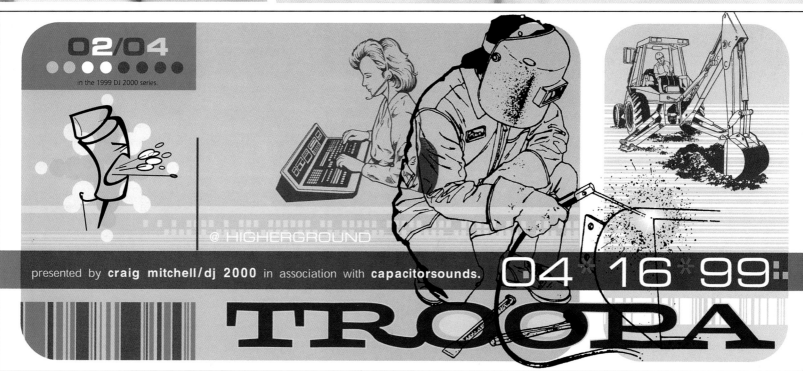

02/04

in the 1999 DJ 2000 series.

@ HIGHERGROUND

presented by **craig mitchell/dj 2000** in association with **capacitorsounds.**

04 * 16 * 99

TROOPA

more than life, more than love austin, tx
1999 | nu:plan.8 | insiders
7.75 x 11 die-cut foldout pop-up cmyk on matte card
d: the invincible loki skywalker

troopa winooski, vt
1999 | craig mitchell/dj 2000 | capacitor sounds
5 x 11 cmyk on matte card
d: capacitor design network

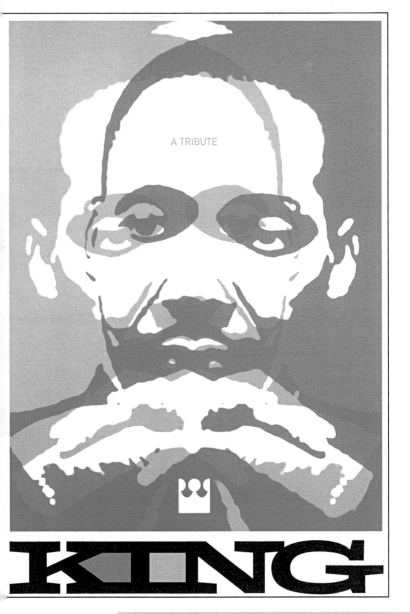

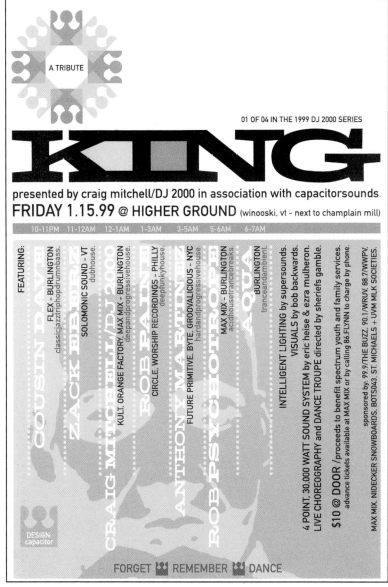

king winooski, vt
1999 | capacitor sounds | higher ground
4.125 x 5.375 cmyk on matte card
d: struggle inc./bots043

rotation iowa city, ia
1999 | brothas n sistas
2.75 x 11 photocopy on pink card
d: nodal communications

contact

a&a graphics
tel: 714/521-8784 fax: 7602
www.AandAgraphics.com
e: aagraphics@home.com

airline industries
l. paul miller. todd baldwin.
akira takahashi.
www.airlineindustries.com
e: info:@airlineindustries.com

the aleph laboratories
tel: 412/761-8173

aya kotake
e: ayakotake@hotmail.com

bbbee
e: bbbee@mindspring.com

beatnix design / erin vernon
tel: 317/335-4475
www.beatnixmedia.com
e: erin@beatnixmedia.com

benno / shaun gough
benno tel: 514/840-0944
shaun tel: 212/697-4895

boyz+girls / flyer nyc
anselm d'astner
www.boyzandgirls.com

capacitor design network
tel: 802/658-0222
e: info@capacitornetwork.com

chipmonk grafx
tel: 818/238-9888 fax: 9112
www.chipmonkgrafx.com
e: chpmonk@pacbell.net

CLRH2OStudios, inc.
clearwater d. hawes
www.clrh2ostudios.com
e: clrh2o@clrh2ostudios.com

cody hudson / struggleinc / 43d
e: bigstrug@hotmail.com

creation uk (DB)
e: db@wbr.com

demo design
justin fines
www.demo-design.com

digital laundre mat / dagmar
tel: 415/865-0971

DirtyDesign
gabriel hunter
e: dirtydesign@earthlink.net

dots per minute
eric paxton stauder. daryl obert.
zack detox.
tel: 212/604-4496
www.bionicresearch.com

the earth program ltd.
joel t. jordan. robb hart. pat lavin.
tel: 212/367-9341 fax: 9342
www.theearthprogram.com
e: urastar@theearthprogram.com

eConspiracy
brian walls
tel: 510/836-0683
www.econ.net
e: econ@econ.net

factory design labs
www.factorylabs.com

groovin design
mike friolo
www.factorylabs.com
e: mikef@factorylabs.com

jive / freshjive
richard klotz
www.freshjive.com

journees / INHouse / nucleart
eric lee
tel: 408/725-1291

kali-yuga designs
rumi humphrey
e: rumi@alienskin.com

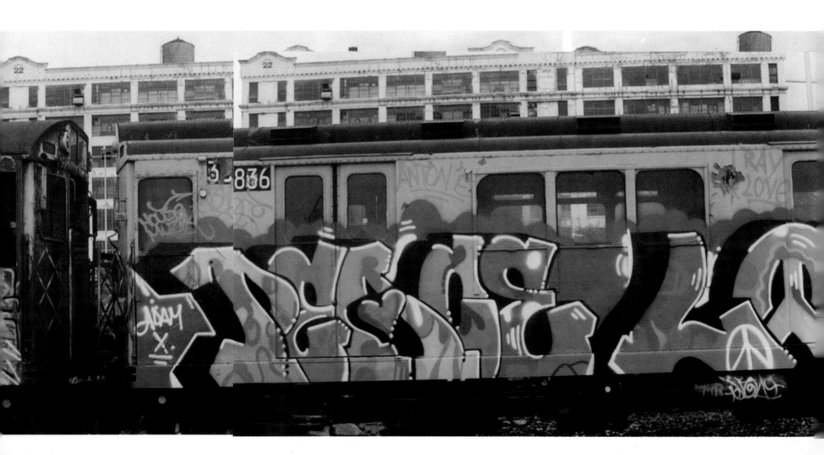

kg2
kevy kev
tel: 614/297-6487
www.kg2-graphix.com
e: kg2@coil.com

kinetic design
chris treadway. grace gordy.
tel: 713/522-0333
www.visualatmosphere.com
e: pixeleyes@visualatmosphere.com

loki skywalker
e: loki@worldramp.net

lonnie fisher
tel: 410/637-6715
www.ultraworld.net

mars graf-x
david marsh
tel: 914/485-8165
www.marsgraf-x.com

maxart
tel: 317/871-2213

nodal communications
jeremy dedic
tel: 309/797-6076
www.nodal.com
e: design@nodal.com

nomad design
kenneth paul. yuan fung.
tel: 415/357-1509

1212
heather sommerfield
right 2 execute
www.r2e.com

pinkroom design
tel: 215/627-0887 fax: 0786
www.pinkroomdesign.com
e: pink7006@aol.com

prototype design
tel: 604/688-7229
www.prototypedesign.net
e: proto@direct.ca

pure roker graphics
raymond roker
tel: 323/993-0291
e: rroker@urb.com

pure, inc. / wpcm
charles e. little II, designer/promoter
www.purefuture.com
e: info@purefuture.com

rivas grafix
paul rivas
e: paulrivas1@earthlink.net

robin e. guthrie
e: robin@techno.ca

spundae / peter b.
tel: 415/575-1575 fax: 1577
www.spundae.com
e: info@spundae.com

stimuli
tom allain
tel: 213/212-4474

studio x see "dots per minute"

third eye graphics
tel: 626/813-8338
www.thirdeyegraphics.com

under design
andrew davidson
tel: 215/636-1700
www.undr.com / www.flyerart.com
e: under@2world.com

viberation graphics
www.viberation.com

windog
doug boehner
e: windog@airmail.net

zack detox see "dots per minute"

zeta-g
www.mikeszabo.com
info@mikeszabo.com

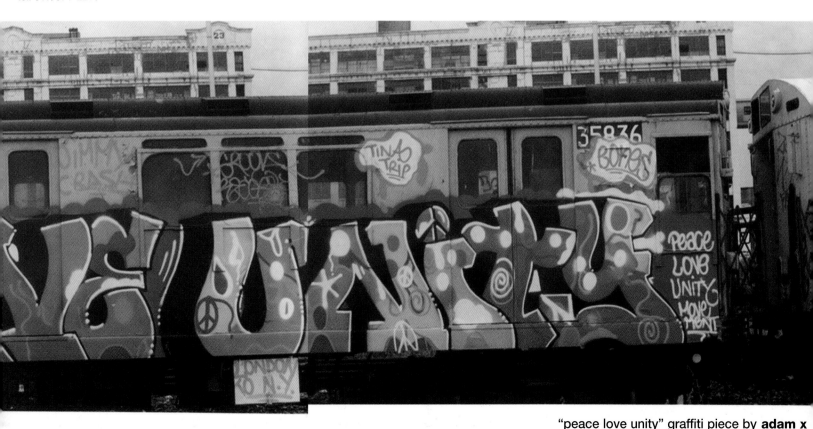

"peace love unity" graffiti piece by **adam x**

gratitude

dennis the menace, frankie bones, andrew davidson / under design, wednesday apres-medi, rick klotz, storm rave, philip blaine, matt e. silve
stan endo, zeta-g, nasa, gavin hardkiss, brian / e con, DB, kurt / drop bass network (www.dropbass.net), raymond roker, scott henry
buzz crew, fever dc, catastrophic, paul rivas, vivien rachles, marian appellof, patrick james lavin, kon t. art, capacitor design network
lonnie fisher / ultraworld, tom allain / stimuli, airline industries, john trepp, jamie brady / activated, matt / massive magazine, tom mellc
charles little, nigel richards, scotto / drop, donnie / freebass society (www.freebass.net), pasqual / insomniac LA (www.insomniac-usa.com
patrick oot / phato usa (www.phato.com), josh wink, erin vernon, rick / maxart, dieselboy, nick cain, alan sanctuary, kevy kev / kg2
satellite records, chipmonk grafx, gary richards, loki skywalker, viberation, factory design labs, benno, jaclyn violet barbarinc
spundae, cody hudson, laura hulon, a&a graphics, nodal, robin guthrie, aya kotake, digital laundre mat, prototype, boyz+girls, matt
www.ravedata.org, aaron / dose (www.lifeforceindustries.com), jason donovan / zen festival, justin fines / demo design, urb magazine
clearwater hawes, eric lee / journees, doug / windog, ryan / destiny productions, kevin / funky tekno tribe (www.funkytekno.net)
tim o'keef, mars graf-x, paul / mark slater, primary productions, kenneth paul / nomad, chris / kinetic design, pinkroom, kevin gimble
circle productions, dennis / third eye graphics, gabe / dirtydesign, bbbee, mike friolo / groovin design, john dwight, kiley thompsor
rumi humphrey / kali-yuga, ronald, eric paxton stauder, daryl obert, zack detox, eric / mole graphics, the aleph laboratories, XLR8R, matt
sunshine kids, jeno / wicked crew, ryan / superstars of love, jay goodwill, tamara weikel, dj bizz, michael rosenberg, aaron / deepsix
damon zwirn, underground peace society, bleep, caffeine, www.flyerart.com, adam x (for the wicked graf piece), ladybug grafiks
don piper, pisces for guidance and wisdom, our friends and families for support and encouragement, guav and robb hart for their count
less hours of scanning, all the designers and promoters who submitted their work, and the entire scene for developing a culture all our owr
peaceloveunityrespect.